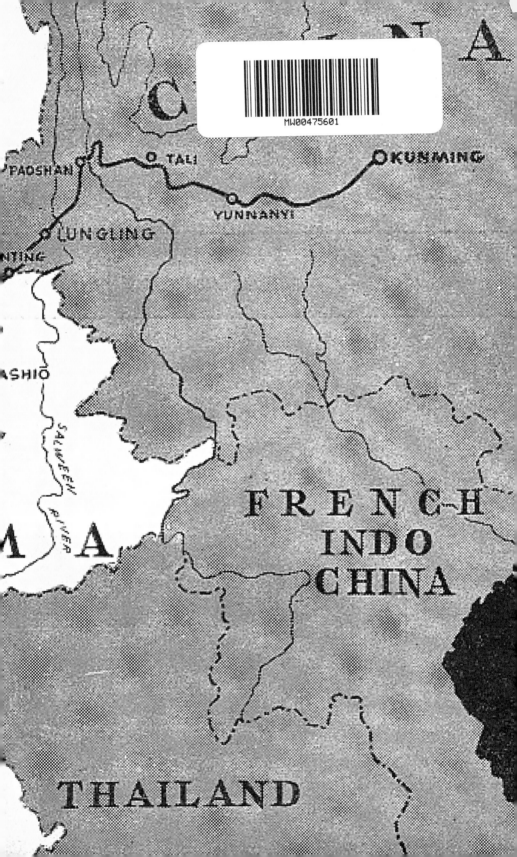

PRAISE FOR
The Last Romantic War

"Filmmaker Ken Burns observed that 'in extraordinary times, there are no ordinary people.' *The Last Romantic War* is the story of an extraordinary family during extraordinary times. Based on the colorful accounts told by her father and mother and a variety of other sources, Robin Traywick Williams has produced a remarkable book that anyone will find compelling reading."

> Charles F. Bryan, Jr., Ph.D., President & CEO emeritus, Virginia Historical

"A thoroughly researched, beautifully and lovingly told dramatic tale. A plot-twisting courtship from swing music dance floors to steaming Burmese jungles via perilous air travel. Evokes 1940s atmosphere and preserves precious memories of the Greatest Generation. The Last Romantic War should interest anyone whose parents or grandparents were involved in WWII. Williams does a fantastic job of telling the story."

> Barclay Rives, author of *William Cabell Rives, A Country to Serve*

"With characteristic humor, Robin Williams unspools a deeply human love story writ large against the backdrop of World War II America. It is a winning tale of love and loss that travels, satisfyingly, around the globe and back to love again. I missed these characters when I was away from this book. Williams' voice in this family saga is one you will not soon forget."

> Gabrielle Guirl Thomas, journalist and television persona extraordinaire

"Reading like an historical novel, this true story of two strong-willed lovers separated by the Burma Campaign of WWII fully engages the reader from the first to the final page. A vivacious Southern belle on the home front captures hearts at military bases dances and country club parties while her roving-eyed (or is he?) would-be fiance slogs his way through the pestilent, disease-ridden jungles of Burma routing the Japanese from the path of the Burma Road. Researched from diaries, war histories, interviews, and family memories, Robin Williams brings alive each of her parents' hopes, dreams, and magnetism at a time of peril, uncertainty and evolving social mores. Moving, vivid, and thoroughly satisfying."

Norman Fine, author of *Blind Bombing: How Microwave Radar Brought the Allies to D-Day and Victory in World War II*

"The heart of this classic story lies in another time, at another place in America's long fascination with love and war. We've seen the story a million times, in books and movies, and we've felt the tingles when the good guy finally gets the girl. But this story is different, in the best of ways.

"Here we have a bright and beautiful teen-ager, Flo Neher, soon to be the belle of countless balls across the Southland. She is only 17 when she meets the man she loves—or maybe she loves, being a teen-ager after all. But war is brewing and soon enough her handsome warrior, Captain Bo Traywick, is off slogging through the steaming jungles of Burma, fighting to conquer evil in one of the most brutal and far-flung theaters of World War II.

"If the reader is a little hazy on the role of Burma in the war, it is all meticulously laid out here by the sure hand of Virginia writer Robin Traywick Williams. As for the romance, the long-distance lovers are the author's parents. As their daughter, she has heard the stories all of her life and augmented her knowledge with formal interviews with her parents and siblings, as well as a trove of her parents' contemporaneous correspondence.

"From this uniquely American saga spanning eight decades emerges a warm and often funny chronicle of war-time romance during the Forties. The narrative's historical accuracy is impres-

sive, but most of all the reader becomes privy to seeing the improbable prevail in ways that bring a fresh depth to our understanding of the Greatest Generation."

Henry Hurt, former editor-at-large of *The Reader's Digest*, author of *Stories from the Road Not Taken, Shadrin, The Spy Who Never Came Back, and Reasonable Doubt: An Investigation into the Assassination of John F. Kennedy*

"Movies and novels have long—and justifiably—explored the compelling tensions of love in a time of war. Few, though, have achieved the rich and layered portrait that Robin Williams achieves with the true love story traced in *The Last Romantic War*. Through her exploration of the rollicking courtship of Bo Traywick and Flo Neher, Williams powerfully evokes the sights, tempos, and textures of American culture thrown into the mid-twentieth century cauldron that was World War II. Williams' mixture of humor and research offers a most captivating read."

Nancy C. Parrish, author of *Lee Smith, Annie Dillard, and the Hollins Group* and *The Downton Era: Great Houses, Churchills, and Mitfords*

"*The Last Romantic War* proves love is the wild card of existence. It also proves that Robin Traywick Williams seethes with talent."

Rita Mae Brown, mystery writer and author of the Sister Jane foxhunting series

Also by the Author

The Key to the Quarter Pole
a novel

Bush Hogs and Other Swine
essays

Chivalry, Thy Name Is Bubba
essays

The
Last Romantic
WAR

How two members of the Greatest Generation
survived love and war.

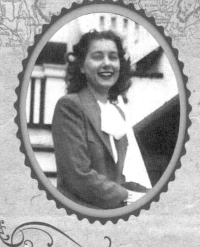

ROBIN TRAYWICK WILLIAMS

First Printing

Author - Robin Traywick Williams
robinwilliamsbooks.com

Publisher
Wayne Dementi
Dementi Milestone Publishing, Inc.
Manakin-Sabot, VA 23103
www.dementimilestonepublishing.com

Cataloging-in-publication data for this book is available from The Library of Congress.

ISBN: 978-1-7350611-3-9

Cover design by Jayne Hushen

Graphic design by Dianne Dementi

Printed in U.S.A.

Photo credits: Unless otherwise credited, photos are from the author's collection. Most of the Burma photos were, as noted, taken by Daniel Novak in his capacity as a US Army photographer covering the war. For more of his work in the China-Burma-India theater of war, see danielnovak.com.

DEDICATION

This book is dedicated to the grandchildren of
Heber Venable Bainbridge Traywick and
Flo Crisman Neher Traywick:

Sarah Brack Traywick Smith
Joseph Grantham Traywick
Katherine Bolling Williams
Riley Ellis Traywick Levines
Crisman Neher Traywick

And to my dear Cricket ~
The women in my family married amazing men, but I
got the prize.

PREFACE

YOUR PARENTS ARE NOT WHO YOU THINK THEY ARE

Dad's war stories about the Burma Campaign in 1944 always held an exotic allure for me, even as a child. His experiences were right up there with *The Call of the Wild* and *Tarzan and the Jewels of Opar*. Even his unorthodox courtship of Mom in the uncertainties of war seemed impossibly romantic.

I have to save these stories, I thought, shoving a tape recorder in front of him whenever he started reminiscing about the war. A few years ago, I dug out the tapes and transcribed them. Fascinated, I read every book I could find on the Burma Campaign. Then I began writing.

My parents' wartime romance was my raconteur father's favorite story - and it's a good one - so that became the framework for the book: how they met and fell in love on a blind date, why they went their separate ways for the duration of the war and how, in the end, wild horses, burning airplanes, mixed up train schedules and pride couldn't keep them apart. But it was still largely Dad's story.

Through the years, as I gave drafts of the project to trusted readers and members of workshops at writing conferences, I began to notice a similarity in their responses. Whatever else they said, there was always this comment: "I want to know more about your mother."

Dutifully I turned my attention to researching my mother's experience during the war. As I worked on Mom's part of the story, I experienced repeated epiphanies about her. The more I delved

into the scrapbooks and diaries of her social life and the more I pressed her about her life in the 1940s, the more I realized that she went through deeply-felt experiences that influenced how she behaved the rest of her life.

My mother is an impressive person, a traditional stay-at-home mom who also became the first woman in Virginia to be nominated by either party to run for Congress. It was important to me that she not come off as a flibberty-gibbet.

Once when I was talking to Mom about the book, I said, "There's a lot in there about the social conventions of the day, girls having lots of beaux but not having sex, the notion that a date was a casual event, and that it was not only acceptable but expected that a girl would have several beaux at one time. I wanted to put your exciting social life in context so you wouldn't appear to be shallow."

She laughed. "But I was shallow. I was only seventeen when I met your father on a blind date at Ft. Benning. And when I was working for Lend-Lease in Washington and having a date at Ft. Myer every night and going to Annapolis and West Point, I was still only eighteen.

"As I've always said, if it weren't for the death and sadness, the war was a very exciting time."

Wow. Imagine having the self-confidence to admit you were shallow.

But there was more to learn.

After I had produced an exhaustive telling of Mom's and Dad's stories, including background on their families and insightful anecdotes about growing up, I gave the manuscript to my mother to read. I wanted her to check it for accuracy, mostly, but also get her take on the overall feel of the book. Had I captured the mood of the home front during wartime?

She returned the manuscript with a few penciled notes in the margins, minor corrections, and said politely, "I don't know how you know all that. You certainly have done a lot of research."

It's touchy writing about someone who is still alive, especially if that person is your parent. It's like painting a portrait. Does it really look like the subject? And a more sensitive issue: Does it look the way the subject pictures herself?

I pressed her. Had I captured the feel of the home front during wartime? Had I told her story accurately? What did she think when she read it?

She sighed. "It made me sad."

Well, yes, wartime is sad. All those young men she danced with at the officers' club, the men she wrote to overseas, the ones who didn't come back…

"It made me sad to think that I'll never be young and beautiful and go dancing again."

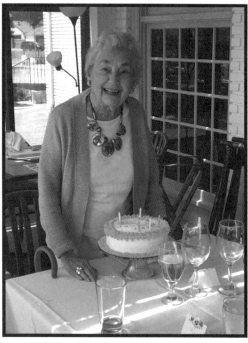
Still a flirtatious belle... (2019)

Which hit me like a ton of bricks. Inside, of course, we are always the same age, and my ninety-six-year-old mother is, somewhere inside, still a flirtatious belle of nineteen.

Mom came out a lot after Dad died. After years spent cleaning up the dishes and letting Daddy hold court in the den with his humorous memories of growing up in the Depression, she began telling stories about her side of the family, noting, "The Traywicks aren't the only interesting family. The Nehers have done a lot of noteworthy things." She even revealed some closely-held attitudes

about her own life. Maybe it was because she no longer played the role of The Woman Behind the Man, the role she had been conditioned in her youth to play. Maybe it was because, for the first time, someone asked her about her life, her stories, her feelings.

She has often quoted her mother-in-law, Miss Janie, as saying, "When you get married, you might as well put your personal feelings in a box."

Clearly she took that advice to heart. But now, seventy-five years later, as I write about the seminal period of her youth, she has unlocked the box and left the lid ajar.

So, as requested by readers, this book includes the untold story of Mom's side of the war. But never fear, you'll get to read about Dad's adventures in Burma, too.

Robin Traywick Williams
Crozier, Virginia
May 2020

PART I – A MAGICAL ROMANCE

CHAPTER 1

DADDY'S FAVORITE STORY

My father was a quite a raconteur. He regaled anyone who would listen (in addition to the captive audience of his three children) with a lengthy repertoire of funny tales about growing up in South Carolina in the 1930s or driving around the mid-Atlantic selling farm equipment or tromping through the jungles of Burma in World War II. But far and away his favorite story involved how he met and married our mother.

"You know, we met on April Fool's Day," he would begin, as though we hadn't heard the story a hundred times. "In the parking lot at the Officers' Club at Ft. Benning." We heard him tell it so many times, in exactly the same words, that we can all recite it ourselves. I recorded three iterations of the story on tape, each a nearly verbatim copy. When we reached adulthood, we began providing sly commentary from the peanut gallery as he spoke. Although he was quick-witted and loved to banter, for this one story he never deigned to acknowledge our witticisms. As I look back now, I think he was reliving the experience as he spoke, seeing in his mind's eye how "this cute little thing came walking across the parking lot wearing a fur jacket and a red dress" and how "her high heels made her twitch just right, dontcha know?" It was the beginning of a love story that he savored for more than sixty years and he often told it with a touch of wonder that the story ended the same every time: the hero gets the girl.

On that day in 1942, just a few months after the Japanese attack on Pearl Harbor, it was clear that the sleeping giant had been awakened. Everywhere you looked, the country was engaged in war preparation. Posts like the one at Ft. Benning, Georgia, were training personnel and factories were producing materièl: uniforms, boots, K-rations, jeeps, carbines, bombs, airplanes and ships. Civilians were buying war bonds, planting Victory Gardens and shopping for shoes and sugar with ration coupons. For his part, Capt. H. V. "Bo" Traywick was preparing to meet two hundred officers on the rifle range for instruction in weaponry. He was a standout among the officers in that field, and he had recently earned an early promotion to captain. As he finished lunch in the mess hall that day, a lieutenant named Sullivan approached him and anxiously launched into a sales pitch. Years later, Daddy recalled Lt. Sullivan's tumble of words: "They just told us we're going out on a night problem and my roommate, Dick Neher, his sister's down here for the graduation day after tomorrow and we told her we were going to take her out tonight and there's no way we can be there. I need somebody to take her out..."

At this point in the story, Daddy would roll his eyes and rear back in mock horror. *"A blind date."* He let the words hang in the air with all their ominous implications. "Man, I wasn't big on blind dating."

Of course he wasn't. He was the most eligible bachelor on the 75,000-man Army post. At twenty-four, he was easily the U. S. Army Infantry's youngest captain, a rank dominated by forty-year-old officers left over from World War I. A smooth operator who usually managed to arrange his living situation to suit himself, he had the additional benefit of looking like a movie star. And he had a girlfriend who was, Dad let us know, "affectionate."

Conveniently for the tide of history, the girlfriend was out of town for the night.

(Years later, this same girlfriend wrote Dad and asked if he were happily married. Mom wrote her back to the effect that yes, he was.)

As Dad hesitated, Lt. Sullivan said, "I'm desperate. We're leaving right now from lunch. Is there anything you can do?"

"Well, tell me something about her," said Dad, playing for time.

"She's a freshman at Hollins College. She's just been to some college dance—West Point, I think—and she's visiting her brother. Her name is Flo Neher. She'll be at the O Club at one-fifteen and she's driving a blue LaSalle sport coupe."

If nothing else, Dad was impressed by the LaSalle, which was a luxury car of the day, and, while he wasn't really convinced about the girl, he decided it might be worth a look. He was headed that direction anyway.

"All right," he said at last. "I know you're in a jam. I'll tell you what I'll do. If I can't take her out, I'll see that Daley, my roommate, takes care of her. He never has a date."

Here the peanut gallery would laugh. *Right, Dad. Dump her on a guy who can't get a date!*

Dad figured that if this gal was on time, he might get this deal sorted out quickly. It was his custom to have his rifle crew pick him up at the O Club every afternoon at one-thirty, which meant he had about fifteen minutes to size up the girl and figure out how to foist her off on Daley, if necessary. So a little after one, he drove over to the club, looking for a girl named Flo Neher.

Little did he know that this girl—a "child" he called her in telling the story—was more than a match for his swagger and banter and success with the opposite sex.

In the 1930s and 1940s, when dating was a competitive sport, the Neher sisters were the undisputed champions of their hometown, Lynchburg, Virginia. Swing was king and a girl who could dance had all the dates she could wish for—and more, if she could make sparkling conversation, too. Betty, the blonde, and Flo, the brunette, had the trifecta: they were pretty, witty and good

dancers. There was seldom a college dance in Virginia or at the Naval Academy in Annapolis, Maryland, or at the Military Academy in West Point, New York, that didn't see first Betty and later Flo swing dancing or cheek-to-cheek with an adoring beau. Both girls had the bulging scrapbooks of dance cards, swizzle sticks and dried corsages to prove it.

They were called "prom trotters" for their practice of trotting from one college dance, or prom, to another. The whole family seemed to be on the circuit at times. When Dick, the oldest sibling, was a student in the ROTC corps at Virginia Tech, he frequently invited his parents—my grandparents—to chaperone school dances, an assignment they relished. Dick and Betty both gave everyone

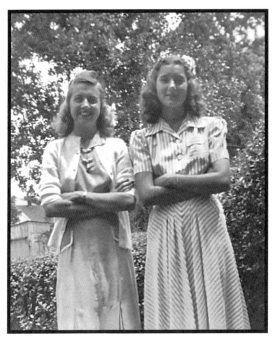

The prom-trotting Neher sisters, Betty and Flo. (c. 1940)

else a tutorial in dancing grace while young Flo watched and learned. My grandfather "Pop" footed the bill for cocktail dresses and evening gowns and my grandmother "Nana" gave the girls shrewd advice on managing the men in their lives.

Betty set records for male attention—one Easter she received thirteen orchids from admiring beaux—and Flo broke them—her senior year in high school, she received bids to fourteen college dances in a row. Despite a dizzying social schedule, Flo was fully engaged in high school activities, maintaining top grades while serving on the yearbook committee, writing for the "High Times" school newspaper and joining the French club and the Latin club. Nevertheless, she skipped her own high

school graduation to attend June Week at West Point, N.Y. For graduation, her parents offered her the choice of a Bulova watch or the trip to New York. Really? What were they thinking?

In 1940, when Flo was sixteen, Betty dropped out of Hollins College and married Ensign Ed Luby, an event that effectively launched Flo into the practice of dating older men. It's a reflection of the lingering influence of the chivalric code that, properly chaperoned, a girl in high school could go out with a man in his twenties without raising eyebrows; it was understood both that she was innocent and that he would respect that.

Flo and Betty were regulars at West Point games and dances.

Ed Luby was an undefeated boxing champion from the Naval Academy class of '38 who was stationed on the destroyer *USS John Trippe*. England was already in the war with Germany, and Ed's ship was on duty escorting merchant supply ships across the Atlantic. Flo was her sister's only attendant at the small ceremony in Boston, arranged hastily during a rare week in port for the ship. (Despite the short notice, the Navy marked the event with appropriate pomp and plenty of circumstance. Among other things, the bride and groom were greeted by a harbor full of ships aflutter with signal flags and sailors waving from the decks while loudspeakers blasted "Here Comes the Bride" throughout the shipyard.) The sisters drove to meet the ship in Boston a week before the wedding. Flo was thrilled to have a role in this exotic adventure and her account of the week is both illuminating and hilarious. We can only assume that Betty and Ed had an emotional reunion,

because there is no mention in Flo's memory books. We hear little about the bride and groom but a lot about Jimmy, Paul and Rusty, naval officers who competed to entertain the bride's baby sister. For six days, according to Flo's diary and her scrapbook, she danced, she laughed, she bantered with Ed Luby's shipmates—and oh yeah, there was a wedding. It's a good thing Betty had gone to marry the love of her life or else she would surely have been jealous of her sister.

Even at sixteen, Flo had the confidence of a girl who was used to male attention. While her diary reveals the usual teen insecurities, she projected a casual self-confidence that served her well, especially with older dates. Twenty-two-year-old Ensign Paul Schultz, who escorted her to dinner one night, fancied himself quite the catch, but he annoyed her with repeated backhanded compliments about her age: "Saaaay, you look pretty grown up after all. I was afraid I'd look like a babysitter tonight." And so forth, causing Flo to seethe behind her Southern belle smile. At some point, he touched her cheek and asked, "Where'd you get that scar?"

Flo shrugged. "I fell out of my highchair yesterday."

Despite their mismatch in styles, Paul was something of a trophy date, so when he asked to come see her in Virginia, she decided to give him a second chance. However, while she looked forward to seeing him, waving his panting letters in front of her friends, the weekend was not a success. Flo knew her own mind, and she decided the handsome naval officer who "probably got every girl he ever wanted" wasn't worth her time after all. Her diary notes succinctly, "Glad he came. Glad he went."

If Mom's high school diary is to be believed, she did not have to put up with men like Paul who didn't merit her attention. Among the pages of teenage dates and drama, she occasionally posted a scorecard like this one from her junior year, Thursday, June 20, 1940:

"I must tell you about today. Frances asked me to have dinner with her this evening and while I was there Jesse Duiguid called me for a date which I gave him. Just as I was leaving Al called for a date for Walter. When I got home Macon called for a date tomorrow nite which I don't think I'll give him. Then Leslie called and wanted me to go on a picnic with Arthur Ike—(which, by the way, I'm glad I didn't do)—Mother said Crist had called - and when we came back (went to see "Brother Rat" again) Phil Strader had called!! Really, Lillian Russell had nothing on me!!"

And again, on August 27, 1941, just before leaving for college: "This was the most heavenly dance! I went with Lynch and we had a wonderful time. I felt as though I was walking on air. Everybody was wonderful to me. Lynch said he liked me better than anyone else, Billy Chipley asked me for a date, Phil Strader gave me a wonderful rush and asked me for a date, Macy asked me for a date, Macon told me he was in love with me and wanted a date, Floyd McKenna asked me for one and to the first ATO house party at W&L, Walter said he was still in love with me! So you can see what a marvelous time I had."

Even after reading Mom's diaries and poring over pages and pages of mementos in four enormous scrapbooks, I could hardly believe the level of attention she received. It's always hard for a person to imagine his parents as young and sexy, but clearly I had to internalize the notion that, once upon a time, both of mine were just that. What made Mom stand out? Pictures show her as attractive-looking, but there were plenty of pretty girls with far fewer beaux. Sure, she was a grand dancer, in an era when being a good dancer counted for a lot. Still, I looked for something else until I finally recognized the clues to her popularity jumping off every page of her scrapbooks. Beside each dance card or train ticket or invitation she wrote, "I've never laughed so hard!" Or, "I've never had so much fun!" That attitude is infectious and goes a long way towards explaining why men were drawn to her. She was always ready to laugh, to party or play or meet new people without worrying if she might mess up her hair or miss attending some pedestrian thing like high school graduation.

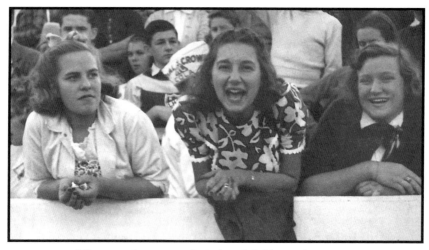

"Flo was always ready to laugh." Shown here with
Helen Wagers and Barbara Bourke. (1939)

By the spring of 1942, Mom was a freshman at Hollins
(with a prestigious academic scholarship) and the United States
was in the war. There had been a slow, behind-the-scenes build up
to America's entrance into war. Factories had already been turning
out supplies for our European allies. Naval vessels like Ed Luby's
destroyer were serving as escorts for the delivery of those supplies,
warding off German U-boats to get the merchant ships safely to
England or France. The military command was quietly training of-
ficers and troops for the war Americans didn't want to fight.

But four months after the attack on Pearl Harbor, America
was humming with preparations. Mom saw the difference on her
spring break. Already life had changed since her older sister left
the college dance circuit to get married. Where just a couple of
years earlier my grandmother had sent Betty off to Annapolis or
West Point with a chaperone, now Mom was permitted to travel
unescorted. She was hardly alone, though, as the trains were
packed.

Nowhere, outside of Washington, D.C., was the domes-
tic war effort more visible than the transportation system of the
country. Men and supplies were shunted around the country like
molecules excited by microwaves. Railroad cars were full of men

in uniform, traveling from one post to another, some for more training, some mustering to go overseas. The trains were made up of day coaches—there were very few sleepers—and people rode sitting up all the way. With gas rationed, families traveled by train. Trains were often so crowded that passengers stood or roamed the aisles making friends. It was the new mixing bowl of American society and Mom reveled in it.

Home from Hollins on spring break, Mom boarded a train in Lynchburg and rode to West Point for a formal dance weekend at the United States Military Academy. Cadet Barry Skaggs escorted her to the Hundredth Night revue, a musical written and performed by the cadets. Afterwards at the dance, Skaggs barely relinquished her to dance with any other cadet all evening. Next to the dance card in her scrapbook, Mom wrote, "Don't let those names [written inside] fool you. He didn't trade a single hop [dance]! He's so *very* cute! We had a wonderful time! I'm supposed to go back May 9. He said his first nice things to me this weekend." Unfortunately for Cadet Skaggs, his charms were about to be eclipsed.

Among the many ramifications of the Japanese attack on Pearl Harbor was the diminished luster of social activities on college campuses, owing to the departure of many male students. My grandmother, in her role as coach of the popular Neher girls, was quick to recognize that the cream of American manhood was now collecting in pools on military posts. Her own son, Dick, a first lieutenant, was among them, and he was directed to help his baby sister meet a few of his colleagues.

In August of 1941, Dick, then twenty-seven, had been called up for active duty, and shortly after the attack on Pearl Harbor, the Army sent him to train in communications at Ft. Benning, Georgia, the major East Coast training camp for the Infantry. Naturally, Mom was delighted when her parents suggested she go visit her big brother. So, after the festivities at West Point, she boarded the Streamliner and headed south with romantic memories of Cadet Skaggs lingering in her mind.

Dick had arranged temporary housing for Mom in a private home just off post, something she was used to from her college dance weekends. He left her his car, a blue LaSalle sport coup, and told her to come to the post the next day, where he had booked a room for her at the Officers' Club.

Mom dressed carefully for her appearance on the army base. Her best friend at Hollins, Jeanne Marie Auberneau, of Chicago, had loaned her a wolf fur jacket to wear to West Point. Although the weather was warmer in Georgia, the jacket looked so good that Mom decided to wear it anyway. Donning a red velveteen dress and checking to make sure the seams down the back of her stockings were straight, she sailed out the door.

Years later, she recalled driving onto the post and being struck by the cadres of soldiers marching between buildings and across parade fields and down the road to the firing range. Rows and rows of young, fit, uniformed and of course handsome men marching everywhere. Rested and dressed up and presented with such masculine riches, Mom decided the long train ride was worth it.

She found her brother's office building, only to be met with the news of a change in plans for the evening. Although he and his roommate could not escort her to dinner that night, Dick told her that Sullivan had made arrangements with a captain to find her a date or to escort her himself. Dick was apologetic but there was nothing he could do.

"Oh don't worry about it," Mom reassured him. "It'll be all right."

Privately, she dismissed the idea of going out with a captain. She had just come from West Point where she danced with her date's faculty adviser, a captain who had fought in World War I. She was nearly eighteen and used to going out with men four or five years older, but this was a little too much. *A captain?* she recalled thinking, *My soul! He must be a hundred years old! Nobody's a captain, for heaven's sake, except people's fathers.*

Mom was pretty good at arranging things to suit herself, and she drove away humming *ty-tee-ty-tee-ty* under her breath. Undeterred by the change in plans, she thought, *I'll just take care of this myself. All I have to do is go up to the club and hang around. I can make my own contacts.* Hadn't she just seen some of the 74,999 other men on the post marching around? She thought the odds good that she could find a good-looking fella to dance with her.

A few minutes later, Bo and Flo drove into the parking lot at the Ft. Benning Officers' Club, each one studying how to ditch the other and improve his prospects for the evening. It was shortly after one o'clock on Wednesday, April Fool's Day, 1942.

CHAPTER 2

CLASH OF THE TITANS
APRIL FOOLS' DAY 1942

In 1942, the overwhelming sense of life in the United States was *motion*. Gone were the will-we, won't-we jitters. In their place was a life-or-death urgency to *go*. The incredible American war machine was in third gear and accelerating fast. Men were going to war. Brides were going to the altar. Babies were going to Granma's. Women were going to work. The whole country seemed to be on a roll, until the grass running alongside the trains that carried recruits to boot camp and troops to transport ships made you think the land itself was moving.

The war had come to American shores, not just Hawaii but the East Coast, too. German submarines—U-boats—roamed the Atlantic, sinking hundreds of ships carrying supplies from the U. S. to Britain. Ranging up close to the American coast at night, the U-boats torpedoed ships silhouetted against city lights. Coastal lookouts were organized to watch for enemy airplanes as well as warships. Citizens in many coastal areas were ordered to install black plastic on their windows and streetlights were doused. Still, some Americans remained in denial about the domestic threat from the European war, and Miami's city fathers, acutely aware of the city's dependence on tourism, refused to institute blackout rules; the merchant marine paid the price for the city's tourism profits, as U-boats sank twenty-five ships off the Florida coast in one two-week period alone.

Already troops were preparing to go to overseas in large numbers for the invasion of North Africa. The recruits were too young to remember World War I, but they knew what was hap-

pening in the Philippines, in Europe and even out in the Atlantic Ocean, within sight of land. They wanted to do their part, feared they wouldn't measure up, lived hard against the day they might die. Those headed overseas had an overwhelming urge to hold onto home, to have some tangible link that would ensure their safe return. Having a wife seemed to be that talisman, and soldiers and sailors impulsively proposed to women they hardly knew just as they were throwing their duffel bags on the boat. For myriad reasons, many women accepted. With or without a ring, though, many women kissed men goodbye and never saw them again.

All of this played out with the soundtrack of Big Band music. Whether in hotel ballrooms or roadhouses or USO canteens, young women and newly-minted soldiers danced and hugged and smooched and fell wildly in love, love on steroids, compressed into weekend passes and last-nights-on-shore. Their feet boogied and their hearts leapt. After dragging through a decade of Depression, everyone, it seemed, was jumping on a jolt of joe—G. I. Joe.

The country was frantically playing catch-up, trying to build a world-class army from the outdated weapons and 200,000-troop peacetime force that remained from the army that had gone to fight "the war to end all wars" twenty years earlier. In the summer of 1939, when Dad graduated from Clemson and went into the service, Portugal boasted a larger army than the U. S.

Dad and his classmates graduated into a shockingly disarmed defense system. At Ft. Moultrie, South Carolina, on his first assignment, Dad drilled troops with fake wooden rifles and bought ammunition out of his own pocket for extra practice. At the war games in Louisiana in 1940, Dad recalled the Army hiring private pilots to fly over the maneuvers and drop paper bags full of flour to simulate bombs. "I just hoped like hell this pitiful army would never have to take the field," he said.

And yet, the great American war machine, once it got rolling, put twelve million people in uniform by the end of the conflict. Along with them went the unfathomable numbers of weapons, vehicles, and war matériel that American private enterprise cranked

out in four years for the Allies to use, as Victor Davis Hanson lists in "The Second World Wars": "nearly ninety thousand tanks…2.4 million machine guns…807 cruisers, destroyers and destroyer escorts, 203 submarines, 151 carriers…as well as three hundred thousand aircraft."

There was another menace threatening the country in 1939, one that would impact Dad's career in a surprising way: polio. An outbreak of polio in the Low Country of South Carolina that year grew into the largest epidemic in the southern United States to that time. Polio, also called infantile paralysis for its tendency to strike children and render their legs useless, is a highly contagious viral infection that attacks the central nervous system, leading to paralysis and muscular atrophy. While today polio has been eradicated from all but a few odd pockets of the world, in the first half of the 20^{th} century, parents lived in fear of the mysterious virus striking down their children. The vectors for transmission were unknown at the time, and there was no effective treatment. Social distancing became the only defense. In Charleston, which was especially hard hit in 1939, schools were closed and public gatherings involving children were prohibited.

Dad was supposed to report to Ft. Moultrie a month after his graduation from Clemson. But the Army did not want anyone to visit the area affected by the epidemic prior to reporting for duty. He couldn't go to his home in Cameron, S.C. With nothing to do and nowhere to go for the month of June, Dad agreed to take two weeks of active duty at Ft. McPherson, Georgia, near Atlanta.

Significantly, his orders noted, "Each officer will rank from June 15, 1939."

As it turned out, those two weeks at Ft. McPherson gave Dad seniority over the entire graduating class at the U. S. Military Academy at West Point. Seniority is critical in the military as a decider for everything from billeting to consideration for promotion. The class of '39 from the service academies and the military schools like Clemson, The Citadel, VMI, Virginia Tech, as well as

the ROTC programs at other colleges, provided the bulk of the field grade officers who fought the war—and Dad had two weeks' seniority on the whole lot of them, due to polio.

After demonstrating his prowess with small arms and his leadership and instructional skills, Dad eventually found himself assigned to the staff of the Infantry School at Ft. Benning, the huge training ground for thousands of soon-to-be-soldiers. He quickly came to the attention of Major Ted Wessels who, in late 1941, was promoted to the rank of Lieutenant

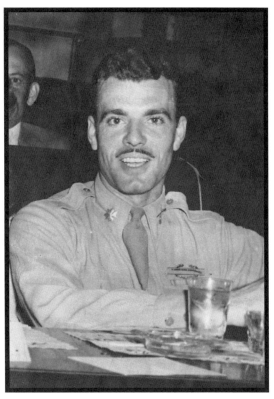

Major H. V. "Bo" Traywick with his Rhett Butler moustache. (1945)

Colonel. He called Dad and two other officers into his office and said, "You're doing a good job and you are making me look good. I won't forget that when it comes to promotions. When I get one, you're going to get one."

Wessels was as good as his word. In rapid succession, the Japanese attacked Pearl Harbor, the United States declared war on Japan and Germany, and Heber Venable Traywick was promoted to the rank of captain. On February 1, 1942, Dad, just twenty-three years old, became the youngest captain in the U. S. Army Infantry. The two weeks' active duty he had served after graduating from Clemson was paying dividends. Warming to his role as a rising star in the Army, Dad turned out a thin black moustache in emulation of Clark Gable, whose role as Rhett Butler in "Gone with the Wind"

had mesmerized the country. His resemblance to Gable was striking and enhanced an already active social life. All in all, Captain Traywick was quite pleased with himself. All around him in the officers' quarters were West Point graduates of '39 who were barely first lieutenants and whose jealously was apparent. Privately, Dad didn't blame them, but he didn't let it worry him, either.

In the spring of 1942, as the pace of training infantry soldiers at Ft. Benning picked up, Dad found himself in a very satisfying situation: a respected officer with rank ahead of his peers, superior housing and a nice social life.

Dad's penchant for arranging things to suit himself extended even unto parking spaces. He was known to drive around a parking lot or even an open field for ten minutes, seeking the perfect parking spot, sometimes trying one and then backing out in favor of another one—closer to the door, shaded in the afternoon, out of the way of falling meteors, whatever. Although he coveted the first space in the lot at the Ft. Benning Officers' Club, a little sign on the curb notified all and sundry that the slot was designated for the general, and even the man-about-the-post wasn't quite ready to angle for that one. But the spot next to the general's space was not reserved and Captain Traywick counted it a win when he could get that one.

On that cool spring day in 1942, as he drove to the O Club to check out a girl who needed a date, Dad recalled, this whole blind date idea became less and less interesting. He hoped he could find his roommate, Daley, before dinnertime and pass the girl off.

As he turned into the lot, he saw that the prized spot next to the general's was open. But there was a car in front of him, poking along, threatening perhaps to take *his* parking space. He honked the horn insistently and when the driver hesitated, he zipped around and claimed the parking space.

At this point in the story, the peanut gallery always mumbled about Dad's rudeness, which Mom confirmed.

Dad ignored the comments, lost in his reverie about his first look at Flo. "As the car crawled past, I saw it was a blue LaSalle." Here he grins. "With a pretty girl at the wheel."

He dawdled until the LaSalle parked and a slim brunette came walking along the island between the rows of cars with an alluring swish. She wore a red dress with a sassy little fur jacket and carried a tiny overnight bag.

Here in his telling of the story, Daddy would stare off into space and smile, the video of that moment playing on a loop in his head. Sometimes he recreated a soft whistle. O-*kay*. He timed it so that he got out of the car and reached the island just as she passed.

She caught him looking at her legs and glanced down. Just then he laughed. "Your slip's not showing," he said. "I was checking to see if your seams were straight. It's gotten to be a phobia with me."

Before she could respond to his impudent comment, he removed his hat and, with all the courtesy of an officer and a gentleman, he said, "Can I help you with that bag?"

With all the charm of a Southern belle, she answered, "Thank you," and handed it to him.

"Is your name Flo Neher?" he asked as they walked.

"How'd you know?" she laughed in surprise.

Dad was in his element, impressing a pretty girl with his *savoir faire*, and Mom was in hers, letting a handsome man try to impress her. She noticed his captain's bars, put two and two together and decided not to hold that against him after all.

Here Dad lovingly recalled every word, every gesture they made to each other, how he asked if she had had anything to eat and how, when she said, "No and I'm starving!" he called to his favorite waiter, "Fields, get me a chicken salad sandwich and a chocolate milkshake right quick!"

Dad paused to tell us he didn't know if that's what Flo wanted, but it was too late anyway. Chester Fields, a waiter Dad cultivated with big tips—"bigger than I could afford"—practically saluted "YesSIR!" and took off.

Dad took Mom to the desk and made sure her reservation was in order. When she came back down from her room, the sandwich and milkshake were waiting. They chatted as she ate. When Dad's rifle crew and car arrived, he told them to go ahead. After lunch, rather than leaving this pretty girl alone at the club and driving his own car to the rifle range, he said, "Can you ride me out to the range?"

Dad continued with his spontaneous program of impressing Mom by taking her to his fiefdom and showing off his crew. The rifle range was similar to a driving range, with a long row of individual positions from which to fire. Out across the red clay field some two hundred yards was a corresponding row of targets. A crew of men worked in the pits that ran along in front of the targets, putting up fresh targets and phoning scores to Captain Traywick and the instructors. There was a tower behind the firing positions, and a staffer with a telephone received scores and relayed instructions from the captain to the target crew.

Captain Traywick supervised seven officers doing the individual training and another crew running the equipment down in the pits. It was a far cry from his assignment at Ft. Moultrie just two years earlier when his troops drilled with wooden rifles.

"You see," said Dad, pointing to a red flag waving from the pits. "That's a miss. They call that 'Maggie's drawers.'" He delivered the impertinent slang with a straight face and Mom smiled at the joke.

"What's that for?" she asked, pointing to another flag.

"Bull's eye. They run the flag down when somebody hits a bull's eye."

After giving Mom the tour, Dad showed her an M-1 rifle and asked if she would like to fire it. Naturally, she was eager to try. First he phoned the men in the pits and informed them that the young lady was going to shoot. Then he showed her how to hold the rifle. This, he told peanut gallery with a sly grin, gave him the opportunity to put his arm around her shoulders.

Mom took the rifle and Dad seated it on her shoulder so the recoil wouldn't give her a black eye. Resting the heavy weapon on the railing and sighting down the barrel, Mom squeezed the trigger as Dad instructed. Then POW! And BAM the target went down and came back up with a hole in the middle.

"Bull's eye!" Dad said with a grin.

Completing the conspiracy, the flag came down and the soldier on the telephone confirmed her hit.

While Dad described the training program, the class arrived - two hundred men marching in for their afternoon of instruction. "This is just one class. I have a new class starting every week," he explained. "I have seven working days of instruction with every class, the Officer Candidate class and the refresher class, both."

Here Mom, if she were in the room and not out in the kitchen, would interrupt. "All I could think about was, *Two hundred men! All physically fit and attractive! Officers!* I thought it was all very glamorous."

Dad had to make a show of working, so he took Mom up to the command platform overlooking the range and assigned Lt. Green to answer her questions. The platform filled up with officers in short order and Dad soon realized he was going to have to protect his interests. Relieving Lt. Green of escort duty, he walked Mom to her car and told her he would meet her at the club at five-thirty.

Mom drove off in the LaSalle, bought some twenty-five-cent-a-gallon gas and went into the town of Columbus to buy a

wedding present. With men being called up and sent overseas, couples often got married on short notice, and Dick had volunteered her to be maid of honor in a friend's wedding the next day. Having played the role in Betty and Ed's nuptials, she figured it was her contribution to the war effort. The only thing that bothered her was the idea of wearing a black crepe dress. It wasn't very appropriate for an afternoon wedding, but it was all she had.

Still, she felt quite satisfied with herself. Having met her attractive date for the evening and disrupted the entire rifle range, Mom felt her visit to Ft. Benning had gotten off to a good start.

Captain Traywick, meanwhile, was finding it difficult to concentrate on training young officers to shoot straight. He waited till about three-thirty and thought, *Hell with this. I'm going to have to go back and see about that gal.*

Turning to Lt. Green and the rest of the crew, he said, "I think you've got this group doing well. I'm going to leave it in your hands." And he left.

If Daley thought he was going to have a blind date that night, he was out of luck.

Chapter 3

The Courtship
April-May 1942

It's not often that you hear a fairy tale from Prince Charming's point of view, so it was sweet the way Dad spoke of being dazzled by Mom. "She wasn't but seventeen, a child, really," he would say, shaking his head in awe, not of her youth but of her poise and attractiveness. For the peanut gallery, it was clear that the combination of innocence and sex appeal knocked Dad out.

They had dinner at the Officers' Club, where an orchestra played four nights a week. Dad had on his dress uniform, olive slacks with a sharp crease, a matching shirt and tie, and a blouse, or jacket, with his insignia over the left pocket. Mom had mercifully shed the wolf fur jacket and wore an evening dress, a sharkskin gown that flowed flatteringly over her figure and swirled around her ankles.

Fields had Dad's special table ready: a table for two just off the dance floor, between the two sets of double doors, first table in the dining room.

"Would you join me in a cocktail? A glass of wine?" he asked when they were seated. She declined, so he turned to Fields and said, "A co-cola for the lady, and I'll have a scotch and water."

"YesSIR!"

Throughout dinner Dad poured on the charm. Mom admitted to us that she was pretty dazzled herself, but somehow she held her own, snapping smart come-backs and keeping Dad on his toes.

After dinner, the orchestra switched from background music to dance music. The trumpets rapped out the opening bars of Glenn Miller's "In the Mood," a special favorite of Dad's. The song had every element a dancer of the swing era could ask for: a toe tapping beat, a score that emphasized the blood-churning horn section and the popular device of repeating a musical phrase softer and softer and then louder and louder until it reached a brassy climax.

"Come on!" exclaimed Dad, grabbing Mom's hand and jumping up from the table. To his unending delight, she danced as well as he did, matching him step for step, ready for his spins and relaxing for a lingering moment when he enfolded her in his arms on the last note. They danced to every song, pausing only when the orchestra took a break.

"Would you like a little fresh air?" Dad asked.

Although the windows were open to the April air, the O Club ballroom was warm after all their exertions. Making small talk, they strolled to the parking lot where they had met earlier that day. Pausing by the monument to Calculator, the post dog, Dad slid his arm around Mom's tiny waist and kissed her. Smiling down on her face in the moonlight, he made a daring proposal. "You cute little thing, you. You're just about what I've been looking for. What do you think about us getting married?"

Years of experience navigating tricky conversations had trained Mom to handle even surprise marriage proposals on blind dates. Taking her cue from his tone of voice, she took his proposal for banter and played along. "I think that sounds like fun," she said lightly.

"You know, I always propose on the first date," he said.

"And I always accept," she replied.

He laughed and kissed her again.

Mom maintained her poise until he walked her to her room at the end of the evening. In those days a man left a girl at her door. He didn't come in.

"How long are you going to be here?"

"I have to go back to school day after tomorrow."

This put a real glitch in Dad's plans. Anne, his regular girl, would be back in town the next day fully expecting a dinner date with her regular guy. At the moment, he didn't see any way out of that.

"Well, you'll just have to come back to visit when you get out of school in June," he said, giving her a final peck on her forehead.

"I'd like that," she said in a demure voice that turned into a shriek as Dad ran his fingernail down the zipper on the back of her dress. When her dress did not fall off, Mom said, "Goodnight, Captain Traywick," and shut the door.

Once in awhile, the stars align and there is a perfect lovers' night. This was one of those nights. The beautiful girl. The handsome guy. The glamorous setting. The orchestra playing. The young couple meeting at just the right moment in their lives. In retrospect, their union seemed inevitable, but the course of true love never runs smooth, especially during wartime. The war had brought them together but the war would keep them apart, too.

The next day, Dad was in a quandary. Here he had met this cute little thing he wanted to see a lot more of, and his regular gal was back in town. Nobody went steady in those days, and Dad and Anne did not have "an understanding." However, he called her often enough that she expected to keep hearing from him. And they had a confirmed date that night. As entranced as he was by Mom, Dad wasn't ready to jeopardize his sure thing in Georgia until he saw where things were going in Virginia.

After a night of romance straight out of the movies, Mom took Dad's absence the next day, her last day at Ft. Benning, with great disappointment. *These things take time*, she told herself, trying not to think about the fifteen-hour train ride back to Virginia. Years of dating had taught her that men went out with lots of different girls. And if they were smart, girls did not act possessive or jealous—they just went out with other people themselves. Which is what she did.

She had a date with Dick's roommate, Sullivan. After dinner, they drove to a night spot across the river in Phenix City, Alabama. It was a roadhouse with a band, a place where brown-bagging was accepted. In the days before liquor-by-the-drink, roadhouses and clubs provided mixers and patrons brought their own alcohol in a discreet brown paper bag. To a large extent, this applied to men, because girls like Mom didn't drink.

Seated by the dance floor, Mom was surprised, pleased and a little flustered to see Dad come in the door. With him was a blond woman holding his arm in an easy, proprietary way that told her a lot. *Un-huh.* All that talk last night was just talk. Why would she think a good-looking catch like Captain Traywick didn't have a girl? Still, it begged the question why he would come on so strong with her.

Dad and Anne took a table across the room, while Mom made sure she was at her vivacious best with Sullivan. After awhile, she looked up to see Dad asking to dance with her. They bantered lightly before Dad went straight to the point. Unable to put off Anne for the evening and knowing Mom was going back to Virginia the next day, Dad spun Mom around the dance floor and asked her to meet him for a late date.

Mom suddenly felt empowered. Dad had showed his hand.

Over her years of juggling beaux, Mom must have felt like Scarlett O'Hara, who famously lamented to the young men surrounding her at the Twelve Oaks picnic that it was too bad a girl had only two sides. The solution to that vexing problem in the

1930s was a "late date." Girls and boys would say goodnight to their date after a movie or a dance and then hotfoot across town to see someone else for a couple of hours. Sometimes it took a bit of manipulation to get shed of your early date. It helped if your date had a curfew, as the cadets at the military schools did. Mom noted in her scrapbook that the weekend of VMI's 1941 spring dances she spent so much time at neighboring Washington & Lee she hardly knew which school she was visiting. Next to a dried gardenia from VMI Cadet Billy Waddell, Mom wrote, "Saturday night I had a late date with [W&L's tennis team captain] Jack Mallory. I met Tommy Dorsey and ate pretzels with Frank Sinatra at the Delt house…Had lunch at Phi Kapp house Sunday."

So when Dad tempted her with "What do you say I meet you at the O Club about twelve-thirty?", a flush of pleasure made her glow. As she followed her partner's footwork, she did some calculating. Although she regularly went out on late dates, this, she shrewdly assessed, was a different situation. Captain Traywick was clearly accustomed to girls who succumbed to his admittedly extensive charms, but, well-tutored by her mother, Mom knew that a little resistance to those charms would make her stand out from the crowd. Nana had a saying for every social situation: *Nana's Rule #4: That which is unattainable is more attractive.* Accordingly, Mom smiled at her handsome dance partner and said airily, "No, if I'm not going to be the first one I'm not going to be the last one."

Mom knew it sounded silly when she said it. *But this is different,* she told herself. *We have to set the standards.*

This is different, indeed, thought Dad, who wasn't used to pushback from anybody, especially little teenaged girls he had just proposed to. Taken aback, he couldn't help but grin at this spunky gal barely out of high school who was saying no to *him*, the man-about-post. Unconsciously imitating his father, who, many years before, had had to deal with a young Virginia gal who said "no" to him, Dad said, "Well, I'll just have to follow you back to Virginia."

Back in Lynchburg for a couple of days before returning to school, Mom confided in her parents the startling news: "I'm in

love." She seemed as surprised as they were but there was no question she was walking-around-in-a-daze-in-love. Outside the family, she played her cards close to her chest, telling her friends only that she had had a great time and met lots of attractive men on her travels.

At the end of spring break, Mom went back to Hollins, quite sure she had never met anyone like Bo Traywick. She tried to downplay the romantic evening of their blind date and keep her expectations in check. It was entirely possible that she would never hear from him and the blond girl would keep her hold on him. As badly as she wanted to see the handsome Army officer again, she knew she had made the right move when she turned him down for a late date. Her instincts were validated when a letter arrived at Hollins a week later, inviting her back to Ft. Benning. "I've got orders to Birmingham," he wrote. "I'll be leaving here soon and then in all probability going overseas."

Two weeks later, she caught the train to Georgia again, willing the train to roll faster, praying that somehow Bo would be spared from going overseas.

Overseas. It was a word that once implied the excitement and allure of an exotic vacation but now carried the prospect of that ominous phrase, "We regret to inform you…" For Mom, the grainy newsreels and black and white headlines suddenly burst onto her consciousness in vivid color. Her romantic cloud was pierced by the realization that the man she had fallen in love with was going to war. Had she joined the sisterhood? Would her future look like that of the bride whose bouquet she had held just a week before, whose new husband had already gone to that dreaded place, *overseas*? Or that of her sister Betty, holed up in an apartment in Boston nursing a new baby while her husband spent weeks at sea dodging German U-boats?

At Ft. Benning, though, going overseas was the least of Captain Traywick's worries. Once again, he had to figure out how to keep his girlfriends separate. Puttering around in Anne's kitchen, he said casually, "You know, I had this blind date as an accommo-

dation to this friend of mine, and I was just being nice and I invited her back down. And don't you know, she *accepted* and she's coming tomorrow." He tried to sound put out.

Whatever she thought about this arrangement, Anne said, "Oh, that's all right, I'll just take the weekend off."

Here the peanut gallery would make puzzled faces at each other. *What does that mean?* It was a strange way to describe Anne's response, but that was the way Dad always told the story.

Dad met Mom at the station in Atlanta. To his delight, she was just as pretty as he remembered.

Mom recalled hugging herself excitedly all the way to Georgia and wondering whether she would remember what Dad looked like. As the train pulled into the station, she debated about wearing her hat or carrying it in her hand. Which would look prettier? She stepped off the train with her hat in her hand, scanning the crowd on the platform and waving excitedly when she saw him. How could she have forgotten that handsome face? He hurried to hug her and she dropped her hat in his embrace. He caught it and handed it back to her as they laughed.

On the way to Ft. Benning in Dad's green Ford, they decided to stop at Hume Music Store to buy a new record. Crossing the street, they paused in the median for a car to pass. Out of the corner of his eye, Dad noticed the shocked expression of the driver of the passing car.

It was Anne.

By the time he got to his room in Collins Hall a bit later, the phone was ringing madly. It was Anne: "What in the world do you mean with that? That's a cute girl! You didn't say she was *cute!*"

"As if I would date a dog," Dad informed the peanut gallery, who nodded in agreement. Listening to Anne's diatribe seemed to emphasize Mom's charming innocence in his mind.

He made a half-hearted attempt to mollify her and found himself relieved when she hung up in his face. He had already moved on.

The second date was as magical as the first, and this time when Mom returned to Hollins, she received a cable asking what size ring she wore.

Floating to the telegraph office, she dashed off a telegram: "Platinum. Size five."

CHAPTER 4

A BOY FROM THE LOW COUNTRY

There was never anything small town about my father. His taste ran to glamorous venues and bespoke tailoring and his sense of dignity was unflappable. He could, as he once did, leave a cocktail party at the White House, find the battery in his car dead and joke about asking the President for jumper cables. Tall and handsome with athletic grace and an arresting presence, he strode through life with a sense of purpose and an entourage of admirers. Despite his self-deprecating manner, he always seemed in command, projecting the kind of worldly self-confidence that is inbred and unconscious.

And yet he was raised in a small town, a remote village surrounded by cotton fields and pine forests in Depression-era South Carolina. Still suffering from the war and Reconstruction, Southern states like South Carolina found the Depression to be more of the same. Men hunted for food with their shotguns and families often traded goods for services in a thriving barter economy. The social order was more dependent on manners and culture than money for the simple reason that no one had any money. Even if there had been money, there was little beyond basics of food and clothing to spend it on. Certainly nothing in the way of luxuries, arts or entertainment.

Somehow my grandparents, a physician and a college-educated teacher, overcame the drawbacks of raising their children in this cultural desert and produced a young man who was the embodiment of the gentlemanly ideal in that time and place. That he was also a scamp made him wildly attractive to the opposite sex and, occasionally, the despair of his family.

"The youngest child always raises himself," my grandmother, Janie May Traywick, was quoted as saying about her baby boy. By today's standards, Dad may have done that, but he had plenty of strong, if sometimes indirect, influence from his family. His brother, Joe, eight years older and revered as only the First Son can be, occupied another universe but set an example of manhood. His sisters, Mary Hope and Bruce, were closer in age but still old enough to lecture their mischievous little brother with a tone of despair. His father, Paul, made sure he learned responsibility from doing chores and *noblesse oblige* through the example he himself set as the physician to an impoverished community. His mother, a Virginian, saw that his education included refinement. The preacher at the Methodist Church next door contributed to his education, as well, inculcating a strong sense of Christian faith in the boy.

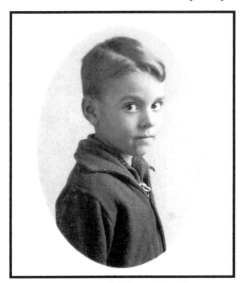

Butter wouldn't melt in his mouth. (c. 1926)

For a long time as a child, Dad's chief aptitude seemed to be an unfortunate tendency to break people's arms, which his physician father was obliged to set for free. He tripped a girl as they returned to class after recess and she broke her arm. Then he wrestled with a boy on the back of a wagon, and when they fell off, the boy broke his arm. Most spectacularly, he stabbed another boy —accidentally, of course—with a dart he had made out of one of his father's discarded syringes, a dart he had flung into the sky and that fell out of the sky directly into the palm of his shocked classmate.

It got to the point when a wounded child was presented to Dr. Traywick for treatment, he would ask, "Did Heber have anything to do with this?"

Eventually, Dad grew taller and acquired other skills. Despite the cultural deprivation of life in the 1930s in Cameron, South Carolina, Janie May saw to it that her children received lessons in deportment and exposure to culture commensurate with their social background. For instance, a gentleman knew not only how to dance but how to conduct himself at a dance, making sure to dance with each lady at his table, escorting her back to the table, offering to fetch a glass of lemonade. Thanks to lessons in the kitchen from his mother, Dad became a good dancer and was tolerated at parties by his big sisters in exchange for dancing with the wallflowers.

Although otherwise well-matched, my grandparents, "Doc" and "Miss Janie", were at odds on the issue of dancing. Doc didn't dance, while Miss Janie had musical notes bursting from her toes. She was, therefore, dependent on her sons and close friends to give her an occasional turn on the dance floor. She knew when her fourteen-year-old baby, who was already six feet tall, danced with her, she could step and whirl because he was almost as good as she was. In those days, a dance was usually a community affair, and the guests covered every gen-

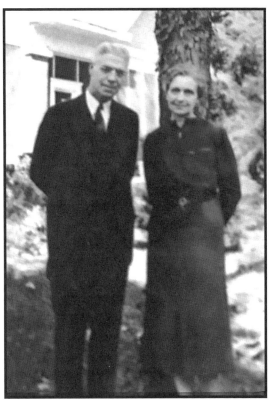

Dr. Asa Paul Traywick and "Miss Janie" Crute Traywick (1930s)

eration. The host or organizers would set up a victrola and guests would bring their favorite 78 rpm records, thick black discs the size of dinner plates. Like any hormonal teenaged boy, Dad gravi-

tated to the pretty girls, but he often settled for one of Mary Hope's friends who had snaggle teeth and bad skin, just because she could really cut the rug. He accepted his sisters' thanks and compliments on his manners with false modesty; the truth was, he would do 'most anything to have a good partner on the dance floor. When he got to college, his skill on the dance floor earned him the nickname "Crazy Legs".

The Traywicks and the Crutes—Janie May's family—were among the early English settlers of America, and they fought in the Revolutionary War and the War Between the States. Somehow, the two families escaped service in World War I: The men in both families were turned down for service. Neither Paul, born in 1879, nor Janie May, born in 1886, was far removed from the consequences of those earlier wars, and both had childhood memories of Confederate veterans and Confederate war stories.

The Traywicks settled in the Carolinas and the Crutes, in Virginia. Dad's grandfather, J. B. Traywick, began his career as a preacher while incarcerated at the notorious Union prison at Point Lookout, Maryland. He was undoubtedly moved by the suffering and privation he saw there, as well as the knowledge that his brother had died there. Perhaps recognizing the limitations of preaching as a vocation, J. B. Traywick's son Paul went into medicine. At the dawn of the 20th century, when a "doctor" could go into practice on the strength of a two-year certificate, Paul graduated from Johns Hopkins' three-year program with the highest GPA ever previously recorded there and then sought additional training. He spent an adventuresome year in Montana as chief resident of a hospital and then, in what must have been culture shock, studied in New York under the famed surgeon Dr. Bainbridge.

Paul Traywick—even the grandchildren called him "Doc"—was by all accounts an excellent doctor and surgeon, highly respected by his colleagues and beloved by his patients, but throughout his life he remained unaccountably shy about his professional skills. Despite his otherwise adventurous spirit, he declined various leadership roles in the state's medical association

and he declined invitations to conferences in Europe and offers to practice in London and New York. He began by declining the opportunity to join Dr. Bainbridge's staff in New York around 1905, instead returning to the South to practice medicine in the small town of Cameron, South Carolina.

The local doctor, Sam Summers, who was approaching retirement, had invited the up-and-coming young man to join his practice and even gave him a room in his home. The relationship became one of mutual admiration and respect. Grateful for the opportunity, my grandfather, still in his twenties, was always careful to give "Dr. Sam" public deference and occasional cover as they called on patients together. If Dr. Sam lingered too long over a diagnosis, Doc might say, "Would you say this was a case of thusandsuch, Dr. Summers?" Or, "Do you think we should use suchandsuch a treatment, Dr. Summers?" Dr. Summers, grateful that the hot shot new doctor did not expose his obsolete skills, showered him with gifts, including a plot of land at the other end of the Summers' vegetable garden. Thus, in 1908, Dr. Traywick and his bride set up housekeeping in Sam Summers' peapatch, where they built a two-story clapboard house with a wide front porch. A magnolia tree stood sentinel at each corner of the front yard, providing natural jungle gyms for the subsequent grandchildren. A small stable, a chicken house, a privy and other outbuildings grew up in back. (The family relied on a privy out back until the 1920s, when Doc had indoor plumbing installed to support two bathrooms, one upstairs and one down. Despite this concession to modernity, he himself continued to use the outdoor facilities, which, in his opinion, afforded more privacy.) While not palatial, the Traywick homestead showed a comfortable level of affluence in a state and a locale that still suffered from the economic devastation of the war and Reconstruction.

The house stood on the western edge of the village. Yet a bored child could climb the magnolia tree at the corner of the yard and watch the four o'clock train clickety-clack through downtown, a mere four blocks away. The commercial district of Cameron stretched two long blocks along Main Street. The railroad tracks

ran down the middle of the wide street, and the white businesses on one side mirrored the black ones on the other. On one side ranged Dr. Traywick's drug store and medical office, C. D. Bull's cotton office, Ferstner's dry goods store, the grocery store, the white funeral home and a few other establishments.

Across the tracks from the white business district were two blocks of commercial establishments owned by and catering to the majority black population of Cameron: a general store, Henry Jenkins' funeral home, the African Episcopal Methodist church, a tavern.

Main Street was wide enough for five or six cars to pass, wide enough for great wagons loaded with five-hundred-pound cotton bales to turn around and back up to the railroad tracks. The town existed at all because the Coastline Railroad decided to build a depot in that spot to load cotton. And because of the depot, C. D. Bull decided to build a cotton gin to comb the bolls clean of their seeds before bundling them into bales. Late in the year, wagons stacked with burlap-wrapped cotton bales, each about six feet across, crowded the wide street beside the train station, looking for all the world like a bunch of rag pickers jostling for a place in front of a fire.

The Low Country of southern South Carolina is flat as a tabletop, and the cotton fields and long-leaf pine woods around Cameron grow in black sandy soil. At that time, the population, too, was largely black, and all, black and white, depended on the economy of cotton and lumber and subsistence farming.

Forty-five miles from the state capital of Columbia, Cameron was a two-hour buggy ride from Orangeburg, the nearest city. Comfortably settled in this quiet, unsophisticated village, Paul and Janie May Traywick raised four children, including a baby boy, Heber Venable Traywick, nicknamed "Bo."

CHAPTER 5

THE RING AND THE WARNING
JUNE 1942

Although there was, in all probability, somewhere in Birmingham, a ring suited to Bo's taste, he nevertheless decided to go home to make this important purchase. The Traywicks have always been close and he was eager to share his excitement with his parents and get their blessing. After dinner, Dad recalled joining his parents and Granma Pearl by the radio in the front parlor, as was the family custom. Doc was smoking his pipe, ensconced in his leather chair. Miss Janie, as the servants called her, and her mother, Granma Pearl, were sitting on the couch doing needlework.

After talk of the war and news about where Dad's friends had been posted, the conversation turned to Dad's social life in Birmingham and he proudly told his parents, "I have a girl."

The way he said "girl" attracted everybody's interest.

"A girl? You don't say," said Doc

"And I'm going to marry her," said Dad.

"Really?" Doc stopped tapping the ashes out of his pipe and looked at his son. "Tell us about her."

Dad launched into a recital of Mom's beauty and charm with all the enthusiasm of a star-struck lover. Although his parents smiled and said all the right things, he sensed a certain reticence, and when first Granma Pearl and then his mother retired for the evening, he and his father had a heart-to-heart talk.

"How long have you known this gal?" Doc said, drawing on his pipe.

"Since the, ah, early part of the spring." He was confident that was long enough. After all, he'd been around. He knew. Mom's charm and innocence and her quick wit made her irresistibly different from every other girl he'd known.

And then my grandfather cut to the chase. "And how are you planning on supporting a wife?" Doc asked. "You don't have a trade or a profession or even a job to come back to after the war."

This was no mean question. In the lull before the storm nobody saw coming, Doc, like other parents in America, worried about his children's potential for success in the bleak job market of the 1930s. Although the American economy had gradually improved following the Crash of 1929, the burden of FDR's aggressive federal intervention had led to a recession in 1937-1938, setting the economy back once again. In the 1930s, the agrarian South was still agrarian, which meant that nobody starved, but it also meant there was no industry to provide jobs. Prospects for a reliable income seemed limited to graduates of medical and law schools, with perhaps some hope for those educated in the sciences or engineering - none of which applied to Dad. Dad's college career at Clemson was distinguished more by high-jinks than academic achievement, and he graduated with a degree in industrial engineering, which he admitted later, "could be anything."

Doc himself had a solid career in medicine, which his older son had followed him into, so he wasn't worried about Joe. The two middle children were girls, and they were expected to marry suitable husbands who would support them and their children. Despite my father's drive and intelligence, my grandfather worried considerably about his youngest child. Would he find a way to make more than a subsistence living? How would he be able to offer a woman the expected stability and support for her to consent to marriage? What on earth would he do, could he do? Those doubts from his own father undoubtedly contributed to Dad's quest

for success - the familiar story of a son trying to earn his father's respect.

Sitting there in the front room, though, Dad understood what his father was saying but he had confidence in himself, confidence gained from his years of arranging the situation to suit himself. If that was somewhat non-specific in terms of a career path, Dad was nevertheless confident it would all work out in the long run. But since at that moment Dad could not name some specific job that he would have, he fell back on his current employment. "Well, I feel like I've been successful thus far in the Army, and I'm considering making a career in the military."

Doc nodded. "And your intended, Flo, you say you've discussed that with her?"

"Yes."

"How old did you say she was?"

He told him. Here Dad would roll his eyes for the benefit of the peanut gallery, confiding, "At least she'd had a birthday recently, and it didn't sound like she was in junior high."

His father's response to the news was measured. Doc picked up the matches, struck one and relit his pipe, puffing vigorously. When he had it going to his satisfaction, he leaned back in the leather chair and exhaled a stream of smoke. "I'm just saying maybe you'd better think about this thing a little bit more. Eighteen's mighty young to be a widow."

Dad had enormous respect for his parents and their opinions, but the passion he felt for Mom outweighed all other considerations. As in other vignettes about my grandparents, Doc displayed appreciation for the fact that his son was a grown man, twenty-four years old; he had said his piece and that was that. It was a relationship of mutual respect.

So my Dad had no hesitation in saying, "Daddy, would you come with me to Orangeburg tomorrow and help me pick out a ring?"

And Doc had no hesitation in replying, "I would be honored to help."

The next day, father and son drove eleven miles to Henebry's Jeweler in Orangeburg, where they selected a brilliant-cut diamond ring with a cluster of smaller stones on either side. The setting was platinum, size five. Despite Doc's reservations about the engagement, apparently he not only helped pick out the ring but paid for it too.

The following Friday, June 22, Dad met Mom at the train station in Birmingham for their third date.

Because of his weaponry expertise, Dad had been transferred to the Replacement and School Command headquarters in Birmingham in May as Assistant G-3. In Army parlance, G-1 refers to the personnel division, G-2 refers to the intelligence division, G-3, operations and training, and G-4, supply and logistics. This was a temporary posting, Dad knew, a holding pattern while he and the U. S. Army decided where he would be most useful to the war effort. Eschewing the limited bachelor officers' quarters, he took a bedroom suite in a private home, where he had more comfort and privacy. Locally, officers were provided membership in the Birmingham Country Club, and Dad's satisfying life continued uninterrupted.

It was Deep South summertime hot when Mom arrived, so they spent the afternoon swimming at the country club. As they splashed and flirted in the water, he teased her. "If we're going to be engaged," he said in a bantering tone, "we need to get a ring. How about tomorrow we go by the dime store and pick one up?"

"Why not a paper one from a cigar?" she teased right back.

Later that evening he picked her up for dinner and a dance at the club. He took a circuitous route, however, winding up the mountainside to Vestavia Garden, a scenic site overlooking the city. In the dusk, they could barely make out the banks of roses or the spent blooms encrusting the rhododendron. There below them,

in the crease between the mountains, steel mills glowed in the dusk, turning out munitions for the war Dad would soon be joining.

When he presented her the ring, she was so excited she was almost speechless. She gasped and slid the ring smoothly on her finger, turning her hand this way and that to admire it, then giggled and smooched his cheek. As he squeezed her in return, Dad could not imagine being any more in love. He felt he could personally go kill all the Japs in the war.

At the dance that evening, they showed the ring around and accepted everyone's congratulations. Not surprisingly, as this was the South, an old girlfriend of Dad's was in the crowd. Mom remembers the girl sizing her up and raising her eyebrows at the ring. Turning to Dad, the girl said, "I don't believe you, of all people, handing out a ring."

"You'd better believe it," said Dad, grinning at Mom.

Mom enjoyed the whole fairy tale romance.

CHAPTER 6

THE VIRGINIA BELLE

When Mom came home from that first trip to Ft. Benning and said flatly, "I'm in love," her parents were surprised but, even though Mom was still a few weeks shy of her eighteenth birthday, they took her seriously. For one thing, my grandmother Nana was only seventeen herself when she and my grandfather Pop eloped. For another, although Mom had lots of beaux, Nana recalled, "She was different about Bo. She came home that first weekend and said, 'I'm in love.' She had never said she was in love with any-body before she met Bo, and"—here Nana would shrug—"well, she always knew her own mind."

When my Traywick grandmother Miss Janie said, "The youngest child always raises himself," she could have been talking about the Nehers. Whether Nana was preoccupied by Dick's and Betty's affairs or simply worn out by the time her youngest child came along, she often let Mom go her own way. Betty had a round face encircled by blonde curls that begged for ruffled collars and frilly skirts, which Nana, a talented seamstress, delighted in sew-ing for her. But when Mom chose to wear corduroy pants and work boots to elementary school—this in an era when girls wore skirts, period—Nana didn't fight her. "I don't know why I did it. Maybe it was my way of rebelling," Mom recalled. Notably, she made the decision to switch to dresses when she reached junior high—eighth grade—and took an interest in boys.

As the youngest child, Mom observed her older siblings and learned to navigate the world. Family stories abound of Betty as a child being willful and foot-stomping rebellious. Mom noted the resultant switchings administered with a frond from the privet

hedge, and instead of being open defiant, she quietly went her own way, to the occasional consternation of her parents. When her mother fussed at her, instead of stamping her foot and arguing, Mom merely hummed tunelessly under her breath: *ty tee ty tee ty.* It was more polite than sticking her fingers in her ears and shouting, "La la la I can't hear you," and Mom had been raised to be polite.

The tuneless humming kept Mom from showing her hand. That "tell" became a repeated feature in the song of her life, indicating a quiet, non-confrontational determination to do things her way.

Mom wasn't wild or bad, she simply did what she chose, even as a child. One day, without mentioning it to anyone, she took it in her head to walk eight blocks to Denver Avenue to play. Mom recalled from an earlier visit that her mother's friend, Mrs. Wright, had stored all of her daughter's toys in the family's walk-up attic.

When Mrs. Wright answered the door, she found seven-year-old Flo Neher on the porch. "Mrs. Wright," said the child, "can I play in your attic?"

Surprised, Mrs. Wright nevertheless invited the little girl in. All afternoon Mom amused herself with an exquisite dollhouse and tea set that used to belong to Mae Wright. When she sauntered home at suppertime, she found her mother absolutely frantic with worry.

"Where have you been?!" demanded my grandmother, torn between anger and relief.

"Playing in Mrs. Wright's attic," Mom replied, shrugging off her mother's distress.

As her mother berated her, Flo bowed her head and hummed softly, *ty-tee-ty-tee-ty.* My grandfather probably didn't say much. He left the disciplining to his wife. Plus, he knew that Flo pretty much did what she wanted to.

My Dad was full of adventure and welcomed even the most random opportunity for an exciting new experience. Mom does not. For her, the American colonists represent the epitome of insanity. As she is fond of saying, "If it had been up to me, we would all still be in England."

But fortunately, her forbears didn't feel the same way.

My grandfather, Clarence Raymond Neher, who went by C. R. or "Pop", and my grandmother, Flo Crisman, both came from Midwestern farm families, descendants of European immigrants, restless pioneers who helped settle the frontier. Even at the far edge of civilization, both families prized education.

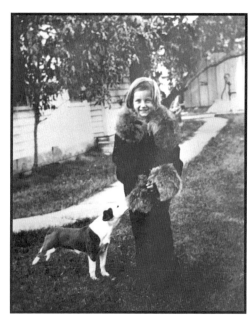

Flo on a visit to her grandparents' farm in Iowa. (c. 1929)

Flo in Lynchburg. (c. 1930)

The Nehers were among a group of German immigrants who came to America in the early 19th century seeking religious freedom. They settled in Indiana and farmed.

C. R. left the farm to attend Manchester College (now Manchester University, a small liberal arts school in Indiana owned by the Church of the Brethren), where he lettered in four sports. Upon graduation, he taught at Southern Iowa Normal School, Business Institute and Conservatory, a girls' school in Bloomfield, Iowa. Among his students was Evelyn

Crisman, the daughter of a prosperous farmer. Perly Crisman came of cultured English stock and he plowed and worked the farm while wearing a shirt with a collar and a tie. Although they weren't too far removed from pioneer days in that part of Iowa, Crisman built a two-story frame house, painted it white and stocked it with Aubusson carpets and a piano. He hired a tutor to come to the house and teach his four daughters and one son, before sending them to boarding school in town.

After calling on Evelyn a few times, C. R. discovered she had a beautiful younger sister at the school. He was immediately enamored with Flo, and when she was seventeen, student and teacher ran off and got married.

C. R. took his bride to the big city—Chicago—where he studied law and taught school while she had a baby, a boy they named Dick. At some point, C. R. received job offers in both Wyoming and Virginia. Without hesitation, my grandmother announced that she wanted to "return" to Virginia. Although she had never been there, she felt a romantic attachment to the Old Dominion because she had heard her grandparents speak of it so often. For Flo Crisman, Virginia bespoke culture and breeding and the social traditions of an aristocratic English background.

In 1917, when the Nehers arrived in Lynchburg, the city had largely recovered from Reconstruction and had begun to thrive. Once a major center of tobacco auctions, the city's economy had expanded into the manufacture of steel and shoes. The central business district, now an artsy district of loft apartments and restaurants, hung on the steep slopes above the James River. There were tiers of commercial buildings dug into the stony cliff face above the brick warehouses lining the riverbank. Remnants of the canal locks that enabled transport up the river from Richmond as far west as Buchanan were still visible, and a small dam provided hydroelectric power for the steel mill glowing beside the river.

In the 1890s, the Rivermont Land Company had laid out a broad, tree-lined boulevard along the bluff extending two miles westward from the commercial district. Well-to-do Lynchburgers

built stately Victorian homes with columns, large porches, deep front lawns and circular drives along the new street named Rivermont Avenue.

My grandparents bought a house a block off of Rivermont Avenue. It was plain but well-located in a middle class neighborhood. The two-story frame house boasted a front porch with a tin roof and a glider. The front yard, enclosed by a hedge, was so small that C. R. wondered why he had to pay someone to mow it. "I could do the whole thing with scissors in about fifteen minutes," he said. By the 1930s, the family was comfortably ensconced in the city and my grandfather supported his wife and three children as an accountant and a teacher of business classes.

Although neither Old Money nor Old Lynchburg, the Neher children were part of that social circle. Mom's best friend was Frances "Fanny" Watts, whose palatial Tudor house was the site of

Betty, Flo and Dick Neher. (1927)

Dick (100) and Betty (95) celebrate Flo's 90th birthday. (2014)

many of the memorable social events of the day. By the time Mom reached junior high school, she and six classmates had formed a tight group, memorialized in periodic photographs. In addition to Fanny and Flo, the circle of seven included Margaret Ann Hopkins,

Ceeva Rosenthal, Jellis Kirk-
patrick, Barbara Bourke and
Helen Wagers. The girls, along
with the boys in their group,
hung around the Watts home
nearly every weekend. At one
point, Fanny asked her father
if he would put in a swim-
ming pool. Mr. Watts snorted.
"The only time I get any peace
around here is when your
friends go up to Oakwood to
swim."

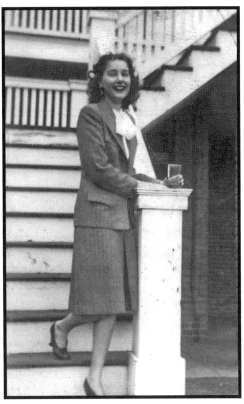

Oakwood Country
Club was the center of social
life for the Rivermont crowd
in the 1930s and 1940s. Other
than the cream stucco exterior,
the clubhouse on Rivermont
Avenue has changed little over
the years and, while it has enter-
tained many successive genera-
tions, it still stands as a symbol

Flo's generation grew up at
Oakwood Country Club.
(1942)

of the wartime era for those who came of age then. Mom's genera-
tion hung around the porch or the pool all summer and danced to
Big Band music in the ballroom every weekend. During the war,
her crowd gravitated to Oakwood, dancing, sipping bourbon, knit-
ting tighter the old connections while the world outside seemed to
be coming apart. The club served as a clearinghouse for news of
local boys and also as a refuge, a reminder of the civilized world
whose existence was at stake.

CHAPTER 7

THE ANNOUNCEMENT
JULY 1942

Mom turned eighteen on May 9, 1942. She had finished her freshman year at Hollins College and seemed in no danger of contributing to the embarrassing marital record of Hollins alumnae. Hollins, which has always had high academic standards, was never a girls' finishing school. However, Mom said, at the time only forty-eight percent of graduates got married, a worrisome statistic in an era when most girls, even "A" students like Betty and Flo, were pursuing an M.R.S. degree.

Dick had vouched for Bo to Nana and Pop and they had faith in their youngest child's judgment. Nevertheless, as she left Birmingham with the ring on her finger, Mom told Dad he would have to come to Lynchburg and speak to her father.

On July 2, Dad headed north to Virginia. After the conversation with his own parents, he realized speaking to Mom's parents would be a challenge, so he spent some time composing his remarks for Mr. Neher. He had a vague what-have-I-done feeling that reminded him of being called into the superintendent's office at Clemson. *What'd I do to mess up now?* He would be sure to have his pants creased like a knife blade and his shoes shining like a mirror when he called on Mr. and Mrs. Neher. Mom had already warned him about her father: "You'll have to tread lightly. My father is very big and very short-tempered."

Dad felt confident he could handle this. Just one more hoop to jump through for the girl he loved. When he met my five-foot-seven, mild-mannered grandfather, he cut Mom a look of exasperation. The two men got along famously.

Later that evening, Mom took her handsome beau to meet her girlfriends and show him off. Ceevah and Fanny squealed with excitement at the ring. "We have to have a party," said Ceevah.

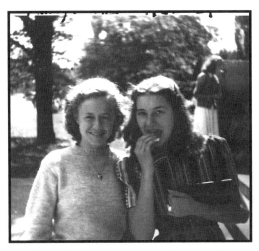

Flo (R) with her best friend, Frances Watts. (1939)

"We can have everybody come over to my house tomorrow night," said Fanny.

The next day, Dad called around Lynchburg to find an orchid corsage. When the local florists came up short, he asked to borrow Pop's car so they could drive fifty miles to Roanoke in search of the elusive flower. "This is one night you rate orchids if I have to drive to New York for them!" he insisted.

That evening, a large crowd gathered at the Watts' house, site of many memorable parties before and since. Fanny and Ceevah had transformed the Tudor mansion into a garden of magnolia blooms. Dad was resplendent in his dress uniform, and the precious lavender orchid bloomed on the shoulder of Mom's ecru sharkskin dress. As was the case at most social events during the war years, there was a noticeable absence of young men. There was music, though, and hors d'oeuvres and cocktails on the terrace, and one teenaged boy approached Dad and said, confidentially, "Say, I hear someone's engagement is going to be announced tonight. Who do you think it is?"

It seemed obvious, since Dad was the only single man in attendance who was old enough to get married, but he just smiled and said he didn't know.

The combo played "In the Mood," allowing Mom to show her friends what a great dancer Dad was. For his part, he tried not to hold her too tightly when they played Glenn Miller's new hit song, "A String of Pearls."

Mom was hanging adoringly on his arm when the Western Union delivery boy rode up on a bicycle with a sack full of telegrams. He circulated through the room, passing out telegrams that read, "Flo and Bo to the altar will go."

After another deliciously romantic evening, Mom drove Dad to the train station where he kissed his girl goodbye, boarded the Streamliner at midnight and found a seat on the crowded train.

Many years later, Dad confessed that the train ride back to Birmingham was a long one. He pulled the brim of his hat down over his face so he could dream a little and sleep his way back to Alabama. For awhile, a smile creased his face. But then, even as he savored the thought of having Flo to himself, he heard his father's voice asking "How are you going to support a wife?"

A wife? He grimaced a little at the thought. A wife needed a place to live. He thought of his father giving his mother a household allowance and wondered where he would get such a sum of money, even with the support of the United States Army. Then there was the war. He'd already been in conversation with the administration about his posting overseas, where he wanted to go, when he would leave. And who knew how long this thing was going to drag on? He didn't like to entertain the notion that he might not come back, but, as an academic question, it had to be considered. Where would that leave Flo? An eighteen-year-old widow. He sucked on a cigarette. Maybe he'd been a little hasty with this thing. When he proposed, how did it get from banter to platinum size five? There wasn't any question that he loved that little gal, but love was being subordinated to reality as the Streamliner clickety-clacked farther and farther south.

Man, I have really messed up this time.

CHAPTER 8

THE LETTER AND THE RULES
JULY 1942

On Monday, still on a heavenly cloud after the announcement of her engagement, Mom danced her way to the record store and bought "A String of Pearls" to mail to Dad.

On Tuesday, she received a letter from her roommate, Jean Marie Auberneau, inviting her to visit in Chicago in August. She smiled dreamily, imagining Auberneau's reaction to her engagement. She might even be married by August.

On Wednesday, she received a letter from Dad. Racing upstairs to her room, Mom excitedly slit the envelope and teased out the letter from her beloved. Unfolding the heavy stationery, she saw his angular hand, so familiar now and so dear. *Dearest Flo*, he began, and her heart skipped a beat. *You know how much I love you*, she read.

But.

In Dad's retelling of their courtship and in Mom's supplementary comments, the exact contents of The Letter were glossed over and joked about. In later years, under direct questioning, they revealed the letter had made the rather sensible suggestion that they wait to get married until Dad came home from doing his overseas duty. He apparently voiced the point his father had voiced to him, that eighteen was mighty young to be a widow. He expressed his affection for her in that depressing four-word phrase, I-love-you-but.

Mom was stunned and confused. There was no way to hide this development from her sharp-eyed mother while she processed the information herself. When Nana asked her what was wrong, she said, "He just wants to wait a little while."

"Wait?" Nana said. "After he rushed you off your feet and gave you a ring? Now he wants to 'wait'?"

Mom nodded miserably.

Nana demanded to read the letter, after which she announced, "Sounds like cold feet to me." Which did not make Mom feel any better.

Mom could not believe Dad had given her a ring only to suddenly change his mind. Nana more or less agreed with her, but since they knew little about Dad, it was hard to judge. Mom had never met his family. Other than Dick, whose acquaintance with Dad at Ft. Benning was slight, there was no one to vouch for him, no one to give them any indication of his background, his character. Up until the arrival of The Letter, the vibes had all been good.

The question now was, how to respond.

My grandmother was very perceptive about men and she had coached both her girls through tricky situations with various beaux over the years. Men had all the advantages in those days. They made the calls. They did the asking. It wasn't enough for a girl to be attractive; holding the interest of several men simultaneously took a certain amount of management—something Nana was particularly adept at. I've often wondered at her skill, she who had been raised on a Midwestern farm and eloped at seventeen. How did she learn to navigate so well the social conventions of the South in the 1930s?

By the time I came along in the 1960s, Nana's advice had been virtually codified as Nana's Rules. There was no boy-girl situation for which Nana lacked a pithy saying, but they all stemmed from Rule #1: *Girls don't call boys.* Translation: Boys like to do

the chasing. Still, a girl could act in a way that would encourage a boy to chase her.

For instance:

Rule #2: Pull him to you with one hand and push him away with the other. Example: "Oh, Billy, I'd love to go to W&L Fancy Dress with you - you are the *best* dancer—but I already have other plans that weekend."

Rule #3: Sometimes men need direction. Example: "Oh, Billy, I'd love to go to W&L Fancy Dress with you, etc. I wish you had called me sooner."

Rule #4: That which is unattainable is most desirable. Translation: Don't worry about turning Billy down. You've just whetted his appetite.

Rule #5: You're not going to meet anybody sitting at home. Translation: Don't sit by the phone waiting for that one certain fellow to call. Go out with Mortimer Snerd and be seen.

Rule #7: If he really likes you, he'll be back. Translation: Let him sulk. Don't try to make up to him, let him make up to you.

Nana always believed in keeping the upper hand. The core of her philosophy for dealing with men was an insistence that a girl maintain her dignity. The only way to maintain one's dignity was to reject anything less than enthusiastic pursuit by a man. Never give a man the idea that you are waiting around for his attention, or, heaven forbid, begging for his attention.

So Mom waited hopefully for Nana's advice on how to handle her fiancé who wanted to delay the wedding. She was sure her mother would know the right way to phrase a letter or telegram, the right touch of indignation or charm or dismissal that

would bring Bo panting back to her side, begging forgiveness and immediate nuptials.

"Send the ring back," Nana said.

C. R. Neher – "Pop" (c. 1960)

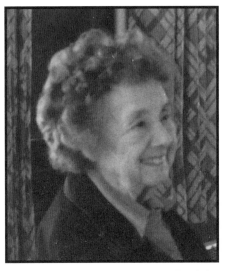

Flo Crisman Neher – "Nana" (1981)

PART II – Going Separate Ways

Chapter 9

Meanwhile Back at the War
Spring 1942

The world was a dark place in 1942. Daily reality for millions of people around the world was bound up by the rapacious imperialism of two cold and cruel regimes that were successfully dividing up the globe. In the 1930s, America and Great Britain had tried to ignore matters as Japan and Germany engulfed one neighboring country after another. Physical attacks by the Axis powers finally forced what remained of the West to push back and fight for freedom. It was almost too late. Japan and Germany had the jump on the U. S. and the U. K. For four years following the Battle of Britain and three years following the attack on Pearl Harbor— -years of desperate bloody fighting in countless countries—no one could be sure how it would all turn out.

Bo and Flo's courtship unfolded with the free world knocked on its heels, at the deepest darkest moment of the war. As Rick so aptly observed in *Casablana*, "It doesn't take much to see that the problems of [two] little people don't amount to a hill of beans in this crazy world." The romance between Bo and Flo was headline news among maybe ten people and their subsequent breakup, among even fewer.

Throughout the spring and early summer of 1942, as Mom rode the train from Lynchburg to Birmingham, the war metastisized in Europe, North Africa, the Mediterranean, Asia and the

Pacific. The Allies desperately fought to contain the Axis powers somewhere, anywhere, as the aggressors seemed to overrun their neighbors in every direction. It was truly a worldwide war, not a handful of hot spots in Syria or Chechnya or Ukraine or Somalia.

German U-boats enjoyed the peak of their killing power, a period their submariners called "the American hunting season" as they torpedoed hundreds of merchant ships, scattering thousands of bodies and millions of tons of cargo on the floor of the Atlantic Ocean.

France and the rest of western Europe suffered under the weight of the Third Reich, while to the east, the Germans controlled big hunks of Russian territory and expected, with some reason, the collapse of Russia.

In North Africa, German General Erwin Rommel had swept the Mediterranean coast and, from his position just sixty miles from Egypt, seemed poised to take the Middle East.

Hitler, with the Atlantic Ocean and Europe under his belt, the Mediterranean coming along and chunks of Russia under German control, began pursuing his cultural goals in earnest. Concentration camps in Poland and western Russia became extermination camps, as the Germans began gassing Jews, gypsies and other "subhumans" with despicable efficiency.

In the Pacific, the situation looked just as bad for the Allies. Rather like the fly eating the spider, Japan dreamt of controlling all of Asia—its enormous neighbor China, the subcontinent of India, the Malay Peninsula, the Asian Pacific islands—and by 1942, that goal seemed within reach. Japan controlled virtually everything west of the international date line, north nearly to Alaska and south to the Australia coast.

As the leaders of what remained of the free world met and anxiously argued about what to do next, the outcome of the war was very much in doubt.

This was the backdrop to Mom and Dad's courtship, the scene that played out on newsreels behind them.

What did not show up on the newsreels to any great extent was the CBI: the China-Burma-India theater of war, also known as "the forgotten theater." It was only later that the world learned of the exotic and harrowing experiences that characterized the war in Burma (Myanmar).

As jaw-dropping as Burma war stories were on a micro level, from a strategic standpoint, Burma was important only insofar as China was important.

Early on, China's participation on the Allied side was critical as a bulwark against continued Japanese expansion. The resources required to fight China necessarily diminished Japanese efforts elsewhere. China was at this time quite backward, but it offered one great resource: manpower. With such an endless resource, a Chinese general could and did say, in all seriousness, that Japan would have to kill fifty million soldiers before it became significant.

The problem was, with the Japanese blockade of the Chinese coast, there was only one route by which the Allies could send desperately-needed war materièl to the Chinese troops, only one slim land bridge between China and the outside world: the tiny British colony of Burma.

So, although the tide of war inevitably led to a reordering of priorities, for a period in 1942 and 1943, Burma occupied a pivotal position in war strategy. A remote, tribal region jammed into the Himalayan foothills between India and China and stretching southward along the western border of Thailand, Burma had been overrun by Japanese troops right about the time Bo was giving Flo a ring in Birmingham.

The fall of Burma contained a dramatic event that eventually led to my father's service in the CBI—which, in turn, helped focus his mind on marrying Mom.

In March of 1942, as the Japanese poured into Burma from the south, Gen. Joseph W. Stilwell, a brilliant field commander who spoke Chinese and understood the culture, was sent by Allied command to manage the CBI.

Stilwell arrived in Burma just in time to retreat.

Defending the colony were British troops with contingents of Indian troops from Britain's other colony nearby, plus several thousand poorly-trained Chinese troops. Stilwell's efforts to organize these mixed units into effective resistance to the Japanese proved futile, and in a matter of weeks, all civil order in the country collapsed under the Japanese onslaught. Civilians and soldiers alike fled north and west. General Stilwell evacuated the bulk of his staff by air in the waning days of April but as he prepared to leave Mandalay by train on May 1, news came of a train wreck up the line.

With the escape hatch rapidly closing, Stilwell, a few remaining staff members and servants, a news reporter, a Quaker ambulance crew, Dr. Gordon Seagrave and nineteen Burmese nurses left in a caravan of trucks, jeeps and sedans, headed north to the airport at Wuntho. They struggled for three days to go one hundred fifty miles. The narrow road was dry and dusty and chock-a-block with refugees: Indian civil servants, Burmese civilians, and Chinese, British and Indian troops. All across the middle of Burma, a great wave of terrified humanity lifted up and swept northward, racing ahead of the barbaric invaders. It was every man for himself.

In Wuntho, Stilwell learned that the hope of a flight out was gone, and there was no more road. All around him there was chaos, looting, wrecked trains, bonfires of supplies and hollow-eyed women carrying bundles and dragging crying children by the hand.

They were trapped.

There was nothing to do but walk out of Burma. So, a few hundred miles from Bataan and a few weeks after the Death

March, the fifty-nine-year-old general led a ragtag band of people on a two-week hike over one hundred fifty miles of some of the worst terrain in the world. Between Wuntho in north Burma and Imphal in India, there lay an unmapped expanse of hot steaming jungle full of leeches, snakes, tigers, elephants and malarial mosquitoes, the Chindwin River and the Chin "Hills," jagged peaks of 10,000 feet through which no road had ever been cut. Stilwell pushed the group hard through the perilous country, mindful of the greater danger from Japanese troops often just a few miles behind them.

On May 20, sixteen days after leaving Wuntho, Stilwell led his band of refugees into India intact. Arriving in Imphal, the five-foot-nine general weighed one hundred twenty pounds and was mad as hell. Like MacArthur, Stilwell, too, made a memorable statement:

"We got a hell of a beating," he told the press. "We got run out of Burma and it is humiliating as hell. I think we ought to find out what caused it and retake it."

The loss of this small, remote, exotic hellhole was of great strategic importance, because it closed China off from Allied supply. Perhaps even more alarming, the taking of Burma opened the way for the Japanese to take over India. The Americans didn't care about saving Great Britain's colonies for her, but keeping China in the war was imperative. Plus the Japanese had to be stopped somewhere. Burma thus became the focus of the China-Burma-India theater of war.

Stilwell spent the next eighteen months flying between the British-American command at Delhi, and the Chinese capitol at Kunming, planning how to invade and recapture Burma and re-open the land bridge to China, goals that were assigned a high priority by the Allied command in 1942.

Stilwell's plan to achieve these goals, which he had formulated while marching out of Burma, began with bringing in American officers to train Chinese troops for the effort. He felt

the Chinese had the makings of good soldiers, they just needed training and leadership. So the call went out for officers who were experienced weaponry instructors and fluent in Chinese.

Capt. H. V. "Bo" Traywick met half the requirements.

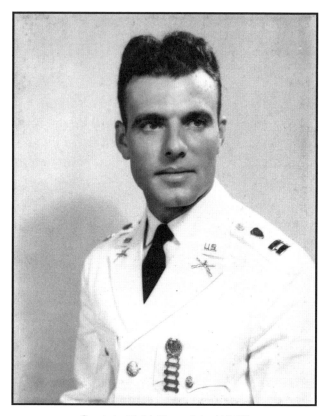

Captain H. V. Traywick. (1942)

CHAPTER 10

JINGLE JANGLE JINGLE
SUMMER-FALL 1942

In every telling of their courtship, Mom and Dad invariably referred to the change in their relationship in the somewhat neutral phrase, "when Flo sent the ring back". They never "broke the engagement" or "split up" or "had a fight"—because, as Mom pointed out, "We didn't have a fight." In the old days when a couple went their separate ways, a gentleman gallantly allowed the lady to claim she had initiated the breakup and thus save face. But I never felt as though Dad was allowing Mom her pride, it seemed more like Mom was covering for Dad, author of the equivocating letter. Both of them skipped over the letter fairly quickly, but Dad seemed to rather enjoy feigning shock at the spunky gal who responded promptly and unequivocally.

As he told it, after dispatching the fateful letter, he didn't know exactly what he expected in the way of a response. When the ring showed up a few days later without so much as a note, the message was clear. The ring arrived one day and the next, there was a 78 rpm record in the mail—the romantic gift Mom had mailed the morning after their engagement party. Confused by the timing of the two packages, he dismissed the significance of "String of Pearls" and flipped the record over to see Flo had salted the wound by sending him, "Jingle Jangle Jingle, Ain't You Glad You're Single?" He was young, he was proud and he had been tactless, if not outright wrong, so he resorted to self-righteous anger. Any second thoughts he had about the letter were quashed by his wounded pride. He had made a sensible suggestion, that they delay the wedding until after he had done his rotation overseas, but she

was acting like a spoiled child, throwing a hissy fit just because they couldn't get married right away. To hell with her.

Dad was at that time serving as a weapons expert at the Replacement and School Command in Birmingham, Alabama. The R&S Command was an administrative outfit occupying two floors of the Jefferson Hospital building in Birmingham. At some point, the commander-in-chief at R&S Command, Gen. Harold R. "Pinky" Bull, had asked Dad to be his temporary aide, pending the arrival of another officer. It was not onerous work, and Captain Traywick had plenty of time to show his fiancée the sights when she came to visit. Then, after he became un-engaged, he had plenty of time to devote to reestablishing his social life as a man about town.

According to Dad, he had an office and a secretary and little to do for several months until his replacement arrived. He merely wore the insignia and received the citation—and occasionally escorted General Bull's daughter, Patty, to dinner at the Birmingham Country Club. He also went out with other local girls, including Bambi Edwards and Nancy Lester, who happened to attend Randolph-Macon Women's College in Lynchburg, Virginia. Before she left Birmingham to go back to school for the fall semester, Nancy invited Dad to come to Lynchburg for a school-sponsored dance. Dad decided that might get sticky, so he declined.

Aware that his replacement as General Bull's aide was arriving soon, he began looking for his next assignment. Dad had felt uncomfortable for some time that his brother, Joe, a doctor with no military training, was due to ship out momentarily while he, a military professional and infantry officer, hung around the Birmingham Country Club. As he explored options with the personnel office, he ruled out Europe because of the weather. With Raynaud's syndrome, he told the clerk, his fingers turned white and ached painfully in the cold. He knew he couldn't stand the cold.

Searching other theaters of operation, the clerk found a request for ten weapons experts to go to China and train Chinese troops. Weaponry. China. Dad perked up. The idea of traveling to

such an exotic, mysterious land appealed to his sense of adventure and curiosity. There was just one catch. He didn't meet the language qualification.

Later he told the general that he'd like to go to China as a weapons expert, but they wanted people who spoke Chinese.

"Oh hell," said Gen. Bull, "they've got a million interpreters over there. If you want it, put your name on the list and I'll take care of it."

Dad was scheduled to depart from San Francisco, and he had about a month before his orders called for him to report to the west coast. First he tidied up his desk in Birmingham. Then he went to Ft. Benning for a few days to pick up some training manuals and attend to his affairs. He made his reservation on the train for the west coast. He packed his uniforms, his fatigues, a few personal items.

There was just one last piece of business. He went home for a few days to say goodbye to his parents. It was a hard visit. He recalled his brother's happy little family as he made his own preparations for deployment, but he tried to put Flo out of his mind. That was over and he couldn't do anything about it. He reminded himself of the exotic expedition before him. He'd been intrigued by the prospect of unimagined adventures in the Far East, but confronted with his parents' brave farewells, he had a few misgivings. What if he never saw any of his family again? He found himself outlining his mother's cheek, studying his father's hands, recording their voices.

As he left, he gave his mother a present. "Momma, would you wear this for me?" he asked, as he gave her a diamond ring.

She smiled sadly and slipped it on her finger, a pitiful exchange for sending her second son into the arms of war.

For thousands of years, mothers have sent sons into battle, each one a moment of unimaginable torture. Miss Janie must have been reminded of her own mother's experience. Granma Pearl,

who lived with Dad's folks, had been a child during the War Between the States and she remembered her three brothers leaving for war. She frequently told the story around the dinner table of her youngest brother. He had come home on furlough for a few days of rest and home cooking and wanted to stay. His parents, torn by every kind of fear for their child, told the boy he had to return to his unit, that, as a soldier, he would either be shot as a deserter, or found and killed or captured by the Yankees.

Granma Pearl vividly recalled being an eleven-year-old girl, crouching halfway up the stairs, peering through the spindles as the scene unfolded. The boy, who was only sixteen at the time, hugged his mother, cried, and said he didn't want to go back. She hugged him, steeled herself and told him he had to go.

As Dad packed to leave for China, he must have had that heart-wrenching story in mind, sensing the hardship his parents would endure when he left. He particularly worried about his older brother and hoped somehow he would be spared from going. As a doctor, Joe would be valuable wherever he was sent, and Dad prayed the Army would put him to work in a stateside hospital.

Thinking of Joe with his wife and baby, Dad had mixed feelings about The Letter. He pictured the ring—"platinum, size five"—and tried to imagine Mom's emotions. What if he never saw her again? He had always been able to win over any girl he set his sights on, but Mom was different. He wasn't sure, even if he were free to pursue her now, he could win her back. Worse, he couldn't even try for…what? A year? Two? She'd be married to somebody else by then. A cute gal like Flo Neher didn't stay on the market long.

He was leaving home for a long time, the future uncertain. He *did* want someone waiting for him, with or without a ring. So, a bit nervously, he picked up the phone and dialed "0." "Operator, I want to make a long-distance call to Lynchburg, Virginia."

He didn't have a prepared speech because he didn't know what her reaction would be. In the past when he had called a girl

after a long absence, she was generally so grateful to hear from him that the conversation was easy. Even if the girl made a show of being cool or miffed, he could banter his way back into her good graces.

But this was different. He had given this girl a ring.

And she had sent it back.

He would have to take her temperature first and then launch his charm campaign. As he heard the operator in Lynchburg ring the house, he felt confident but cautious. When she came on the line, he'd say, "Hey, baby," as he always did, and he'd know in a few seconds how it was going to go. He'd ask her about school, what she was studying.

He didn't know she was working in Washington.

CHAPTER 11

RULE #6

In the summer of 1942, my mother was not a vivacious prom-trotter or a flirtatious belle or a glowing bride-to-be, she was a broken-hearted eighteen-year-old girl. She had seen the mountaintop and plunged to the bottom of the abyss.

Just a few months before meeting Dad, Mom had boldly confided in her diary: "I have just come from seeing 'That Hamilton Woman'—and I am so deeply moved, I feel I must express my feelings in some way. A love story like that. Sometimes I feel as though I were born for a great love. One that would take complete possession of me. To love and be loved in a like manner must be the most wonderful thing in the world…"

Magically, a great love had taken possession of her. But after months of experiencing the love story she had foreseen, she found herself dealing with the tragedy of losing it. So it was the second part of her diary entry that now seemed prescient: "These silly words—someday I'll read them and laugh at their sentiment. Someday in my mediocre life—when I'll know that you only read about loves and tragedies and no matter what happens - the heart goes on beating, and people go on living."

She poured out her otherwise closely-held feelings in a short story about a girl named Ellen who lived in Washington, D.C., and suffered a broken heart. Tellingly, she wrote about Ellen's *feelings*, the emotional devastation of a young woman who had been wooed and won by the handsomest man on earth and who had somehow lost his love.

If the story of "Ellen" is to be believed instead of Mom's scrapbooks, she awakened every morning to the thought *This is another day without him.* As she began to recover from the initial pain, she studied the quality of her emotional state. *Strangely enough,* "Ellen" thought, *you don't die of a broken heart. You go on living, eating, speaking in a normal tone of voice instead of screaming, as you would like to do, and the world is not to guess that your life has crumbled around you.*

Of course she was deeply wounded. A bright popular young girl swept off her feet by a dashing Army officer seven years her senior, a man who gave her a ring and held her arm at a very public engagement announcement, only to suddenly equivocate and disappear. She had to have been hurt, confused, embarrassed - and then depressed to find every morning that it wasn't just a bad dream. It was over. The magical months of courtship were over.

It was impressive how stoically she dealt with her disappointment, building a network of emotional fibers as fine and as hard to break as a spider's web. You could almost see the silky-steel scaffolding going up around her heart, a framework for holding her emotions in place whenever the slings and arrows of fate attacked her—her casual dismissal of Dad to her friends, her chin-up charm with subsequent dates, her refusal to reach out to Dad after some time had passed.

My grandmother knew sending the ring back would shock Dad and bring out his true feelings, even if it took awhile. She was willing to gamble that Dad would come to his senses and return to Mom's side, determined in his resolve to marry her. *Rule #4: That which is unattainable is more desirable.* Unfortunately, while he was sorting out his feelings, however long that might take, Mom was stuck with a pile of uncomfortable emotions.

As she confessed later, "[Nana] made me send the ring back. I didn't want to." Without alcohol to drown her sorrows in, she turned to Twinkies.

"He'll be back," Nana prophesied, but Mom wasn't so sure. In the meantime, she needed a distraction and a confidence-booster.

Fortunately, Mom's roommate had invited her to Chicago, so Mom packed a couple of party dresses and a lot of hankies and boarded the train.

"Go to Chicago and have a good time," Nana told her. "Having dates is more fun than sitting at home brooding." Nana's rules were clear on this point. *Rule #6: The cure for man is men.*

Jeanne Marie Auberneau—"Aubie"—Mom's roommate from Hollins, made sure she had a festive visit to Chicago, taking her to parties and seeing that she met plenty of available men, men who were delighted to entertain the vivacious Southern belle. It was all a nice diversion, but Mom had to work to project the *joie de vivre* she didn't feel. Years of practice came in handy, and the flirty banter rolled off her tongue automatically. But in between dancing to Duke Ellington and laughing at the Broadway hit, "My Sister Eileen," Mom called her mother in tears several times. Nana was horrified at the extravagance of long distance phone calls but held her tongue. Finally, Nana sent her heartbroken daughter the draft of a letter to send to Captain Traywick. In a sign of her growing strength—aided by her pride—Mom read the letter and tossed it. She'd sent the ring back. What more could be said?

The same week Mom got The Letter, her sister had a crisis of her own. Betty and Ed were living in an apartment in Boston, where the *USS Trippe* came to port between convoys. Betty, then twenty-three, spent long grim stretches alone with her baby, since the ship was at sea for weeks at a time with only a few days in port. There was no housing on base for the families of naval personnel, and Betty had no support system in Boston.

Dragged down by the stress of fending for herself and the toll of pregnancy and motherhood, Betty became ill. She went to the hospital with double pneumonia, leaving her baby in the care of a neighbor she barely knew. As soon as Nana dispatched Mom to Chicago, she boarded a train herself and went to Boston to care for her daughter and grandchild.

On August 1, as Mom was packing to leave Chicago, she received a telegram from her mother: "Can you arrange to come

on here instead of home. Mom." She changed her train ticket and went to Boston, where she spent two busy weeks charming the uniformed men at the Naval Officers' Club.

Mom's scrapbook of her social life in the Forties belies her heartbreak, as there is a seamless transition from enthusiastic entries about Bo and their engagement to enthusiastic entries about a dizzying succession of military officers. Thank heavens for the war.

"Johnny LaMint was visiting Aubie—gave me [this corsage] when I left."

[Next to a picture of two men posing in front of a prop plane, with one man circled] ___ of Charleston, S.C. Met on the train [to Boston]—was I glad to see a Southerner! Knew everyone I knew from Clemson—including Bo."

"Henry Tweedle - 6'2", 190 lbs, blond and cute! Hank and I went canoeing on our first date! Sort of a poor man's holiday for a naval officer!"

"[Lt.] Walter [Lennon] was wonderful to me when I was in Boston. I had met him at an officers' dance in June in Lynchburg. He's 33, from Providence, R.I."

One of the fun things about reading Mom's scrapbooks is seeing how her beaux competed to treat her to new and interesting activities. One Boston beau took her to a drive-in movie on the Cape one night. The drive-in theatre in Weymouth, Mass., advertised itself in a flier as "New England's First Open Air Automobile Theatre." So new were drive-ins that the flier advised patrons on what to expect: "No Parking Troubles. Just drive right in, stay in your car, and enjoy our shows! Your car, parked in the theatre, offers all the advantages of a private box. Any type of dress is correct at the Drive-In Theatre, and you can smoke, converse and relax within your own car without the least disturbance to your neighbors in the audience."

Chicago was fun, but back home in Lynchburg, Mom once again let her broken heart occupy all her attention.

With Betty healthy again, Nana turned her attention to her younger daughter. Mom was no longer crying every day, but Nana knew the quiet life of Lynchburg would give her too much time to brood. She had to position her daughter to meet other men and take her mind off Bo. Once again, brother Dick was called upon as the agent of Mom's social life. Dick had by now finished his communications course at Ft. Benning and been assigned to Ft. Myer in Arlington, Virginia, just across the Potomac River from Washington, a two-hour train ride from Lynchburg.

Washington was, of course, the center for planning the supply system and conduct of the American war effort. All the best and brightest men who were not involved in actually training or leading troops were congregated in Washington, in one of the many offices around the city or, beginning in 1942, the brand-spanking-new Pentagon. The capital was designated "Military District of Washington" (MDW), and Dick himself was appointed Communications Officer of the Military District of Washington.

It wasn't Chicago. It wasn't Boston. It was better.

When Nana suggested Mom go to work in Washington, she perked up. After her brush with the grown-up institution of marriage, she thought returning to college was vaguely juvenile. But she liked the idea of going to work. Unlike most of her friends, she had had a summer job one year, doing clerical work for Gilbert Moving and Storage, one of her father's bookkeeping clients . She proved to have a head for business, and at the end of that summer, Mr. Gilbert had asked her to skip college and stay, promising to teach her how to bid jobs. Now, the prospect of earning her own money again was appealing. (She had spent her first paycheck - $8.10 - on a red feather cocktail hat, a telling purchase if ever there was one.) But financial independence paled next to the fact that Dick would take her to the social events at Ft. Myer. Plus, the Naval Academy, housing more handsome young men in uniform, was only thirty-five miles away.

Rule #6 was perhaps her favorite rule.

Chapter 12

Belle of the Beltway
Fall 1942

Ironically, although it was the war that pulled Mom and Dad apart - Dad's obligation to go overseas - it was the war that helped Mom deal with the heartache. Mom never came out and said so, but sending the ring back opened her life up to all the excitement and social and professional opportunities of wartime. For a bright girl who enjoyed work, the timing could not have been better.

When Mom took a job in the war effort, she became part of a national phenomenon that would outlast the war and have far-reaching consequences: working women.

"In my day," Mom said, "girls went to high school, went to parties and got married. No one thought about being a lawyer or having a career." Marriage and motherhood were the path to fulfillment, but there was another, practical reason, too. In the crush of the Depression, a married woman who worked was frowned on for selfishly taking a job away from a man with a family to support. When Mom recalled her high school summers spent at the pool at Oakwood or organizing tea dances and house parties, she said, "No one had a job in high school. Lots of people's fathers didn't have a job."

The change came rapidly, once the government began drafting millions of young men for military service.

In 1940, federal government jobs were actually off-limits for women. By 1942, the government was not only hiring women,

it was promoting government employment as a patriotic way for women to contribute to the war effort. There was a genuine need for women to fill many jobs in the war effort, but government officials knew that getting women to work meant overcoming deeply entrenched societal expectations. Rosie the Riveter and other female characters became the stars of a propaganda campaign by the government designed to assure women (and their families) that their place in the workforce was both necessary and socially acceptable.

Of course, it was agreed by the men running the campaign that the notion of women working was a temporary expedient that would vanish after the war: The men in uniform would come home to their jobs and the women would go back home to theirs.

How that played out is a whole 'nother story.

When Mom arrived in Washington in August of 1942, Dick took her to the government personnel office located in one of the temporary buildings erected on the Mall for the war. There was no shortage of jobs for smart girls with office skills, and Mom put her experience at Gilbert Moving and Storage to good use when she was hired as a clerk with the Lend-Lease program.

Her job involved tapping a calculator all day, running the tab on how many jeeps and boots and pyramidal tents were sent to which country. For this, she was paid a hundred and fifty dollars a month—"ten dollars more than the graduates of Annapolis were making," she told us smugly. "Midshipmen got a hundred and forty when they graduated." Seventy-five dollars every two weeks was an impressive amount of money, when gas was twenty cents, a new house cost $5,000, a movie ticket was twenty-five cents and dinner at a nice restaurant cost two dollars.

Dick had an allowance for housing that he used to pay for a room at 125 N. Irving St., near Arlington Cemetery. When Mom arrived, he turned the room over to her and went back to the BOQ at Ft. Myer. The bedroom was almost subterranean but it had a private bath and charming landlords, all for twenty dollars a month.

Each morning Mom caught a bus to work. Often as she waited for the bus, someone would stop and offer her a ride. With gas rationed, ride-sharing was in vogue. From the bus she could see the cranes at work on an enormous five-sided building going up on the banks of the river. Already partially-occupied, the building covered twenty-nine acres of floor space, making it the largest office building in the world. Called simply "The Pentagon," it would, when completed in April 1943, absorb the military offices and personnel from seventeen other buildings.

After work, Mom often stopped at Ewarts Cafeteria for supper. The signsmith had programmed the lighted sign to blink the letters in order to form a message: E-A-T, then A-T, and finally, E-W-A-R-T-S. For fun on the weekends, Dick took Mom riding on the horses stabled at Ft. Myer. Used to pulled the caissons, the black or grey draft horses were so wide, Mom said she could hardly get her legs around them.

Mom's landlords, Harvey and Blanche Miller, were friends of Dick's. Harvey ran the ten-cent store in the village, and Blanche kept their two little girls. Somehow or another Harvey had gotten hold of a 1930 Duesenberg Town Cabriolet previously owned by tobacco heiress Doris Duke. It was very glamorous: it had a thirty-two-valve, eight-cylinder engine, gold-plated fixtures and a dividing glass for the chauffeur. (Fully restored, the car sold at auction in 2016 for $1,254,000.) Mom and Dick and the Millers themselves thought it ironic that the couple lived in such a modest house but kept a Duesenberg in the basement garage.

With gas rationed, the Millers couldn't get but four gallons a week, barely enough to drive the Duesenberg around the block. Harvey would say, "Here I own a Duesenberg and I have to go to work on a bicycle." Mom thought Blanche and Harvey were lots of fun. Once she found them sitting in the elegant car in the garage saying, *BdnBdnBdn*. Then Harvey turned to Blanche and said, "Would you like to drive for awhile?"

If the Millers thought they were going to get a lot of baby-sitting out of Mom, they were in for disappointment. With all the

military officers passing through the city, the pool of potential dates was enormous. Mom went out with Dick's friends at Ft. Myer and then met more men at the events on post. Midshipmen at Annapolis and cadets at West Point wrote her, and Mom, still only eighteen, made regular trips to both military academies for dance weekends and football games that fall.

Going out meant dressing up, none of this jeans and popcorn at the movies: Uniforms or tuxedos for men and cocktail or evening dresses for women. Mom and her date would meet Dick and his fiancée, Pat, at the Shoreham Hotel or the Mayflower for dinner. Afterwards, the hotels offered floor shows for entertainment or an orchestra for dancing.

Mom's friend, Fanny Watts, whose family had hosted her engagement party, was in school at Bryn Mawr and one weekend she came down from Philadelphia to visit. Fanny was a classmate and friend of Polly Longworth, daughter of Alice Longworth, the socialite daughter of Teddy Roosevelt. In a foreshadowing of Mom's later connection to several White House residents, Fanny took her to tea with Mrs. Longworth. They had a nice visit, despite Mrs. Longworth's reputation as an acerbic older lady. Mom chuckled about it later. "At the time, I didn't realize what a rare opportunity that was."

A few weeks later, Mom went to Philadelphia to see Fanny. On the two-hour train ride back from Philadelphia to Washington, she sat with a handsome Marine captain named Toni Castagna. Castagna was headed overseas, and by the time they reached Washington, he had proposed. She had been down that road before and no longer took such suggestions as banter. Declining, she nevertheless promised to correspond with him and gave him her address.

In her telling, Mom would downplay the effect of her own charm. "In those days, men were desperate to have someone waiting for them back home. Couples would meet at a dance and get married that weekend, the day before the man shipped out."

If they had given frequent flier miles for train travel, Mom would have been a member of the platinum club. Just as the exciting social life of wartime conditioned her for going to parties the rest of her life, all her shuttling up and down the eastern seaboard imprinted her with a lifelong attachment to train travel, despite the crowded, uncomfortable conditions: Trains were so crowded, the sleeping cars had been converted to day coaches, but that didn't stop people from sleeping all over the place. People even spilled out into the compartment between cars. On one trip, Mom found herself in the outside compartment talking to soldiers crowded around a concessionaire selling snacks. The concessionaire wanted a break, so he asked Mom to take over for awhile. She recalled the moment as an example of the communal spirit of the times. "Everybody helped, whether they knew each other or not."

Washington was just what the doctor ordered for Flo. As the weeks went by and - contrary to her mother's prediction - there was still no word from Captain Traywick, she let herself be distracted by the energy of wartime Washington.

With the attention from so many attractive men, her confidence began to reassert itself. How *dare* Bo Traywick sail into her life and out again like that? She wouldn't waste another tear on a man who obviously wasn't worth her time, not when she had a host of cadets at West Point and midshipmen at the Naval Academy fighting for scraps of her time, scraps left over from the long line of Army officers who called on her and took her to dinner and dancing at the Shoreham, who took her to plays and parades and football games and glamorous military parties, who sent her telegrams and flowers and bracelets and scarves and who wrote love letters and declared their affection and beseeched her to marry them.

She would not let Bo Traywick so much as cross her mind.

And he didn't, unless she were dancing and the band played "A String of Pearls" or "In the Mood", making her long for the tall

dark officer who turned her so lightly around the floor. Nobody, she thought wistfully, could dance like Bo.

In late September, Mom took the train home for the weekend. Stepping off the train, she saw her father waiting to pick her up. "Hello, Popsy!" she called and rushed to hug him.

On the ride home, her father joked that he was running a taxi service to the train station. After Betty's bout with pneumonia, Ed had encouraged her to rent an apartment in Lynchburg. Although she had her parents nearby for support, it meant long train trips to Philadelphia or New York or Boston to meet Ed whenever his ship was in port. Sometimes she took the baby with her, but most times my grandparents kept her. As a baby and as a small child, Michele spent so much time with my grandparents that ever after they referred to their guest room as "Michele's room".

After Washington, Mom said, Lynchburg seemed like Brigadoon. Beyond the absence of young men, the city was virtually untouched by the war. Life went on quietly and peacefully, just as it always had. Baby Michele was the only reminder that there was a war on, out there somewhere else.

After dinner, as she was getting undressed for bed, her mother called her to the phone. With a little smile at the corner of her mouth, Nana said, "I told you he'd be back."

Mom's heart leaped as she heard Dad's voice crackling over the line between Cameron and Lynchburg, but she kept her voice cool, nervously waiting for him to make some apology for that incomprehensible letter. Dad was friendly but restrained, as though waiting for her to make some overture. But it wasn't up to her to make the first move, so she waited, chatting politely, while he decided whether to apologize or not. In the end, the formality of the conversation prevailed. He said he had orders for China. She wished him a safe journey and he thanked her. There was nothing to do then but hang up the receiver.

Now that she had won the Mexican standoff with Dad—he had reached out first—Mom cheered up considerably. Nana was right, he would be back. She just had to be patient. Meanwhile, there were long lines of men eager to entertain her and, perhaps, win her heart. She cut her hair in a perky new style and lost the weight she had put on in the summer. Once again her scrapbook filled up with dried corsages, dance programs and swizzle sticks from fancy restaurants.

CHAPTER 13

ON A SLOW BOAT TO CHINA
DECEMBER 1942

After the disappointing phone call to Mom in September - She had been annoyingly pleasant: *I hope you'll be safe.* "Damn it," he told the peanut gallery. "That wasn't what I wanted to hear." - Dad went on a dating spree himself. First, before catching a train to the West Coast, he called on the Southern girls he knew. Then, while waiting in San Francisco to board ship, the daughter of a White Russian couple who had fled the Reds a year or two earlier. And then all across the Pacific, Red Cross nurses aboard ship and New Zealand and Aussie girls when the ship docked for supplies. Mom was the last thing on his mind. He was a free man, off to see the world, meet a girl in every port and maybe dispatch the enemy along the way.

Dad approached the trip to China with his customary sense of curiosity and adventure. He had never been on a ship before and found, with his usual good luck, that he would be sailing on an opulent cruise ship.

Late in the evening of December 7, 1942, the first anniversary of the bombing of Pearl Harbor, Dad boarded the former French cruise ship *Ile de France* and set sail from San Francisco with 10,000 enlisted men and a small contingent of officers, Red Cross nurses and other specialty personnel. The ship was bound for Bombay (now Mumbai) where the passengers would disembark and ride the train across the vast subcontinent to their assigned stations. They had been told to expect a trip of forty days and forty nights.

But this was no slow boat to China. Though fleet, the former cruise ship would follow a circuitous route owing to Japanese dominance of the western Pacific: San Francisco to Hawaii, south to Wellington, New Zealand, a southern loop to Perth, Australia, and finally a wide western loop to Bombay on the west coast of India. Even though the cruise ship was faster than any enemy vessel, the captain prudently zig-zagged across the Pacific Ocean. In those days before GPS and satellite communication, the fearsome enemy could be anywhere.

Rather than allowing the *Ile de France* to fall into German hands, the French owners had loaned the vessel to the Allies for use as a troop ship. Modifications were made to the lower decks to accommodate thousands of enlisted men, but with the exception of double bunks in some of the staterooms, the upper decks—"officer country"—were untouched.

Decades later, Dad still marveled that his passage to India was as luxurious as any English gentleman's, given that the vessel remained, in all respects that affected him, a fully fitted-out luxury cruise ship. He and each of the other officers aboard would enjoy, among other perquisites, a suite with a sitting room, a dining room with tablecloths and silverware, and an exclusive upper deck.

"I went over like you would go now," Dad told us.

Here someone in the peanut gallery would snort. *Typical. Bo's Luck.*

At their first stop, in Hawaii, the officers and enlisted personnel had twenty-four hours to look over the railing and contemplate the harbor wreckage at Pearl. Dad's first look at war was powerfully quiet. Silently he and his fellow passengers viewed the destruction wrought on the scenic harbor. Much of the debris on the docks had been cleared away, but jagged sections of the *Arizona*'s superstructure jutted from the water alongside the dock as a haunting memorial. It must have been sobering to look out at the devastation and think of the hundreds of drowned men whose bodies remained trapped within the sunken ship.

After restocking the ship, they took off from Hawaii and went straight south through the windy latitudes known as the "roarin' forties," then turned west towards New Zealand, slogging through high seas all the way. The skipper announced to all aboard the moment they crossed the equator, and 10,000 men crossed that off their bucket list.

On one of his explorations of the ship, Dad found a companionway that led up to a platform in front of the stack. The platform, a sort of a widow's walk, provided access to the huge cylindrical exhaust stack for maintenance workers. It was seldom occupied, and Dad found it provided a fabulous view of the sea as well as a welcome respite from the anthill below.

In preparation for their duties in China, Dad and the other officers met with language instructors twice a day. Learning a language was not Dad's gift, but he dutifully attended class and learned some of the basics. In between language classes, he kept himself amused gambling and chatting up the Red Cross girls down the hall, activities that were more in keeping with his talents. He enjoyed his usual good fortune in both arenas, although the poker pots with $500 tested his nerves a bit.

Although there was no way to mail his letters until they reached port somewhere, Dad wrote his family anyway. On December 22, he wrote a short V-mail note to wish his father happy birthday. His mother handled the letter-writing duties from home, but Dad longed to hear directly from his father occasionally and made no secret of it.

"Dear Daddy, There is no news except that I've seen so much water that I don't think I'll ever be thirsty again. I haven't gotten sick a time tho. I'd like to tell you where I am, but you can see that that's impossible. To pass the time away, I got in a crap game last night and I seem to have had beginner's luck. This letter was initially meant to be a Happy Birthday affair, so many Happy Returns of the day. I think that maybe we might be allowed to walk on land for

a very short while on Xmas day somewhere. I'm growing a mustache and chin whiskers so you should see me. Give my love to all and write me a letter sometimes just for a surprise. Love, 'Bo'"

The *Ile de France* steamed into Wellington on Christmas day. It was a beautiful summer morning and Dad climbed up on the platform and sat there for a couple of hours, watching the foreign port grow larger and larger. He was roused from communing with nature when it occurred to him that a boatload of soldiers would be pouring down the gangway onto the dock, each one looking for a hotel room and a drink, not necessarily in that order. Since he himself desired those very same things, he immediately developed a plan. From his high vantage point, he could see what looked like two or three hotels several blocks inland.

The ship had barely docked before Dad and his buddy, O'Brian, were hustling into town ahead of the crowd. They went inland and found a nice hotel. Then they set out to see what sort of entertainment Wellington offered to handsome young American officers. Their interests were fairly simple.

"Mostly we drank. And…goh-lee, that was a pretty girl! She was from the South Island, and (mumble, mumble) that's all you need to know about her."

Cue snickers from the peanut gallery.

Built on a hillside sloping down to the protected harbor, the Victorian city appeared a lush green with magnolias, lilies and other familiar plants. Roses bloomed in wild profusion every-where. Although it was Christmas day, many establishments were open. Most New Zealanders welcomed their allies enthusiastically, but some resented the well-paid American soldiers sparking the lo-cal girls. A common complaint was that the Yanks were "overpaid, oversexed and over here".

The steady influx of American soldiers passing through New Zealand and Australia on their way to war brought great

cultural change to the land down under. Music and dance steps, cigarettes and dress styles all came as exciting news to the girls of New Zealand and Australia. It turned out to be a transformative period in the cultures of both countries, and officers Traywick and O'Brian did their part to provide the local girls with cultural enlightenment.

The first thing Dad ordered in New Zealand was "a freezing cold glass of milk." *Preparing your system for a couple of hard days at liberty?* the peanut gallery teased.

After the break, the men re-boarded to rest up for their next stop, in Perth, Australia. From there, the *Ile de France* steamed north through the Indian Ocean towards Bombay.

They had been traveling for more than a month, all but a few days of it at sea, when the serious thoughts about life and death and war that every soldier entertains began to intrude on Dad's daily activities. He had gotten used to the roll of the ship and the comical way his legs wobbled when he went ashore. He'd played poker till he was bored. He'd met all the Red Cross girls. He'd played hard on liberty. He'd even learned a few words of Chinese.

Having exhausted the diversions available on a troop ship, he started to think. The platform in front of the stack became his couch as he ruminated about life, the ever-present Pall Mall cigarette his only companion.

It was a turning point in his life. There on the rolling deck with the infinity of sea and sky sweeping away in all directions, beckoning him to choose which way to go, he contemplated his twenty-five years on Earth and committed himself to a path that only the power of world-wide war could change.

At home with the peanut gallery, Dad recalled his thought process well, gazing into the distance as he relived those analytical hours aboard ship.

He thought of his parents first.

He pictured his father treating patients, driving around the county by himself. Even as a young boy of eleven or twelve, Dad had spent many hours driving his father on his house calls. He was tall for his age and looked older—not that anyone in 1930 cared how young he was to be driving a car. South Carolina had just begun issuing drivers' licenses earlier that year, and even then, according to Dad, all you had to do was ask for one. "If you could reach the pedals, you could drive." (When the sheriff came by the house to tell Dr. Traywick about the new requirement for a driver's license, Doc reportedly counted up his household and said, "Well, George, you'd better send us half a dozen.")

The chance to spend time with his father is something every boy prizes, and Dad was no exception, despite the work that was often involved. The most pressing need was usually to change a flat tire. In the 1920s and 1930s, the unpaved roads were full of nails that had worked loose from horse-drawn wagons, and flat tires were depressingly common. In the days before penicillin, any spot of broken skin was a potential threshold for disease. Dr. Traywick could not afford to knock the skin off his knuckles changing a tire or fixing a flat, and he often waited for help to come along. Dealing with so many patients in conditions far from antiseptic, he was bound to keep himself free of infection. Then there was tetanus, a painful, often fatal condition whose victims suffered spasmodic contractions of the voluntary muscles, commonly called "lockjaw." A rusty nail, the rusted rim of a wheel, the jagged edge of a stable latch all might harbor the tetanus germ. The antidote, tetanus toxoid, had been developed in 1924, but prevention was easier and cheaper than treatment, even for a doctor.

Dad speculated that his father would get Tommy Glivins or one of the other boys around town to drive him and fix the flat tires.

He thought wistfully of his momma, a ladylike presence at the dinner table, patient with the help, no matter how foolish or troublesome they were, teasing his sisters with a straight face and

discussing the day's events with his daddy. He was old enough to appreciate the understated humor each of his parents employed and the twinkle in their eyes when they shared an inside joke. It was amazing how well-suited they were for each other. He supposed you always considered your own parents' marriage as the norm, but really, could every couple be as perfectly matched? And happy? How did you find that person?

When faced with a conundrum, Dad was fond of saying, "Let's analyze the situation." He'd pull out a legal pad and draw a line down the middle, titling one column "pro" and the other, "con". He didn't have a legal pad on the catwalk of the *Ile de France*, but he went through the mental motions as he analyzed the search for a suitable wife. "I thought about all the girls I'd ever been with. Rosie. Mary Lightfoot. Billy Clyde Mitchell. Anne. Flo Neher. Bambi Edwards. That White Russian girl. Vicki, in New Zealand. Which one would I want to be the mother of my children? Which one would I like to see across the dinner table?" One by one, he went through the list. Each had her merits. But while he enjoyed the affection of most of those girls, he was drawn to the innocence of only one.

Once again in his story-telling, Dad seemed to relive the experience.

He chuckled as he recounted walking Mom to her room at the Officers' Club and how she had jumped when he ran his fingernail down her zipper. And how she told him "no." No, she wouldn't late-date him the next night. And in Birmingham: No, she wouldn't invite him into her room, even though she had a ring. He loved her spunk. He loved her banter. And man, could she dance! It was hard to believe she was only eighteen.

"So I said, by God, that Flo gal is the one that I want."

And he wrote her a letter. A different sort of letter.

Dad had his pride, but he found it easy to subordinate to his determination to win Mom's hand. And determined he was. He

wrote a heartfelt letter of apology, holding nothing back. Even as he wrote, though, obstacles seemed to appear on the paper below his signature.

Assuming Mom responded favorably, how could he possibly pursue the courtship while he was in China? What would be the status of the relationship? Without a ring to hold them together, could he maintain her affection *in absentia* for the duration of the war? How many years would that take?

Silver goblet from the *Ile de France.*

But Dad was nothing if not optimistic. As he said on so many other occasions, "There's bound to be some kind of way to make this thing work." And he sealed the letter with a cheerful whistle.

CHAPTER 14

GOING TO INDIA

Aside from threats to his personal survival, Dad took most things in stride, even travel to exotic lands like India and Burma. He was curious and observant, exploring the land and the culture, relishing the chance for new experiences without judging them for their pleasure quotient. It was more imperative that they be interesting. Pleasant or not, an interesting new adventure would make a good story later, as was certainly the case with India.

Dad arrived in Bombay in early January 1943, and it's a good bet the romance of international travel was not his initial impression. Leaving the dock, Dad and his wingman, O'Brian, met India head-on by wading through a briar patch of beggars. In South Carolina, he recalled, a man might approach him on the street and say, "Mister Heber, can you loan me a dime?" But here he was beset by hoards of ragged children and hailed by crippled adults, all grabbing at his uniform and crying, "*Bak-sheesh!* Please, sahib! One ana!"

The sight of India's teeming masses of brown-skinned humanity living in poverty amidst the educated white British officers and the British soldiers would have been at once foreign and familiar to a young man from the Deep South. The social order was familiar but the scale was not.

While he had been raised in the economic deprivation of the Great Depression, he had never before seen *want*. In South Carolina in the Thirties, there was no money in circulation, and grown men with families would work for a dollar a day. Still, no

one he knew went hungry. Everybody had a garden, a few chickens, maybe a cow.

But India was suffering a famine at the time. A catastrophic failure of the rice crop (due to disease) combined with the loss of rice imports from Burma, which was now in Japanese hands, resulted in massive starvation across the country.

Dad recalled an R&R visit to Calcutta (Kolkata) and the stunning sight of starving people on the street in front of the Grand Hotel, where he stayed. Every morning a lorry came around and picked up the bodies of those who had died in the night.

Every afternoon, Dad saw hotel employees doling out leftover food to beggars in an alley beside the building. Women, often carrying babies with distended stomachs, would line up in the alley, each one holding a bowl. Hotel employees would scrape plates and pans of leftover food all together into a large trashcan, from which they would ladle a large undifferentiated glop of food—rice, lamb, lentils, potatoes, curry, bread, fruit, cake—into each bowl. Women who carried babies and an empty can received a ration of milk, as well.

However, it wasn't the poverty that made the deepest impression. Dad's take on India could be summed up in one word: "Filthy."

For one thing, the lack of sanitation was appalling. Poor people—which was most of the population—did not have access to indoor plumbing. Nor did they have outdoor plumbing, or any kind of public facilities beyond the odd fire hydrant opened from time to time. They lined up along the railroad tracks or simply walked out into an open field and squatted down. Or they just turned their backs to the road.

For a man of Dad's modesty and dignity, this was disconcerting.

It wasn't just the lack of sanitation that made the country filthy. Free-roaming livestock made many roads and public

places—even the bazaars—into a manure-paved stockyard. Fortunately for all, dried cow pies had value as fuel and building material, and women in brilliant silk saris could be seen collecting cow dung and carrying great woven baskets of pies on their heads.

The old ways are still evident in India. (Kolkata, :

Barely had Dad registered the poverty and the filth than he was exposed to the third indescribable shock of Indian life: the traffic.

In reliving his first taxi ride in Bombay, Dad always shook his head and opened his eyes wide in mock terror. "The cab drivers are all Sikhs, with their turbans, and they honk their horns all the time. Honk honk honk honk honk. You've got everybody in the road at the same time, taxis cabs, bicycles, cows, trucks, women in saris with these great big baskets on their heads, rickshaws. I don't know why they don't have wrecks and people getting killed all the time. They do, but not as much as you would think. The taxi driver inches along then when he sees a hole he mashes on the gas and honk honk honk honk honk. Oh Lord, I was sure I'd be killed before I got to the war."

Dad, it's safe to say, never developed a nostalgic interest in returning to India. He settled in and made the best of his circumstances, absorbing cultural details with interest, but in later years when he recalled his military service and his around-the-world travel, the only place he wanted to revisit was Hawaii—a place where he never even got off the boat in 1942.

CHAPTER 15

RAMGARH AND CLAUDE
1943

Once Dad had made up his mind he wanted "that Flo gal" and abased himself in a letter of apology and affectionate devotion, there was little he could do but wait. The shoe was on the other foot as he anxiously awaited her response. It had been six months since he kissed her goodbye at the train station in Lynchburg. He was under no illusion that she was sitting home pining for him. The ring and the record proved that. Still, he had been surprised to learn, when he called her that night in September, that she wasn't in school, that she was working in Washington. In retrospect, that was discouraging news. He was sure she was having a date every night. Hell, she might even be engaged to someone else by now. He knew it would take weeks to hear from her, if she wrote him at all, so he tried to put it out of his mind and get on with discharging his part of the war: training troops in China.

As it turned out, Dad never made it to China. He spent a lot of time with the Chinese and he learned to speak Chinese, but he never went to China. He spent the best part of 1943 at a military camp in Ramgarh, India, training Chinese peasants to be soldiers. Then he spent 1944 in Burma as a liaison officer embedded with those same Chinese troops as they fought the Japanese, clearing the way for engineers to build the Ledo Road.

The camp at Ramgarh was a huge compound with row upon row of *bashas* housing American instructors and Chinese students, both officers and men. There were training areas, rifle and artillery ranges, mess halls and parade grounds, just like the in-

fantry school at Ft. Benning. It was even hot and dusty. There was no Officers' Club with a band four nights a week, nor college girls visiting from Hollins, but all in all, it wasn't an unfamiliar set-up. Even the prevalence of local labor to fill thousands of support positions must have appeared normal to Dad.

He shared a three-room brick building with two other captains, Gunther Shirley, a Californian, and Robert Kadgihn, who came from Iowa. Each man had a bunk with a frame for the mosquito netting that hung like cobwebs above a thin mattress. Adjoining the main room was a lavatory, and adjacent to that was a little room with a metal tub for bathing. Water for bathing was brought in by an Indian servant—a "bearer"—who heated the water outside. Not that much was needed in the way of heat. The Indian sun threw down fiery pitchforks, and the humidity melted all one's clothes together in a sticky wad.

Their orderly was a boy named K'lute Rham. Unlike his Midwestern and West Coast roommates, Dad was accustomed to dealing with house servants and he handled the arrangements with K'lute Rham, assigning his duties and, mostly, making a pet out of him. The first thing he did was nickname the boy Claude. The second thing he did was express shock when Claude, in the custom of English orderlies, began unbuttoning Dad's shirt in preparation for his bath. After snapping "What the hell are you doing?", Dad told Claude he could undress himself and that all the boy had to do was announce, "Mohster, your bohth is ready."

The Indian people had a history of secure and relatively lucrative employment as servants and clerks during the Raj - the period of British colonization - and family members trained each other for the positions. A small boy, Claude looked younger than his fourteen years, but he was smart and absorbed English readily. He lived with his mother and various other relatives in the little village of Ramgarh and had been trained by an older relative he called Brother Benny.

Claude, who was in his first job as a bearer, looked to Brother Benny for guidance and occasional help with translation. If

one of the three captains spoke too rapidly and Claude couldn't follow, he would nervously say, "Get Brother Benny," and dash away. Benny worked for some other officers, and he would appear in a moment, saying with great dignity, "What is it, sir?"

Dad recognized Claude's quick mind and enjoyed watching him learn, whether it was the English language or American customs. As U. S. soldiers abroad have done in every war in every land, Dad adopted a local child and shared with him the fantastical contents of his American purse. Mindful of the example his parents had set sharing food and other necessities with their own servants, he paid Claude generously, sending him home frequently with a bonus bag of rice or some canned goods from the Post Exchange. He shrugged when his roommates said he spoiled the boy.

After a hot steamy day of training illiterate Chinese troops how to fire Lee-Enfield rifles, Dad enjoyed indulging in his pet project. He took Claude with him everywhere, zipping around on a motorcycle with Claude hanging on behind for dear life and squealing with excitement. Claude rapidly became bilingual and his whole family benefited from Dad's generosity to the boy.

One day Claude came to him and said he was going to Patna for the weekend to get married. Taken aback, Dad tried to dissuade the boy. Claude informed him that his family had arranged the marriage, and that the weekend trip included the wedding only; he would be back at work, sans bride, on Monday. Dad could not get his mind around such an arrangement and did his best to talk Claude out of it, but Claude chose to follow his family's cultural tradition and came back from Patna a fourteen-year-old married man. It was just another reminder for Dad that he was in a foreign land.

Seated: K'lute Ram ("Claude"). Standing L-R: unknown and Brother Benny. (1943)

CHAPTER 16

BRITISH JUNGLE WARFARE SCHOOL
MARCH 1943

In short order after arriving in Ramgarh, Dad was confined to quarters, released, promoted to major and selected for specialized training at the British jungle warfare school in Darjeeling.

Dad liked the military life and excelled at many aspects, as grades of "superior" on his fitness reports attest. He gave serious thought to making a career of it, but ultimately opted for life in the private sector, where success was dependent on his own efforts and not the opinions—and occasionally, whims—of those above him in rank. While there were numerous officers who recognized his abilities and helped advance his career, one or two experiences with small-minded officers soured him.

One such experience occurred in February of 1943 at Ramgarh. Dad had been at the camp only a short time when he mysteriously ran afoul of someone up the chain of command, and he found himself "tied to the flagpole"—restricted to quarters. He was allowed to leave the *basha* only to go to the dining hall.

Dad had a history of flouting authority in college and his early days in the Army, so he carefully examined the record. In this case, though, no item of a remotely controversial nature came to mind. Yet the order restricting him to quarters carried serious implications: the next step might be court martial.

After spending forty-eight hours studying the situation, Dad suspected some kind of petty *schadenfrade* on the part of the com-

manding officer, Colonel Carleton Smith, who had served in World War I and had been treading water ever since.

"When they expanded the armed forces so rapidly in 1940, you had a bunch of old people who were World War I officers, not retired. There wasn't anything for them to do, really, so they sent them off on all kind of assignments that were not troop command assignments. We had several of them at Ramgarh, like Col. Smith, who was the chief liaison officer for the 22nd Division [Chinese]. He should have been retired, you know, but they had to give him a job somewhere.

"His aide, Ken Laney, was a college friend of mine. I outranked most of the officers my age over there, just like I outranked a couple of Clemson graduates who finished school ahead of me. Laney was one of them. He was a lieutenant and I was a captain."

Recalling his anger at the situation, Dad told the peanut gallery, "I'd be damned if I was going to let some leftover World War I colonel sink my career in the Army." Donning his dress uniform, Dad sent his roommate Kadgihn to ask the colonel for permission to come see him. The colonel replied that Traywick could leave his quarters to come to his office.

Sharply turned-out despite the suffocating heat, Captain Traywick stood at attention beneath the ceiling fan and told his commanding officer the truth. "Sir, I would like to know what the situation is. I have no idea why I've been restricted.

The colonel said, "You can't think of any reason?"

"No sir."

On the theory that a good offense is the best defense, Dad politely but pointedly went through the highlights of his military resume for the benefit of the colonel. "I got my military appointment from Clemson in 1939, as a Thomason Act officer. In 1940, I took the course for Rifle and Heavy Weapons Company Officers at Benning. Because of my excellent scores, both on the range and

on the written exams, I was kept as an instructor and promoted by Gen. Theodore Wessels." Wessels was then in Ceylon at the command headquarters for the China-Burma-India theater of war, so that caught the colonel's attention. Now a lieutenant general, Wessels had promoted Dad from first lieutenant to captain while at Ft. Benning.

Dad went on to tell the colonel, "Then I was sent to Birmingham to R&S Command as a weapons specialist. I was temporary aide to Gen. 'Pinky' Bull while I was there." Warming to his cause, Dad made another important point: "There are a lot of officers over here who were just railroaded but I'm not one of them. I came over here by request. They had an opening in China for ten officers who were weapons experts and I asked for that appointment and was given that."

He paused long enough for the colonel to absorb this information and then he said, "I don't know why I was restricted to quarters and I don't know who did it." Although he strongly suspected the colonel himself was to blame, he smoothly offered a face-saving exit: "Sir, would you find out what the story is? Because if I'm in trouble, I need to get ahold of some of my people, like General Wessels, at Ceylon, or General Bull."

The colonel cleared his throat and looked thoughtfully at the ceiling. Then he looked at the captain standing at attention before him. "Captain Traywick, this certainly bears looking into. Let me see what I can do. Dismissed."

"Thank you, sir."

Amazingly, the next day, Captain Traywick received notification that he was no longer restricted to quarters.

Two weeks later, Captain Traywick received word that he had been promoted to major.

In March of 1943, the American command at Ramgarh chose three officers to send to the British jungle warfare school in

Darjeeling: the recently-promoted Major Traywick, who turned twenty-five while he was there, and two other officers, one of whom Dad described as an "older man" of about forty.

Darjeeling is a state in northern India, a herniated lump popping up between the Himalayan nations of Nepal and Bhutan. As it adjoins the Rooftop of the World, Darjeeling might be called the Side Porch, but the Indians call it "hill country." The steep-sided mountains rise abruptly out of the hot, flat fields of tea to cool heights of six-eight-ten-thousand feet. The British took a leaf from the book of the Indian royalty and built resorts—"hill stations"— all through the uplands to escape the merciless heat of the lowlands in the summer.

Like Assam, Darjeeling is tea country, and both states boast endless oceans of tea bushes cropped thigh-high to facilitate harvest of the tender new leaves. Raised among the cotton fields in the Low Country of South Carolina, Dad found the tea plantations with their troops of local labor bent to the harvest a familiar sight.

Pickers harvest tea leaves in Darjeeling. (2011)

However, he was unprepared for the matted jungle slopes rising above the fields, his first introduction to the dangerous, disease-infested, challenging terrain that he would have to train Chinese troops to fight through.

For two weeks, the three Americans and about fifty British officers camped among the giant *dhupi*—pine—trees, learning about jungle camouflage and how to live off the land, cross rushing rivers and deal with unfriendly wildlife. The course opened with a strenuous curriculum of bayonet practice, house-to-house fighting and obstacle courses, all involving live ammunition, with some instructor-added smoke and bombs to simulate the confusion of a

real battle. The men learned about explosives and booby traps, setting up road blocks and fire suppression. The ubiquitous bamboo plant, growing in dense groves, came in for special attention, as the men learned about its value as a strong but lightweight building material. The stalks are hollow and divided into chambers by woody membranes, making them also useful as improvised flotation devices. Additionally, they learned that a stalk of bamboo the thickness of a man's arm would contain water. In country dominated by swamps and marshes of non-potable water, such a factoid might prove useful.

The course concluded with a three-day survival hike in unfamiliar territory, which, Dad told his parents, was "right rugged."

Provisioned with a full canteen, a tangerine, some tea, a little pouch of sugar and a cookie or two, the men were dropped off one by one around the countryside and told to meet on top of a certain mountain, then find their way back to the camp. Dad set off walking towards the peak. All morning he walked through flat, relatively open land, taking a swig from his canteen as the Indian sun grew hotter. Scanning the landscape ahead, he judged which side of the mountain afforded the easiest route up and adjusted his direction. By noon his water was gone and the mountain appeared no closer. He sweated through his long-sleeved fatigues and they dried in the sun. Then he sweated through them again. By early afternoon, the terrain began to close in with swells and tight clumps of tall bamboo. Rhododendron exploding with scarlet flowers formed a gorgeous, annoying impediment. Mosquitoes and strange aggressive flies attacked him. By mid-afternoon, the jungle had engulfed him. He followed a game trail that wound beneath the canopy and applied the lessons he had learned about staying on course without a compass. He noticed with revulsion masses of green leeches, hardly the size of an inchworm, clinging to the leaves along the trail. The blood-sucking parasites waved blindly, reaching for any passing mammal that brushed their perch. Dad checked to see that his pants legs were tucked into his calf-high canvas jungle boots and his sleeves were buttoned at the cuffs.

Spying an open area, he found a cart path winding up the mountainside and ran into a few of his colleagues. As they climbed, they compared notes. All were out of water and hungry to boot. Over the edge of the steep trail, down in a gully about thirty feet, Dad saw banana bushes. Carefully, he climbed down and picked some fruit. He knew what to expect from the wild bananas: lots of big seeds and very little fruit. But it was better than nothing.

It was dark by the time they reached the summit, where they found a maharaja's primitive hunting lodge. Suffering from thirst, the men found water in some rain barrels—water shimmering with mosquito larvae. Recoiling at first, the men reminded each other that mosquito larvae weren't toxic. The adult female mosquito transmits malaria and other diseases through her bite, but the larvae won't hurt you.

They built a fire, boiled the water, strained it through a handkerchief and, of course, made tea. Then they experienced the feeling of having nothing to eat. Nothing to eat after a long day of hiking with no lunch, either.

But there was plenty to keep them occupied until they fell asleep. The hike through the jungle had left the men covered with fat green blood-sucking leeches. As Dad knew from experience, the worm-like parasites would get on his legs and crawl up to his groin, where they buried their heads in the tender skin. The men had all been warned not to pull the leeches off because the head would separate, leaving a bleeding wound. The leeches would, however, respond to mosquito repellant, backing out quickly when they were touched.

The men lacked such civilized amenities on this trip, but Dad and others had come well-supplied with another leech treatment: cigarettes. He fired up and began touching the swollen parasites all up and down his legs, picking them off and squashing them one by one as they let loose. He counted twenty-five that night.

After dealing with larvae and leeches, the jungle warfare school class assigned sentries and slept on the ground around the hunting lodge.

After a thin cup of tea the next morning, the men filled their canteens and headed down the mountain. Dad walked on ahead of a group of chatting officers. Near the bottom of the mountain, the cart path opened up in a flat place and Dad halted suddenly at the sight of a tiger. The huge cat had entered the trail about fifteen yards ahead. A rush of sensations swept through him. The hair on his neck prickled and his heart leaped to alert, while his brain processed the carnivore's non-threatening body language. His first coherent thoughts were: *Look how big that booger is*, and *What a magnificent animal.*

For his part, the cat paid no attention to the men, crossing the trail in a leisurely fashion and vanishing in the jungle.

The men pressed on through the jungle towards the base camp, conferring periodically about their route. They dodged tiny leeches on the trail and made a wide circle around wild elephants in their path. Dad saw another tiger, once again marveling at the size and beauty of the cat.

That night Dad and some of the men slept in a wide creek bed that had a little bit of water running down one side. He found a sandy pit among the gravel and, after de-leeching his legs and taking a turn at sentry, fell asleep. The next morning he awoke to wild elephants drinking from the stream.

While Dad had done a bit of living off the land by finding edible plants he had learned about in class, he hadn't found enough sustenance to offset the physical exertion of the hike. But after two and a half days, his stomach had given up its demands and quit growling.

As the men made their way towards the base camp, they passed a little collection of huts on the side of the road. Out front of one squatted an old man in a loincloth, cooking something on a hibachi. Dad immediately seized the opportunity. Offering the man a couple of rupees, he was rewarded with a bowl. Seizing the mush, he thought: *I don't know what the hell this is, but I'm gonna eat it.*

Sated, he returned the bowl to the old man, noting the distinctive bone structure and mahogany skin color. He wasn't a Hindu, he was from one of the tribal groups that inhabited the region. Dad smiled and thanked him in Hindi anyway. It was the best he could do.

Whatever mush the man had concocted boosted Dad enough to make it through the afternoon and stride alertly into the base camp before suppertime. As usual in tests of outdoorsmanship, Dad acquitted himself well, earning scores of excellent and superior on his fitness report. Armed with a variety of new skills and a deep appreciation of the dangers of the jungle, he returned to Ramgarh to begin training Chinese soldiers in earnest.

And to check the post office.

CHAPTER 17

DATING PATIENCE
SPRING 1943

By New Years Eve of 1942-1943, Mom had become accustomed to dating captains and occasionally chuckled at the memory of her reaction to hearing Bo's rank. She rang in the new year with Captain Paul Miller, Post Adjutant of nearby Bolling Field. She had met Miller on December 21 at a reception hosted by the new Women's Auxiliary Army Corps, a chi-chi event where Mom rubbed elbows with Vice President Henry A. Wallace and Secretary of War Henry L. Stimson. After the reception, Captain Miller took Mom to dinner (Hogarth's) and dancing (Shep Fields' orchestra at the Victory Room). Miller made a serious bid to dominate her time that winter, teasingly introducing her around as "Mrs. Miller" and sending her flowers on a regular basis, but while Mom encouraged him on one hand, she continued to maintain a full dance card of other men.

As the pace of the war effort increased, the pace and tenor of her social life changed. Mom wrote letters daily, corresponding with men who were actually in the war zone, like Captain Harry McCool, a bombardier who had survived Doolittle's raid on Tokyo. More and more she found herself going to farewell parties, high-spirited affairs tinged by the unspoken motto, *Live for today, for tomorrow we may die*. Somehow, the more foolish and high-spirited the men acted, the more it choked her up. *Carpe diem*, she recalled from her study at Hollins of the Roman poet Horace. She lived for today, but what about a tomorrow that might hold the death of so many bright young men?

One such farewell event involved a boozy rendition of "Thanks for the Memories" with poignant replacement lyrics:

Thanks for the memories
Of Mobile Force Reviews
Of orders all confused
Washington dames, Arlington flames, Anacostia booze
We thank you so much.

Many's the time we have feasted
And many's the time we have fasted
Ah well, it was swell while it lasted
There's no harm done – no wars won –

So thanks for the memory
Of dances we've enjoyed
Of times we've been annoyed
We're leaving now but we'll return and when we do–o boy!
We'll thank you so much.

Young women seized the day by marrying their departing lovers, both partners eager to experience the pre-war normalcy of marriage, if only for a few days. Weddings practically became an industry with 1.8 million couples tying the knot in 1942, up from 1.4 million in 1939. As weddings increased, the average age of the participants dropped by a year, to twenty-three for men and twenty for women. But wedding planners, even if there had been such a thing, couldn't capitalize, as most weddings were hasty affairs. After a night or two together, the newlyweds might be separated for months or years. Troop ships didn't wait while men tended to personal affairs. For myriad reasons, Mom and her generation grew up fast.

On February 6, 1943, Mom found herself serving as bridesmaid in yet another wedding. Just as she stood beside her sister Betty when she married Ed Luby, Mom stood beside Pat Collet when she married Dick Neher. Mom tried not to think about her own near-miss and just be happy for her brother.

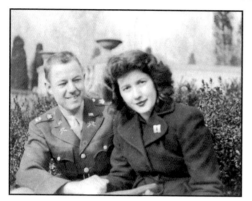

Mom's brother Dick married Patricia
Collet in 1943.

She had pretty well moved on after her romance with Dad, although from time to time she remembered their last conversation, a stiff phone call before Dad left for China. Having now said goodbye to so many other men headed to war, she regretted her formal tone of voice.

But one day in February, she got the precious chance for a do-over. Five months after that phone call, seven months after she sent the ring back, the letter Dad wrote on the *Ile de France* arrived in Washington.

Unfolding the paper, she read, "…I had a right watery Christmas, so this is a belated Christmas card…"

Oh! He was at sea! And where was he now? Was he in China, where he'd told her that night on the phone he was headed? How long had the letter taken to find its way around the world and back to her? A million questions flew through her mind as she read, but they were all answered at the end when he told her he had been wrong, that he missed her and loved her and wanted her back.

Mom read Dad's letter with joy. It was a relief to know the man she loved was big enough to apologize. She had stood strong. She had not called or written or chased after him. She had not in the teensiest way let him know that she missed him, that she cared even a fig about him. He had learned the hard way that a girl like Flo was even rarer, even more precious than he had initially thought.

PART III –
COMMITTED VS. CONFLICTED:
THE SECOND COURTSHIP

CHAPTER 18

LETTERS AND OTHER COMMUNICATION

In World War II, mail call was the highlight of a soldier's day, but troops in remote areas, such as deep in the Burmese jungle, had to make do with air-dropped deliveries at uncertain intervals. This, on top of one-way transit time of two to three weeks, made conversation difficult. Mail to and from Burma was so haphazard that in April 1944, Mom received a carved ivory bracelet Dad had mailed in the fall of 1943.

Sixty years later, in the Gulf War, technology allowed soldiers instantaneous communication with loved ones back home. This was touted as a wonderful way to maintain morale among the troops.

When Dad heard about that, though, he was immediately skeptical. "That's no good," he said. Soldiers have to focus on their job. Being distracted by a wife reporting a broken dishwasher or a bad report card or even tearful I-miss-yous was not, in Dad's opinion, good for morale.

So, instead of communicating by Zoom or Skype, they wrote letters. And if there was a particularly urgent message, they sent a cable.

Just as Dad's letter suggesting they wait to get married has disappeared, his letter attempting to make up is also unavailable. In the text of the short story Mom wrote about "Ellen," the officer she loves writes, "Darling, I was wrong. I never realized I could be so unhappy. Please come back to me. I love you."

We can surmise this was pretty close to what Dad wrote.

Recalling the letters she wrote to him, Dad complained to the peanut gallery that they mostly consisted of accounts of her cats sleeping on the bed or catching mice. He would roll his eyes at the notion of receiving such unromantic letters from the woman he loved.

Mom would smirk. "I didn't think you wanted to hear about my dates at Annapolis."

Dad would feign shock then drop his head in concession. "No." Then he would look sadly across the room. "No. I didn't want to hear about your other dates." Here the peanut gallery would hoot at his martyred response and Dad would say, "There I was, all alone in the jungle, sitting on my bunk reading the Bible."

His faux pain was meant to imply that he spent two years abroad chastely saluting Mom's shrine, but the peanut gallery knew better.

Still, he once said rather plaintively, "I didn't care what she wrote as long as she said 'I love you' and sent me some pictures."

CHAPTER 19

TRAINING TROOPS
1943

Dad could talk to anybody, moving easily from Chinese laborers to the son of the Maharaja of Mandi, from discussing livestock with a dairy farmer to telling a joke to President Gerald Ford.

That easy way with people made him a good instructor, too, holding his students' attention with his commanding personality and his sense of humor. He had a way of breaking down instructional material and presenting it in a logical, accessible way. At Ft. Benning, he trained classes of two hundred men at a time in the proper care and use of small arms—pistols, M-1 carbines, even automatic "Tommy" guns.

But when he faced his first class of students at Ramgarh, he realized he would have challenges he didn't have at Ft. Benning. For one thing, his students didn't understand English. For another, they had not even finished the Chinese equivalent of basic training.

They were the rawest of raw recruits.

When Dad arrived in Ramgarh the first of January 1943, there were 32,000 Chinese soldiers in training. Initially, Ramgarh trained the Chinese who had walked out of Burma with Stilwell, but since many of them didn't make it, China's President Chiang K'ai-shek agreed to send replacements. At the time, the United States was sending supplies and war materièl to Chiang K'ai-shek by air from Ledo, in northeast India. The Himalayas shrink down to normal mountain size there, a mere 10,000 to 15,000 feet, and the airlift came to be known as "flying the Hump." Buffeted by

treacherous weather and violent up- and down-drafts, the cargo planes—mostly the WWII workhorse DC-3s—would struggle over the inhospitable range laden with supplies for the war effort in China and make the perilous return flight to India with a planeload of recruits. With the Japanese controlling Burma, the 500-mile airlift in hideous conditions was the only way to get supplies into China and men out. During the three-year airlift, more than 700 planes crashed along the route through the mountains, leading pilots to call it "the aluminum trail".

Day after day for months, the cargo planes brought in replacement troops for two Chinese divisions, the 22nd and the 38th. When they arrived at Ramgarh, Dad was appalled. "They were the most emaciated, ragged humans I'd ever seen." By agreement among the Allies, the British clothed them and armed them and the Americans fed them and trained them. Dad recalled watching in amazement as Chinese officers barked orders at the recruits, stripped them and burned their clothes, cut off their hair, deloused them and gave them a uniform and a rifle.

Many of them had no clothes to be burned. To save on expenses, the Chinese shipped the conscripts out in nothing but their undershorts. Some of the transport planes had no doors, just an open side for pushing out airlift supplies, so the three-hour flight over the Himalayas was a chilly one.

Fed three meals a day for the first time in their lives, the Chinese soldiers enjoyed an average weight gain of twenty-one pounds in three months.

The Americans also provided two other items that were heretofore unknown to the Chinese troops: medical attention and regular pay. In conflict with Chinese custom, Stilwell insisted on having the soldiers paid individually at roll call, a practice that created tremendous angst among the officers. Back home in China, the officers were accustomed to receiving their unit's pay in a lump sum, from which they took a cut before passing it on to subordinate officers, who made further cuts before distributing the remainder to the troops.

Most of the Chinese, who were conscripted peasants, had never known such luxury: food, clothing, medical care and regular pay. As one illustrative anecdote goes, when the Ramgarh trainees met up with other Chinese troops, the former recounted their good fortune, adding in wonder, "And all they want us to do is fight!"

Initially, as he had volunteered to do six months earlier, Dad trained Chinese troops in weaponry, later adding the jungle training he had acquired in the British jungle warfare school. The British provided Lee-Enfield rifles instead of the M-1 Garand he was accustomed to, but the differences were minor. Although he continued to attend mandatory classes in Chinese, he had an interpreter, too, as General Bull had assured him.

However, he quickly discovered that the interpreter was superfluous. "The Chinese are good mimics. I was always very precise in my routine for handling a weapon, and they learned to imitate my routine perfectly. We didn't even need an interpreter. I could show them what to do and they'd copy it."

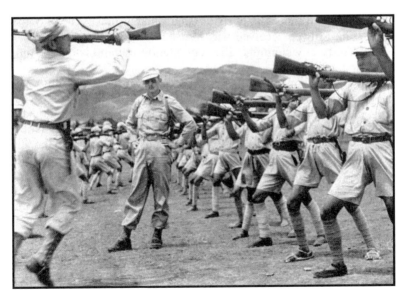

American officers trained Chinese troops at Ramgarh, India. (1943) *(National Archives)*

When he added camouflage, river crossing and jungle warfare techniques to the curriculum, he knew he could simply show the men what to do and they'd copy it.

Periodically, Dad put on demonstrations of his trainees' skills. Usually the audience consisted of the Chinese officers in the camp, often accompanied by American officers. Once a large delegation of Chinese generals and American officers from a sister camp in Yunnan, China, flew in to see a camouflage show and a river crossing.

For the camo demo, Dad sent a platoon of about thirty-five men into an open field. The platoon members, carrying blank ammunition, camouflaged themselves with leaves and grass just before the visitors were ushered to the viewing station.

Assisted by an interpreter, Traywick explained his training methods to the brass, asking them how many soldiers they could pick out. After they guessed one or two, Dad blew a whistle and the soldiers all fired blanks. The officials gasped in surprise when three dozen soldiers shed their disguises and stood up.

The river crossing demo was equally impressive and Major Traywick took great pride in the success of his trainees, accepting the praise of the generals on their behalf.

Not all demonstrations went so well.

Once during a training exercise, the Chinese lost a grenade launcher in the water. They were trying to float the little mortar across on a bundle of bamboo and the raft tilted, dumping the valuable load in the river.

Dad's first thought was, *They'll kill those men for that.* The Chinese could replace a soldier but weapons and supplies were precious. When the Chinese officers needed to discipline a soldier, they shot him or beat him. There was no Chinese brig. The Americans were never permitted to see, but Dad had been told what happened: The offending soldier would lie on the ground and a man would take a bamboo stick and beat him from neck to heels and

back, *whop whop whop*, from one end to the other. "They'd have been a lot better off in the brig, but they didn't have any brig," Dad said.

So, when the mortar went into the river, Dad was shocked into action. He wasn't eager to lose a weapon, but he was more concerned about the human ramifications of the situation. Grabbing a rope, he began setting up a recovery operation.

The water ran swiftly around a little curve at the crossing point. Dad got down in the water to effect the rescue. At his direction, the soldiers tied a rope across the stream, making a taut line. Then they threw a rope across that and tied it to one of the Chinese, who dove down searching for the weapon. The diver, moved to superhuman efforts by the prospect of punishment should he fail, eventually got a hand on the heavy weapon. Clutching his passport to life, the soldier was hauled to the surface by his fellow troops. Recalling the relieved rescue team sitting on the bank catching their breath, Dad shook his head. "That was a close call."

The American officer's obvious concern for the Chinese as individuals was a new and probably endearing thing for the troops. The language barrier made it tough to foster friendships, but Dad took an interest in the Chinese, out of his customary curiosity if nothing else.

One night he and Gunther Shirley wandered over to watch the Chinese opera organized by his troops. Seated on boards set up as temporary seats, they watched the performance unfold on a parade viewing stand converted to a stage. "The Chinese soldiers took all the parts, male and female, and performed a ritualized play with that atonal music, *chung king ying yang bong,*" Dad recalled. Given Dad's limited vocabulary, it was a struggle to follow the plot, but he made sure to applaud enthusiastically and compliment the organizers afterwards. Intentional or not, his effort at cultural outreach won him the respect of the Chinese soldiers and officers.

Dad fell into an easy routine at Ramgarh, working in the morning, knocking off in the heat of the day, playing cards on the

post or exploring the social gathering-places the British officers and tea planters had established around the countryside. One night he tried a club at Ranchi, a town of some size about 20 miles away. There he found an all-British gathering of men, including a few in kilts, and girls who were the daughters of officers or tea planters. His sensitive social antennae picked up the message that the British didn't want the Americans crashing their party, so he looked else-where for entertainment.

Every Saturday night, he learned, there was a dance at Hazaribagh, a small town about twenty-five miles away. They had a club of some sort with an orchestra, and a thirsty officer could get something to drink, such as it was. And there was always sight-seeing. The maharajah of the district lived at Hazaribagh, and on one occasion a group of officers received a tour of his palace. The maharajah's private theater impressed Dad, as well as his private zoo containing ceremonial elephants that were used in parades, tigers and leopards, "the whole nine yards".

One of the few war stories that helps me picture my dad, not as the competent authority figure I had always known, but as a wild twenty-five-year-old boy, involves that quintessential crazy item: a motorcycle.

One day Gunther Shirley, one of his roommates, told Dad excitedly that he had been assigned a motorcycle from the mo-tor pool. Dad decided he'd like to get a motorcycle, too, so they walked to the motor pool.

Gunther's bike had a sidecar. "Come on, I'll show you how to ride this thing," said Gunther, throwing a leg over the seat. Dad got in the sidecar. As soon as they got rolling, Gunther, who had had the benefit of one lesson, twisted the accelerator handle hard and *voom!* The bike took off! As Gunther frantically tried to undo the action, the bike engine whined and the vehicle sped towards the corner of a building. Dad watched helplessly as they headed for a post supporting the roof of a porch. The motorcycle hit the post at full tilt, the bike on one side and the sidecar on the other. With

a bone-jarring crack followed by dusty silence, the bike bounced back and died.

Relieved that the roof had not fallen down on them, Dad said, "Let me outta here," and he left Gunther to deal with the aftermath. *I'm gonna get somebody else to teach me to ride a motorcycle.*

Dad didn't mind driving fast, he just preferred to be the man at the controls. Having been introduced to Indian traffic in Bombay, he was prepared to drive aggressively. The delighted Claude would hop on behind him, holding on for dear life as his *sahib* cranked up the motorcycle and sped down the road.

As the spring wore on and the rainy season began, all life in the camp coasted to a halt in the afternoon. Initially, it was suffocatingly hot, then it became rainy and hot. During the monsoon season, which ran from May to September, life was pretty unbearable. The post was a pool of mud with a froth of steam on top, liberally sprinkled with mosquitoes, gnats and flies. Accustomed to the heat and humidity of the Low Country of South Carolina, Dad did not expect to suffer in the Indian summer, but this was like nothing he had ever experienced. They knocked off work about two or three, and Dad lounged in his quarters as the bloated clouds belched buckets of rain. After the rain fell, the moisture flowed upward, steaming out of the ground and soaking the fatigues of anyone who wasn't already wet from the shower.

But Mom was back in his life, and Dad amused himself by re-reading her letters and day-dreaming about seeing her again. He re-lived the four or five weekends they had spent together, visualizing every moment, every smile, every wave of her long brown hair. Her latest letter, which had arrived in a bunch with others, told him what he most wanted to hear: that she still loved him.

That letter, dated weeks earlier, hit him like an Independence Day fireworks show in the hot muddy camp. Tickled to death, Bo fired off an impudent cablegram in reply: "Very happy to hear from you dearest. Am fit and well. Sorry cannot send money.

All my love dearest." The suggestion that she had asked him for money was a cheeky bit of banter that he knew would make her gasp at first and then have a good laugh.

With Flo practically back in his arms, he impulsively broke things off with an Army nurse he had been seeing, telling his family in a letter, "I've quit my nurse. It's bad over here without girls, but I figure I'm not quite that hard up."

In July Dad found an old copy of Colliers' magazine and read an account of Colonel "Jimmy" Doolittle's squadron of B-25 bombers making a daring raid over Tokyo early in the war. To maintain surprise and avoid the Japanese fleet, the planes left from the deck of the aircraft carrier *USS Hornet* some five hundred miles from the Japanese coastline. Loaded to the gills with ordnance, the bombers had enough fuel for only a one-way flight. They planned to land in nearby China, but only one plane made a safe landing - in Russia. The others crashed or the crews bailed out. Although damage to the Imperial homeland was minimal, the raid's tremendous success lay in shocking the Japanese and lifting the morale of the Allies.

Reading details of the thrilling exploit exacerbated Dad's boredom and frustration and inspired him to consider joining the fledgling Army Air Corps, precursor of the Air Force. Stuck in the mud at Ramgarh, he wrote his parents, "Glad to hear Joe is O.K. [Dad's brother had been in the invasions of North Africa and Sicily at this point.] He's still in on the fun and I'm missing it all—another reason why I may join the Air Corps."

His boredom came to a halt in August when he came down with cramps, nausea and diarrhea. He quickly became incapacitated, certain that he suffered from the dreaded, pervasive, recurrent malarial fever. However, he was diagnosed with the equally dreaded amoebic dysentery. The cure involved a ten-day course of emetine and sulfa drugs. Emetine was a powerful but toxic drug derived from ipecac roots. While effective against dysentery, excessive use led to heart damage. Because the poison accumulated in one's system, patients were limited to two full courses of treat-

ment in a lifetime. In the confines of the infirmary, he wrote Mom about his condition and treatment. It had been several weeks but he had had no word from her since sending off the flippant cable. In fact, as he complained in a letter to his parents, he hadn't received a letter from anyone since the first of August and "my morale needs a pick-up." He hadn't heard from his parents or his brother or his application to the Air Corps or, worst of all, his girl. In his weakened condition, he succumbed to worry—and jealousy— sending Mom a cable as soon as the hospital released him: "No news of you for sometime, darling. Please write or telegraph."

Happy at first that the barrier between them was down, Dad fretted that he couldn't consolidate his position. When at last a letter arrived, among the pages of news about Mom's cats was the passing mention that she was visiting her brother and sister-in-law. Dad knew Dick was at Ft. Benning, and he had no illusions that Mom was limiting her social life to tea with the ladies. It was discouraging to think that he hadn't seen her in a year, and he still had to go fight the damn war.

CHAPTER 20

FLO'S NEXT MOVE
SPRING & SUMMER 1943

In the spring of 1943, Mom was feeling about as good as a girl could feel, given that the number one man in her life was overseas. Dad had written to repair the rift, which gave her the upper hand, on top of which she had plenty of men to take her dancing while she and Dad sorted things out.

But nothing stays the same in wartime. The Pentagon decided to reassign her brother Dick's unit to Ft. Benning as demonstration troops for the officers' candidate school. Benning was, at the time, turning out a class of second lieutenants every week, officers who had been trained on an accelerated program, the so-called "90-day wonders."

Dick left for Georgia with his unit after asking Mom to drive his new bride, Pat, south in his car. My grandfather Pop contributed some gas ration tickets and a ticket permitting them to purchase two tires, and on April 26, they set off. Mom managed to get a couple of days off from work for the drive and the return trip by train.

The sight of Ft. Benning flooded her with memories—fond memories, now that she and Dad were corresponding. As they drove around the post, Mom showed Pat significant historical and romantic points of interest, happily reliving the heady days of the year before. Pat must have been curious that Mom lingered in the parking lot of the Officers' Club. *You cute little thing, you. You're just about what I've been looking for. What do you think about us getting married?*

Two weeks later, shortly after her nineteenth birthday, Mom told her boss at Lend-Lease that she was leaving. John Miles, Chief of the Statistics Branch, immediately wrote Pop, letting him know how valuable Flo was, in the obvious hope that her father would encourage her to stay. Miles included a copy of Mom's "Excellent" fitness report and wrote in part, "Your daughter ably fills the position she holds and does work of a type where replacements are very difficult to procure. She is engaged in confidential statistical work necessary to the successful operations of one of the most important war agencies and should she leave we would feel it a considerable loss."

But Mom had made up her mind.

The visit to Ft. Benning almost certainly played a part in her decision. For one thing, Dick's departure from Washington limited her access to the Officers' Club at Ft. Myer. Many of the men she knew had shipped out, and social life in Washington had slowed down. In addition, June Week at the Naval Academy was approaching and the graduation festivities would include a final celebration with many of her friends, a last chance to hug the boys who had suddenly become the men who had to save the country. Plus, Dick and Pat had invited her to visit them at Ft. Benning. Lounging around the pool, even in Georgia, sounded more appealing than working in a sweltering office through the hot, humid Washington summer. As much as she would miss her girlfriends in the office, she was ready for a new situation.

Famous among Mom's girlfriends was Shirley, whose sad tale Mom recounted dozens of times as an object lesson to me. Shirley's fiancé, Bob, was overseas, and Shirley had practically withdrawn into a convent as she waited for his return. After two years of twisting the engagement ring on her finger and waiting faithfully, Shirley was devastated to learn Bob had dumped her for another girl.

Mom was torn between sympathy for Shirley's pain and annoyance that the girl had so foolishly put her life on hold for two years. The girls had all lost men they knew in the war. "It was a sad

reality that the man you loved might not come home, and even if he did, he might not come home to *you*," Mom frequently said. As much as Mom wanted to give herself over to the pleasure of being in love with Bo, Shirley's story was a fresh reminder of the risks, and she held back a piece of her heart.

Mom went to June Week at Annapolis with Julian "Jay" Arnold and danced and flirted with the class of '44, graduating a year early under the War Department's accelerated program for producing officers. The class of '43 had already graduated in January, six months early. The celebration took on a bittersweet, frenzied feel. She knew so many boys in the graduating class. With war raging all over the globe and the outcome still in doubt, the thought hung over the young men and women that many of them would never see each other again. Many of the dashing midshipmen in their crisp white uniforms would never come home. And which ones would they be? Mom wanted to hold onto every one of her friends. "I saw everybody, really, and got a real good rush [of attention from different men], surprisingly enough," she wrote next to a pressed corsage. "Though I had a program, we didn't bother to keep any of the dances…Don [Wyckoff, another beau] kept watch on me, the old cutie!"

After graduation, the lovelorn Jay Arnold followed Mom to Washington to propose, but by now she had a well-rehearsed response to marriage proposals. She gave him a flattering non-answer, leaning heavily on the war and the military prohibition against marriage for two years following graduation.

Three days later, she taped the party scraps from June Week onto the last page of her 1942-1943 scrapbook. Her final comment reflected the tumult of the previous fourteen months as well as the often-contradictory mix of emotions the war created: "So ends another year. It started with one tall dark man and ended with another. Oh well—c'est la guerre! And am I sick of it!—although I've gone more places than ever before because of it and met more cute men. I only hope next year is as happy and successful as this

has been and that my many scattered friends are safe." - June 12, 1943

It had been an emotion-packed twelve months. Mom wasn't exactly jaded, but she thought she had learned the rhythm of war-time.

But nothing stays the same in war.

CHAPTER 21

LOVE AGAIN AT BENNING
SUMMER OF 1943

After catching up with her girlfriends who had remained in Lynchburg, Mom took off on July 25 for an extended visit to her old stomping grounds at Ft. Benning. Dick and Pat provided a bed and a ticket to dances at the Officers' Club, where Mom succumbed to a bittersweet feeling of *déjà vu*. Everywhere she went, the sound of Bo's banter and the flash of his smile followed her. In a rush of romantic nostalgia, she wrote him and told him she loved him. She smiled to herself, imagining his face when he read her letter and wondering how long it would take for an answer.

Meanwhile, she'd pass the time dancing at the Officers' Club. It was summertime in the South—"hot as Hades" she noted—and as Dad had told her, the O Club doors to the terrace stood open at night. Japanese lanterns cast a romantic glow over the terrace and made squiggly reflections in the water as the band played for dancers around the apron of the pool. Mom seldom finished a dance with her original partner, as men lined up to cut in and claim her attention for a verse or two.

One night she was surprised to find a tall, black-haired lieutenant colonel cutting in. Protocol dictated that a man be introduced to a woman before he presumed to cut in on the dance floor.

"I apologize," the colonel began as he gracefully guided her alongside the pool, "but I haven't been able to get close enough for an introduction all night."

Mom smiled at the compliment.

"My name is Steve Thornton."

"I'm Flo Neher," she said with a smile, "and I'll forgive you."

He artfully led her away from the other officers lurking around, looking for an opportunity to break. Like Bo, he led with authority, allowing her to follow his steps easily. His body language and his colonel's oak leaves kept the other, junior officers at bay, allowing him to finish the song without anyone cutting in.

Mom found him easy to talk to, interesting and attractive, clearly a man accustomed to being in charge. She did not recognize the insignia on his uniform. When she asked about it, he replied, "I'm in the OSS. Office of Strategic Services."

Established in 1942, the OSS was the forerunner of the CIA, the centralized agency whose mission was intelligence-gathering. Steve was a spy. He parachuted in behind enemy lines, arranged missions for the French Resistance, picked up information on the Germans and then, with the help of his contact, a French girl named Violet, sneaked back to Allied territory.

Laughing about it later with the peanut gallery, Mom said she took him for a desk jockey, a stateside planner directing some aspect of mobilization for war. But she tried to act impressed while she fished for information about what he did, lifting her eyebrows to convey her utter fascination. "Really?"

He seemed surprised. "You've actually heard of us?"

This was not how the conversation was supposed to go. He was supposed to say, "Yes, really. And I count paperclips," so she could ooh and ah over him a bit. Now she was out on a limb. "The OSS is an important part of the war effort," she said. Everything was an important part of the war effort, even agencies that planned how many crates of C-rations to ship to Burma, or whatever the OSS did. "Where are you focused?"

"I've just come back from France."

"*France?*" France was in German hands. "What did you- ?"

"Oh, I went over to see a few of our friends in the Resistance. Took a little tour of the countryside. Don't look so surprised. We have a lot of friends there."

Mom wasn't easily impressed by a man in uniform anymore, so it was pleasant to find herself listening to every word this one said.

Steve couldn't tell her much about his missions, but that secrecy only served to make him more glamorous. They danced a few more dances, with Steve careful to break back and collect her again at the end of each song. As the band packed up at midnight, Steve made a date for dinner the next evening

Over the next few weeks, Mom found herself waiting for Steve Thornton's calls, and he didn't disappoint her. When she learned he was twelve years older, she was at first dismayed, but the feeling was quickly replaced by the pleasure of being with a grown man who knew how to treat a girl. She'd been out with other older men but none since Bo who gave her that tingly feeling as Steve did.

Although Dad had no way of knowing it, his worst nightmare was being realized: Mom was falling in love with another man and he had no way to compete. Fortunately, there were still other men around to distract her.

The weekend of August 7, in between dances at the O Club and dinners with Steve, Mom rode the train to Daytona with a girlfriend to see Don Wyckoff, an old beau and rival of Jay Arnold's from the Naval Academy. As she packed to leave, her sister-in-law shook her head in awe. Pat had watched Mom go out with Steve Thornton two or three nights a week and now she was going to Florida to see an ensign and all the while she was writing letters to a major in Burma whom she professed to love! To Pat, a sheltered girl schooled in a convent, Mom's social schedule must have been

hard to fathom. How could she juggle all those men in her own mind?

But Mom had Nana's rules and the example of Shirley and Bob to guide her. "What if Bo meets some Army nurse in India and never comes home? I can't just sit here and hope he comes back one day in five or ten years when the war is over."

Privately, though, Mom had learned to compartmentalize her love life. She kept the precious velvet-lined box that held her affection for Dad over in a corner, a bright corner to be sure, but still an angle of her heart unto itself. Meanwhile, the nineteen-year-old, single-girl side of her emotions roamed casually among the multitudes of men who paid her court on their way to and from war. It was as if she had two separate lives.

After a delightful weekend with Don, she returned to Pat and Dick's house in Columbus to find a cable from Dad, a typical bit of cheekiness:

"Very happy to hear from you dearest. Am fit and well. Sorry cannot send money. All my love dearest."

Grinning, she pasted the cable in her scrapbook with a note: "He's so wonderful! Doesn't he sound happy? He'd just gotten my letter saying I still loved him."

Almost immediately, she learned that he was in the hospital with amoebic dysentery. They were giving him daily shots of some powerful drug, causing her to worry as much about the medication as the illness. She dashed off sympathetic, affectionate letters and was dismayed to receive a cable a couple of weeks later: "No news of you for sometime, darling. Please write or telegraph."

The frustration of the mail.

Still, worry about Dad didn't seem to interfere with her relationship with Steve Thornton. Around the middle of August, Steve took Mom home to meet his family in Milledgeville,

Georgia. Steve came from a prosperous family with a horse farm not far from Augusta. His mother trained Standardbred horses for harness racing, and the farm boasted stables, fenced paddocks and a training track. Whatever she felt for Steve, Mom absolutely fell in love with the Thorntons' big clapboard house with the long porch and the beautiful furnishings. Years later she could still describe in detail her own accommodations in a charming guest cottage with a canopied bed and a fireplace. The weekend was magical. Steve's family welcomed her, and she delighted them in turn. Steve enjoyed her obvious pleasure in the farm and the horses and seemed reluctant to take her back to Columbus when the weekend was over. Although he couldn't claim her every night, Steve saw her as much as she let him in her last weeks at Benning, taking her dancing, of course, and one night to Riverside Driving Park outside Columbus for an evening of harness racing.

On August 29, Steve took Mom to dinner at the O Club with Pat and Dick for her last night at Benning. After dinner, they danced around the pool. As on the night they met, other officers made bold to break and dance a few bars with Mom. As was customary, Steve invited Pat to dance. When she declined, he sat down to wait for Mom.

As Mom returned to the table, she heard Steve say something about "fighting through all the men around Flo." Then, to her horror, she heard Pat's distinctive accent as she laughed and said, "Oh these are nothing. The one you have to worry about is the major in India she's waiting for."

Mom's charm was to make each man she was with feel that he was number one on her hit parade, so Pat's remark—if taken seriously—would undercut her position with Steve. She hastily glossed over the comment. "Pat's right. You'd better be worried," she teased. "Plus there's the captain in Italy and the lieutenant in England. I'm writing to lots of men overseas. Isn't that a girl's patriotic duty?"

"Absolutely," said Steve, but she wasn't sure he was convinced.

Later, as he kissed her goodnight, he said, "When will I see you again?" It was a rhetorical question. He was going overseas again soon, a bitter moment of déjà vu. *Not again.* They agreed to meet in Washington before he deployed.

Mom returned to Lynchburg with a suitcase full of mixed emotions. She was afraid to let herself fall in love with Steve. After all, he had never proposed, even jestingly. He was clearly quite serious about her, but she sensed that he was holding back. Maybe the twelve years' age difference restrained him. Maybe the prospect of another overseas mission was a barrier. Maybe he took Pat's comment seriously—although her dating coach, Nana, dismissed that theory. "If he's serious about you, he won't worry about competition from another man, especially one who's overseas. And if he's afraid to fight for you, you don't want him anyway."

Trust Nana to put things in perspective.

She *was* waiting for Bo, sort of. It wasn't a commitment, it was more a case of not meeting anyone else who could take his place. But Steve had many of the same qualities that attracted her to Bo: the sense of command, the casual but authoritative way he led her on the dance floor, the way he made her laugh as they walked around the horse farm, and, presumably, the shiver when he kissed her.

She fretted over the future of their relationship, debating between Steve and Bo.

What if she renounced Bo and Steve still didn't propose? What if Steve did propose and Bo came home?

CHAPTER 22

THE LEDO ROAD

The purpose of the Burma campaign was to open up a landline to our ally, China, which was being supplied by a daunting and inefficient airlift over the lower end of the Himalayas - itself the fascinating subject of numerous books and memoirs. The landline was a road, beginning at Ledo, a village in Assam, India, passing through the jungle and over the mountains and rivers to Lashio, Burma, there to join an existing cart track over more mountains and rivers into China.

Construction of the Ledo Road, often called the Stilwell Road or Pick's Pike, was one of the major engineering projects of the twentieth century and certainly the greatest engineering feat of the war. The Burma campaign was launched to clear the Japanese out of the way for the road.

The daunting logistics of building the Ledo Road demanded incredible endurance by men under appalling siege by weather, terrain and wildlife and led to repeated stories of bridges laboriously built and instantly destroyed by torrential flooding or whole sections of road washed down the mountainside.

Assam is an Indian province beyond Bangladesh, in the far corner where India meets Tibet, China and Burma. Assam and north Burma are jammed together by the crushing embrace of the Himalayan Mountains. The Brahmaputra River flows out of the Himalayas south through Assam. Two other major rivers, the Irrawaddy and the Salween, come ripping out of the same part of the Himalayas and flow through Burma, cutting deep canyons through

Gateposts at the old Ledo runway from which
planes left to "fly the Hump" with supplies
for China. (2011)

The Stilwell Road/Ledo Road was built
through daunting terrain. *(Photo by
Daniel Novak, US Army)*

jungle-covered, mountainous ribs running every which way: Patkai Bum, Kumon Bum, Sangpang Bum, the Naga Hills, ranges with peaks reaching as high as 10,000 feet in places.

The average yearly rainfall in Assam is 140 inches, most of that confined to the monsoon that begins suddenly and predictably in the middle of May and tails off in October. Monsoon showers are intense, falling sometimes at the rate of fourteen inches in twenty-four hours. The weather pattern across the border in north Burma is the

same. The heat is terrible, the insects carry painful fatal diseases, tiny poisonous snakes can kill you in twenty minutes, and if that isn't enough, there are all sorts of skins sores and jungle rot that thrive in the fetid, humid conditions.

Dad spent several months in Ledo, Assam before the invasion and later recuperated from amoebic dysentery and malaria there.

A remote coal mining village surrounded by vast tea plantations, Ledo was the railhead, the end of the road, the jumping off place for the second Burma campaign. All the supplies and soldiers for fighting the jungle campaign went through Ledo. All the materials, equipment and labor for building the Ledo Road went through Ledo. All the massive logistical support necessary to conduct a war in the China-Burma-India theater of war went through Ledo.

All these people and materials arrived on the Brahmaputra Barge Line, the Assam-Bengal Railway or the military air carriers using Dibrugarh Airport. Much of the gravel necessary to build 478 miles of road was shipped in. Hundreds of steel bridges, including sections for a 1,100-foot bridge over the Tarung River, were shipped in. The monsoon conditions required thirteen culverts per mile to handle the immense runoff without washing the road out, and they were all shipped in. Fifty thousand Americans and 30,000 Chinese laborers and Indian peasants worked on the road. They, too, came through Ledo.

Stilwell Road, mile marker zero, c. 1943 *(Photo by Daniel Novak, US Army)*

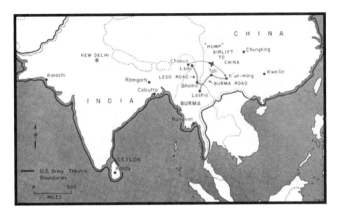

There was a hospital built at Ledo, the 20th General Hospital, to take care of the casualties of the campaign. A field hospital, the 14th Evac Hospital, similar to the M.A.S.H. units of later wars in Southeast Asia, went up fourteen miles out on the Ledo Road. Next to the 20th General Hospital was a landing strip for the little L-5 planes that would bring in the worst casualties from the battle zones. Training facilities, parade grounds, motor pools, mess halls, quartermaster centers, headquarters and administrative offices were established all along the first fifteen or twenty miles of the road to Burma. In addition to the medical personnel, the engineers and the troops providing logistical support, thousands of civilian laborers and civil servants were camped in the area. Finally, there were the men who would actually go into the jungle and shoot Japanese: the 22nd, the 38th and the 30th Chinese Divisions that Dad helped train, some 30,000 strong, as well as a million and a half U. K. troops and small groups of guerillas and other irregular units.

This was the vast military complex that Dad passed through on his way to war.

CHAPTER 23

WILD HORSES AND DRUNKEN LIEUTENANTS
OCTOBER-DECEMBER 1943

In September 1943, Dad received orders to leave Ramgarh and go to Ledo, the staging point for the Burma campaign. He was to be embedded with the 66th Regiment of the 22nd Division of Chinese troops - the men he had been training.

When he broke the news to his orderly, Claude, the boy was devastated. Despite the cultural chasm between them, Claude was devoted to Dad and begged to be taken along. Dad had to refuse but assured him that captains Kadgihn and Shirley would continue to employ him.

It was a touching moment for Dad, who often recounted the conversation. "Mohster, when you leave, I gonna cry," Claude said in his Anglo-American-Indian accent.

Dad smiled and said, "I don't want you to cry, Claude."

One day shortly before he left the training camp, Claude approached him again and said, "Mohster, when you leave my mother gonna cry."

Dad understood the boy and his family were sorry that he was leaving, not only because of their personal attachment, but because he had been feeding the whole family. The famine continued to ravage that part of India. With the image of starved corpses in the streets of Calcutta fresh in his mind, Dad thought a few bags of rice for Claude and his family were little enough to contribute. He urged Kadgihn and Shirley to continue the largesse.

The day he got in the jeep and left, Dad was touched to see Claude, his mother, Brother Benny, Fust Cousin and five or six others lined up to wave goodbye.

The 66th Regiment arrived in Ledo at the end of the rainy season. They were sent out to an encampment eighteen miles east of Ledo along the Ledo Road. Engineers had begun working on the road in December 1942 and had recently crossed the Burmese border, forty-three miles out from Ledo. They had crossed 4,500-foot Pangsau Pass and were headed for the impenetrable jungle of the Hukawng Valley. Stilwell had sent the 38th Chinese Division forward to protect the construction crews and to begin clearing the enemy out ahead of the road construction.

As the 66th Regiment settled into the encampment, Chinese laborers built bamboo *bashas* for the officers to live in. They built Dad a private bungalow with a raised floor and a bamboo roof. Dad furnished his quarters with his foot-locker and several big bedrolls. Inside the footlocker, relatively safe from the dampness, lay his dress uniform and a few personal things, such as a record player and a little cache of letters from Mom and his family. With his jeep parked outside, his *basha* became practically an American homestead.

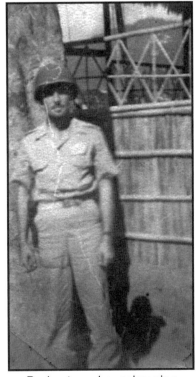

Dad sets up housekeeping in Ledo. (1943)

Dad's opposite number for the 66th Regiment was Colonel Ch'en. The Chinese officer was rumored to have been a warlord back home, an independent operator who recruited his own militia and exacted loyalty from the local residents. As regimental commander, Colonel Ch'en was, in a sense, Dad's host. He was expected to provide for the liaison officer's comfort and security. For instance, whenever

the troops camped in the jungle, the Chinese would make a dugout or build a *basha* for Dad, just as they did for their own officers. A Chinese orderly would wash his clothes and make sure he shared in whatever food the Chinese officers had.

For their first meeting, Dad brought along Major Wang, who would be his interpreter for the duration. With Ch'en nodding approvingly, Wang relayed to Dad the information that a detail of ten men had been assigned as his bodyguard. Dad's poker face came in handy as he considered what a nuisance it would be to have ten men worrying about him all the time. But he was well aware what sparked the offer: Ch'en would lose immeasurable face if anything were to happen to his American guest. Matching Ch'en's nod, he replied, "That is very generous of the colonel but I can't accept that. But thank you for your thoughtfulness."

Ch'en stopped nodding as the interpreter relayed Dad's refusal. "But I insist. It is for your safety."

Now Dad was nodding. "I'm confident the regimental troops will provide all the security I need."

On the other hand, he graciously accepted the orderly Ch'en provided, an untrained recruit named Sin Neet Tsu.

Meanwhile, General Stilwell's headquarters assigned Dad staff initially consisting of three lieutenants to serve as liaisons with the regiment's three battalions and a communications team of four or five men. Beyond assembling his staff in preparation for the invasion, Dad had little in the way of duties. There was nothing to do eighteen miles from the base of activities at Ledo, and he and his officers would go to Ledo when they could. The handiest entertainment centered around the 14th Evac Hospital at Milepost 14. Dad soon developed a friendship with a nurse from Shreveport named Moselle May. While he was delighted to have female company nearby, the gentleman in him had reservations about the conditions the women lived in. He was still upset about it years later, telling the peanut gallery, "That was no place for a woman. They should have sent them back to the 20th General Hospital."

One evening Dad and Lt. Smith, one of his battalion liaisons, took the jeep and went to see Moselle May and the nurses. They brought along Dad's record player and his limited supply of records, as well as a bottle of Canadian Club. Officers were issued a monthly ration of a bottle of whiskey. While the stock varied, Dad said, it was always good quality. The men and the nurses had a rollicking evening, dancing and drinking, before the two officers headed back to their *bashas* in the jeep. Dad had a comfortable buzz, but Smith seemed to be pretty tanked up.

On the drive home, Smith suddenly threatened to shoot Dad. Both men, as was customary, wore their side arms - a .45 pistol. Never one to take a death threat lightly, Dad mashed on the accelerator with the intention of jerking the wheel and throwing Smith out. Just then the lieutenant laughed and said, "I'm just kidding."

It was a hairy ride home, with Smith alternating between laughter and threats of sneaking over to Dad's *basha* later to shoot him. Years later, Dad clearly remembered his orders to Smith when he dropped him off: "Lt. Smith! Lemme tell you something. You better get in the bed and sober up. And lemme tell you something else. If you come over near my *basha* tonight, *I'm* gonna shoot *you*. I'll see you coming. Let's get this straight. I'll shoot you."

Dad slept lightly the rest of the night, although he was pretty sure Smith had simply passed out. The next morning Smith apologized, blaming it on the whiskey, but Dad was not amused, ordering him to give it up.

After that, Smith did his job with his battalion to

Mules (shown here) and horses played a vital role in transportation in the CBI. *(Photo by Daniel Novak, US Army)*

Dad's satisfaction, but the event had put a damper on his interest in double-dating with the young lieutenant any more. Barely had he put Smith on notice than Dad had another hair-raising experience.

Just across the Ledo Road from his *basha* there was a huge parade ground. One day he was surprised to see a herd of several hundred horses kicking up a cloud of red dust. An accomplished horseman, not to mention a bored soldier waiting around for the campaign to begin, Dad naturally took an interest in the diversion offered by the arrival of a herd of horses.

Accustomed to quality bloodstock, Dad was disappointed to see that the Australian pack animals were wiry little stock ponies, their hips and spines pointing up the rigors of travel from Down Under. After awhile though, he noticed a bay gelding that moved pretty well and wasn't starved to death. The wranglers brought the pony over for the major's inspection.

Looking him over, Dad nodded. "You got a saddle of any kind?"

"Yes sir, Major."

After adjusting his six-foot frame on the little horse, Dad found the animal was a decent mover and a pleasant ride. Delighted to have the unexpected opportunity to ride horseback, he called for "his" horse whenever he had a free afternoon.

One day Sin Neet Tsu brought him a different horse. It looked very much like the first one, but it wasn't the right horse. Dad expressed his disappointment to Neet Tsu, who tried to convince him it was the same animal. Finally, he agreed to try the horse.

Although broke to packs, this particular horse was untrained to bit and bridle and had never been ridden before. The sudden weight of a man on his back felt like the attack of a mountain lion, and he reacted accordingly. Dad barely had his leg across the horse's back when the animal took off running.

In a rare stroke of bad luck, Dad had decided to take a ride while the Chinese were drilling on the parade ground directly across the road. The parade consisted not of marching troops but Chinese soldiers driving trucks and jeeps. The Chinese, most of whom had never seen a mechanized vehicle prior to arriving in India, were earnest if not terribly experienced drivers. Furthermore, they knew—and Dad knew—that if they deviated from their assigned track for any reason, they were just as likely as not to be shot by their own superior officer.

So it was not a good sign that, when the horse took off, he headed for the parade ground. No slouch on a horse, Dad shortened up the reins and tried to pull the horse to a stop. He sawed ineffectively on the horse's mouth with the plain bit as the frightened animal raced wildly towards the column of trucks. Despite the horse's small stature, he was wiry and tough and terrified.

Dad, while not technically terrified, experienced a heightened sense of awareness as the runaway horse charged towards the line of trucks on parade. He pulled the horse's head practically back into his chest, to no avail. The panicked animal plunged into the ranks of trucks and half-tracks, tearing around the roaring vehicles in the rosy cloud of dust. Dad knew the Chinese drivers would make no effort to slow down or turn to avoid him or the horse. When the Chinese were told "Go. Follow that truck in front," they were going to follow that truck, even if an American officer fell off a runaway horse in front of them.

I am not going to get killed by some damn pony on the Ledo parade ground, thought Dad as he wrapped his legs around the frenzied horse and rocketed through the rows of trucks.

Miraculously, horse and rider emerged intact on the far side of the column. He managed to steer the horse, still in a dead run, into a grove of trees, where, at last, the animal slowed down enough for Dad to throw himself off.

Swiping the dirt and leaves off his fatigues, an angry Major Traywick led the unbroken horse back to the remuda, where he had

some choice words for the wrangler who fetched him the wrong animal. Furthermore, he told Neet Tsu, "I'm going to have somebody's neck if they ever pull something like that on me again."

Sin Neet Tsu's sullen attitude about the horse was the last straw. Although Dad found the orderly disagreeable, he worried that complaining to Colonel Ch'en would lead to brutal reprisals for the man. Eventually, through his interpreter, he conveyed the notion that Sin Neet Tsu was a fine person but perhaps not orderly material.

The next candidate turned out to be excellent orderly material.

Wu Tsa Mien had been a teacher in his village and teachers were generally exempt from the draft. But Wu Tsa Mien had been recruited with the butt of a rifle. Over the years of internal strife in China, whenever troop strength ran low, the warlord-in-charge would send a detail of men into the nearest village to draft a few volunteers. Wu Tsa Mien was caught in the dragnet, and when he pointed out his occupational exemption, the recruitment officer knocked his front teeth out with a rifle. Once the situation had been clearly explained, he decided to go along with the program. He was therefore grateful to have the opportunity to escape the infantry ranks and serve as an American officer's orderly.

And Dad was delighted to have him. As he had with K'lute Ram, Dad Americanized his orderly's name—Sam Wu—and spoiled him.

Between wild horses and hard-drinking lieutenants, Dad was beginning to think he wouldn't live long enough to go to war. However, the powers that be finally gave him something constructive to do, and he got back to the business of preparing for battle.

He took several units from the 66th Regiment back through Ledo and south to Tirap for ten days of jungle training and demonstrations in the hills. He was in a particularly good mood. The field training exercises provided a break in the monotony, plus he

relished the teaching opportunity and the chance to show off his well-trained troops to visiting dignitaries. And on top of that, glowing in his wallet was a warm letter from Flo and some really hot pictures of her in a bathing suit. When the photos had arrived a few days earlier, Dad's colleagues whistled in admiration.

"You know," he mused, "it's a sin to send pictures like that to somebody overseas in the jungle."

During the demonstration exercises one day, Dad had to jump into a fast-flowing mountain stream to rescue an overloaded soldier. Having saved the embarrassed soldier, Dad turned his attention to his wallet, soaked from his swim. Ignoring the observers, he took the new pictures of Mom out of his wallet and carefully laid them out to dry.

Confident that he and Mom had made up and the engagement was on again, Dad wrote that he wanted her to have a ring. He was under the impression his mother had returned the original to the jeweler in Orangeburg, so he asked Mom her thoughts on a ring. Despite the unhappy associations with the original, Mom told him she thought it was beautiful, and he made plans to replace it - part of his ongoing campaign to maintain his position at the front of the line for Flo's hand.

Having an engagement ring on her finger would, Dad hoped, cut down on her trips to the Officers' Club at Ft. Benning.

With his engagement firming up and his troops ready for combat, Dad turned his attention to the second Burma Campaign. After a year overseas, he was ready to get in, get the job done and get out.

His unit had been directed to prepare to move out with a few hours' notice. He packed his belongings in two parts, some to travel, some to await his return. On December 23, 1943, he opened a letter from his father, something he had hinted at and finally openly asked for. Reading and re-reading it and feeling wistful about home on the eve of the holiday and the eve of his departure for war, he wrote an immediate reply.

Dear "Doc"

Only (1) one more shopping day before Xmas. This is my 2nd in a row away from home and I sure miss it too.

It will be about your birthday [January 12] when you get this, so "many Happy Returns." I believe you're 43 this time – right?

I've never enjoyed any letter so much as this one from you to-day. All the boys' Dads write—Now I can even prove it. So you know, this is the only one I've ever gotten from you in 9 yrs. away from home. [Dad left for Clemson in 1935 at age 17.] If you will try again soon, I know my morale will jump.

Mama is reading this to you while you shave. She is standing in the door to the bathroom and I know it—I've seen it happen a thousand times.

You've been keeping secrets from me about all the horses. Keep them all, I want them.

You and mother have been so good to me over here about tending to all my requests. I'm so impatient when I want something (can't imagine where that comes from) that I can't put it off.

I'm saving my little change as you call it and I can well imagine how I'll be needing it some day. Did that $350 I sent ever get there? I'll hold on to the stubs for awhile longer.

About 25 Americans are getting together tomorrow (24th) at about 2 o'clock for a dinner party to-morrow night. We start with a shooting match at 2 p.m. I think I can hold my own with any of them in any of the weapons.

No packages have come as yet. Maybe they'll get here around birthday time—that's in March you know.

Thank you and Mama for handling the ring situation for me. Never did like that ring very much, but if [Flo] doesn't want it, she'll just have to wait. I know she likes it tho.

I'm running low on [lighter] flints again—just stick a package in a letter about every month.

Give my love to mother, write again soon and many Happy Returns.

Love
"Bo"

Dad wrote from overseas asking his father to name
the foal after Flo.

Chapter 24

The Ring Redux
Fall 1943

Mom spent nine months working in Washington and then two more at Ft. Benning, but in August of 1943, she came home. She was nineteen but felt much older. The war, it seemed, would go on for many years. Bo, it seemed, would be gone for those many years. And in the meantime, Steve would keep her emotions unsettled. Life would never be normal again, but her parents thought it would be good to pretend that it might. They suggested she return to college, not to the isolated rural campus of Hollins, but to the urban classrooms of Randolph-Macon Women's College [now Randolph College]. R-MWC was conveniently located on the streetcar line about two miles from her parents' house in Lynchburg.

Mom mentioned the idea of returning to college in a letter to Dad, and he wrote back urging her to do so (possibly in the vain hope that it would cut down on her social life). Apparently his opinion sealed the deal for her and she began her sophomore year with classes in Greek, Latin, art and history.

Mom's sister Betty was also living in Lynchburg at that time. Months earlier, when Lt. Commander Ed Luby left Boston for the Mediterranean, he told Betty to rent an apartment in Lynchburg and resign herself to a long separation. Ed sailed on the USS *Wainwright*, the flagship of a squadron of eight destroyers, and served as chief of staff to the squadron commander. The squadron provided fire support for the landings in North Africa, Sicily and Salerno Bay.

Shortly after Ed left, Betty visited a psychic who told her she saw her husband "surrounded by water and flames." This proved prophetic when Ed's squadron came under fire in Salerno Bay in September of 1943. Of the eight ships in the squadron, only two survived the artillery fire. The channel roiled with the smoke of artillery from land and sea, and all around the *Wainwright* Ed saw the oil-soaked bay in flames. Behind him, a torpedo ripped into the magazine of the *USS Rowan*, sinking the ship in 48 seconds. Relaying directions from the squadron commander and shouting over the din, Ed thought, *Maybe I am going to die.*

Even when Betty learned the *Wainwright* had survived, she could barely breathe for fear of bad news about Ed. "It was three days before Ed could send me a message saying he was all right," she recalled - days in which the thin twenty-four-year-old barely ate and hardly remembered to feed her baby.

"After the battle at Salerno," Betty said, "they sent Ed ashore to be the naval liaison officer with the Fifth Army under General Mark Clark. He was supposed to tell the Army where the Navy could put their gunfire. They kept him a long time. He always said, 'I could have ended up in Berlin with the Fifth Army if I hadn't gotten them to let me go.' He finally got back to his ship and got a ride on a cruiser back to the U. S."

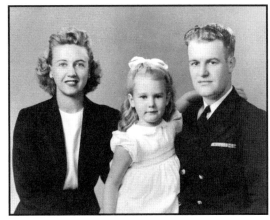

Flo's sister Betty with her husband Ed Luby and their daughter Michele. (1945)

By then a commander, Ed Luby returned home in December of 1943 and went to work in the Pentagon. For the first time in more than three years of marriage, Betty and Ed were able to live together.

The worst of the war was over for them, but it was just beginning for Mom and Dad.

In late September, as the family was rejoicing over Ed's safety, Mom received a cable from Dad that included a pre-arranged signal for her to begin using a different APO (Army Post Office) address. Although he couldn't tell her he was leaving Ramgarh and moving to Ledo, she knew it meant he was going to war.

Mom knew from Dad's letters that he had a brother in the war, a brother with a wife and baby back home. Given Ed Luby's recent brush with death and Betty's anguish, Mom had to have thought, *What if Bo and I had married before he left? And I had a baby? And he got killed in the war?*

It was ironic that when Mom put the war out of her mind to do homework, she spent her time piecing out the ancient Greek account of the Peloponnesian Wars.

On November 12, a cable arrived from Steve Thornton. He was on his way overseas again, but, as he had told her when they parted in August, he had a stopover in Washington. Could she meet him there?

Never one to let school interfere with her social life, Mom went to her professors and begged out of her Saturday classes. She was an "A" student and merited a little indulgence. Dick's mother-in-law lived in Washington, which gave Mom a suitable place to stay.

The weekend was apparently a success and left Mom with a second man overseas who had a hold on her heart. But even as Mom hedged her bets by indulging her affection for Steve, Dad was insinuating himself deeper and deeper in her life and her thoughts. It was Dad's opinion on college mattered. And it was Dad's desire to put an engagement ring on her finger—in pointed contrast to Steve—that helped keep him foremost in her mind. As

Steve left, Bo broached the idea of an engagement ring in a letter. Mom assented but it wasn't the same situation she had experienced in May of 1942. She had by then clearly compartmentalized her social life: prioritizing Dad as her first love, but encouraging Steve in the event something happened...*Don't even think about that...* and then flirting with all the others as a combination pastime and civic duty.

Meanwhile, down in South Carolina, the Traywicks were carrying on with their lives while worrying about a son in Italy and a son in Burma. Although Bo, their baby, had been overseas for almost a year, he had not been to war. But his older brother, Joe, who had left home at the same time, had already been through many months of warfare in North Africa, Sicily and Italy as a doctor with the 20th Combat Engineer Regiment.

Miss Janie wrote faithfully to both boys and wore the engagement ring her younger son had asked her to keep. She and Doc knew Bo was still in love with the girl from Virginia, and, since Miss Janie was from Virginia, she decided to arrange a meeting. Leaving the ring at home, she rode the train to visit her relatives in Farmville, about fifty miles from Lynchburg. While she was there, she wrote Mom and invited her to lunch. Miss Janie rode the bus to Lynchburg, Mom met her at the station and they had a cordial lunch. If Mom had any doubts about the underlying purpose of the lunch, Nana certainly would have told her the obvious: Miss Janie wanted to check her out. Of course, the lunch also gave Mom a chance to check out Dad's family.

In the course of the conversation, Miss Janie raised the subject of an engagement ring, telling Mom that Bo had written them about getting her a new ring. Mom confirmed that he had mentioned a ring in their correspondence, and the two women discussed the subject tactfully. When Miss Janie revealed that she still had the original ring, Mom commented that it was a beautiful ring but perhaps Mrs. Traywick should consult Bo about how he wanted the matter handled. Impressed by Mom's tact and modesty,

Miss Janie invited Mom to visit them in Cameron and reboarded the bus satisfied that her son had selected a suitable girl to marry.

When Miss Janie returned to Cameron, Dr. Traywick asked what her impression of Bo's girl was. "She's so tall," Miss Janie said, adding, "but quite a nice young lady."

A letter from Miss Janie to Flo dated Dec. 1, 1943.

My dear Flo,

I wrote Bo about the ring he gave you last year, as you suggested. You see he did not know that we had not returned it to the jeweler until I wrote him two weeks ago.

In another letter received yesterday he seemed anxious for you to have a ring by Christmas, so I think we will mail your original one to you tomorrow without waiting to hear from him again. If you like that ring, that is all he wants, and I'm sure he will be satisfied.

I am enclosing a snapshot of Bo taken over at [his sister] Bruce's on his last leave before going on foreign service. We think it is good of him.

Dr. Traywick says he would like so much to meet you.

Very best wishes from us both.

Sincerely,
Janie Crute Traywick
December 1, 1943
Cameron, South Carolina

When Mom received the ring, it needed to be resized. Although she could easily have had that done in Lynchburg, for some reason she mailed the ring back to Henebry Jewelers in South Carolina. She said when she took the package to the post office and paid for extra insurance, the postal clerk said, "Are you sending that poor boy's ring back *again*?"

She might as well have been, because she didn't intend to wear it. Just as her older sister did in 1938, Mom put her engagement ring in her jewelry box, there to remain until her man could come and claim her in person.

Dad found himself facing the same problem with one of the Neher sisters that Ed Luby faced with the other one:

In June of 1938, following June Week and graduation at the Naval Academy, Betty came home with a ring.

Betty's ring was a miniature copy of Ed Luby's Academy ring, a broad gold band with "38" embossed on one side and a blue stone set in the top. A miniature ring from the Naval Academy traditionally signified engagement, and every girl who regularly dated a particular midshipman eagerly anticipated the night when he said, "I was thinking of getting you a miniature. Would you like that?"

There was just one problem with being engaged to a midshipman. In those days, the graduates of the Naval Academy were prohibited from getting married for two years following graduation on penalty of being dismissed from the Navy. Since most graduates expected to make a career of the Navy, they took the ban seriously. The thinking was that the young men had lived such circumscribed lives in school that they would benefit from some time out in the world before committing to marriage.

Needless to say, young couples frequently chafed under the Navy's marriage restriction. Among those who felt the Navy's logic had merit was Nana. She recognized what the Navy had observed, that once out in the world, Naval Academy graduates might well find that their tastes in women had changed.

So, when Betty came home with an engagement ring that carried a two-year prohibition on getting married, Nana knew exactly how to handle the situation. She told Betty to put the ring in her jewelry box and keep making the rounds of college dances and summer house parties. Ed was headed to Pearl Harbor to serve

on the *USS Arizona* and would in all likelihood be gone the entire two years. Nana knew if Betty and Ed were truly in love, their love would stand the test of separation. But she also knew that it was entirely possible that Ed would meet another girl and never return. And then where would Betty be? Off the social merry-go-round and hung out to dry.

Betty protested but this was back in the days when children minded their parents, so she put the ring away and made a half-hearted attempt to continue going out with various beaux.

Years later a friend asked Ed, "When you were in Hawaii and on the West Coast those two years, were you and Betty engaged?"

Ed thought for a minute and said, "Well, I was but Betty wasn't."

Bo faced the same issue when he asked his mother to send the ring back to Flo. She was happy to have the ring, but even more than Betty, she was leery of the notion of waiting on a man. The sad story of Shirley and Bob reinforced her wariness.

In truth, Mom probably didn't pause to examine her feelings too closely. In wartime, everyone lived one day at a time. Life was simply too uncertain to do otherwise.

After all, it had been eighteen months since she had kissed Dad goodbye at the train station. It was a testament to his powerful presence that he continued to hold her attention on the strength of five or six weekends together, weekends shared in the urgent early months of the war, a lifetime ago.

And unlike Ed Luby, Dad didn't have room to complain about Mom's social life. While he hoped in vain to clip her wings, he thought nothing of partying with the bevy of Army nurses and secretaries who flocked around. He attracted plenty of female companionship wherever he went and, as far as the peanut gallery could tell, did little to turn it away.

Dad was pretty good-natured about recognizing his own foibles. When Mom or the peanut gallery ribbed him about his double standard regarding her socializing and his own, he just shrugged. "Those gals didn't mean anything to me."

So their romance existed in a weird state of suspended animation. They both cheerfully went out with other people, all the while writing each other deeply-felt letters attesting to their love.

PART IV – SEPARATED BY WAR: DAD TRIES TO REMAIN RELEVANT…AND ALIVE

CHAPTER 25

THE INVASION OF BURMA

The Burma Campaign began in earnest in January 1944, while at the same time in Europe, Patton's Third Army was fighting its way north from Naples. In the Pacific, Nimitz' carrier group was re-taking Kwajalein, and in England, Allied forces (including Dad's brother, Joe) were gathering and training for the invasion of Normandy.

After Christmas, Major Traywick left his footlocker with a few personal belongings in Moselle May's *basha* and drove his jeep down the Ledo Road into Burma with the 66th Regiment of the 22nd Chinese Division.

Another Chinese unit had left in October, clearing the way ahead of the road builders. Now the Ledo Road was open as far as Shingbwiyang, where Stilwell established his *shwebu*, his headquarters. "Shing" sat at Milepost 101, sixty miles inside the Burmese border, and marked a stopping point for Dad's unit before moving to the front line.

On that day in late December, Dad tooted down the Ledo Road in his jeep, zigging and zagging along the winding track through the mountains far ahead of the marching troops. Suddenly, up ahead, he saw a plume of black smoke boiling into the sky. As

he rounded an S-curve, he found a transport truck wrecked and burning. Men on foot were shouting and feinting towards the flaming vehicle. The cab door was open and the driver was hanging out the side screaming for help. Dad leaped from his jeep and raced to the truck.

"The front end had been mashed in, and I could see when I got close that the man's legs were pinned under the steering wheel. I grabbed him under his arms and tried to pull him out but he was caught fast." When that failed, he opened his knife and began slashing the seat of the truck, yanking hunks of seat cover and stuffing out to relieve pressure on the driver's leg. In a moment, the man's leg was loose enough for Dad to drag him out of the cab. Other men helped carry the driver some distance away where they watched the truck burn itself out. Satisfied that the driver would be attended to, Dad eased his jeep around the smoldering wreck and continued on his way to Stilwell's headquarters at Shing.

The peanut gallery shook their heads. *Just another day at the office.*

A few days later, somewhere below Shing, the 66th Regiment left the Ledo Road and plunged into the jungle. Dad virtually disappeared until June when he was evacuated with amoebic dysentery and malarial fever. Buried in a war a world away from civilization, it was hard to carry on a traditional courtship. It definitely put a crimp in his style.

After their whirlwind romance during three months in 1942, the Traywick-Neher relationship of 1944 settled into - what was for Dad, at least - a long slow tedious courtship. Of course, Dad had the distraction of being shot at periodically to help keep his mind off of Mom. And, as he well knew, Mom had plenty of attentive officers to help keep her mind off him. Somehow, he managed to find ways to keep his image in front of her but it was a struggle in daunting circumstances. His first priority was to stay alive long enough to get home.

Dad's role in the campaign put him in an awkward position. The job of liaison officer required him to be part diplomat, part policeman, part tattletale, a guest of the Chinese at times and the gatekeeper to extra supplies at others. It was a delicate job, but one for which he was well-suited. Dad was smooth and a shrewd observer of human nature, characteristics that made him a successful salesman when he returned to civilian life. His ability to put himself in someone else's place, even someone from an entirely different cultural background, gave him an advantage in dealing with the Chinese. Raised in the South, he understood the nuances of social intercourse in a culture with an elaborate, formal social structure. In any conversation with Colonel Ch'en, for instance, he factored in the importance of saving face, the Oriental disregard for life, and a healthy skepticism for whatever he was being told. The Chinese penchant for courtesy over truthfulness made it somewhat difficult to conduct an efficient wartime operation, but Dad soon learned to decode what his interpreter relayed to him.

General Stilwell assigned liaison officers to the Chinese units for several reasons. Mainly he wanted independent, reliable reports about where the units were and what they were doing. Each liaison officer had a radio team to dispatch coded reports to headquarters and receive orders, but the system frequently broke down.

"We were supposed to get the orders from *shwebu,* Stilwell's headquarters, at the same time the Chinese did, but hell fire, we didn't get them. Most of the time I was just tagging along with the Chinese," Dad recalled.

In addition, Stilwell hoped the liaison officers would nudge the Chinese along simply by being his on-site representatives. The liaison officers had mixed success in that role; they had no authority to give orders and could only try to persuade the Chinese officers to do as Stilwell wanted. The fact that liaison officers put in the orders for supply drops gave them a little bit of leverage on occasion.

While there were interesting elements to the job of liaison officer and Dad made the best of it, he was frustrated most of

the time. Dad liked to take hold and get things done, and being at the mercy of inscrutable Oriental officers who were getting back-channel orders from their political leader in Kunming made him feel powerless. When he came home on R&R in 1945, he expected to be shipped back out to the Pacific, where he looked forward to having direct command of American troops.

Once off the main road, the 66th Regiment began bumping into small contingents of Japanese on patrol. As they engaged the enemy, Dad took a great interest in the success of the troops he trained.

Historically, the Chinese approach to war was to give up land and be defensive. Asking Chinese units to go on the offensive meant overcoming centuries of cultural tradition. Dad said Colonel Ch'en would give him any excuse not to attack. "'We can't move out because we don't have enough rations.' Or, 'We can't move out because we don't have the necessary amount of ammunition.' That was just standard. They would go into a bivouac area and set up and cook and they didn't want to move."

Within a few weeks, the 22nd Division was deep in the Hukawng Valley, a remote area of impenetrable jungle, old over-grown trails, glades of ten-foot-tall elephant grass and plenty of wildlife. Dad sent his jeep back and took to riding the Australian pony or walking.

Stilwell's battle plan was to send the units at his disposal in hooking movements to encircle the enemy and cut off his retreat. As the 66th worked its way down the west side of a trail through the Hukawng Valley, they had skirmishes from time to time.

"We'd go around [behind the enemy] and come in and cut the road. Set up a trail block. Then go down further, come in and cut the road. Hold up the Japs on this side [so the other units could attack]."

During these engagements, Dad's job was to follow the progress of the fighting, getting reports from the lieutenants he had

assigned to each battalion and from Colonel Ch'en, and radioing the information back to divisional headquarters. The liaison for the 22nd Division was his commanding officer from Ramgarh, Colonel Smith.

Since their original dust up at Dad's arrival in Ramgarh, Dad had cultivated a good relationship with his superior officer. "Excellent personality and professional ability. Has improved training in regiment since his assignment," wrote Colonel Smith in Dad's efficiency report dated January 5, 1944. Continuing, he wrote, "Doing a splendid liaison job," displaying in his choice of adjective the influence of living in a British colony.

Dad: "I had a radio team with the regiment and I had one with each of the three battalions. There was a three- or four-man team with each battalion. They had the old-time World War I generator, which was a box about six or eight inches square. You'd sit here with a tripod and crank the generator, and this fellow over here with the key would be trying to get a message through.

"The radio teams were American. I had a Navajo Indian for awhile. Merrill's Marauders used them a lot. They could transmit messages *in the clear* during a battle because the Japanese couldn't understand them. They never did break that code."

Dad's team at regimental headquarters was led by a man named Foreman. He and his three teammates had joined the Signal Corps in Washington. According to Dad, Foreman laughed and said, "We thought we were going to stay in Washington for the duration, but they packed us up and sent us over here in the jungle."

From time to time, Dad would go to the divisional headquarters, which was usually set up a mile or so behind the front but might be as much as five miles back through the jungle. The dense vegetation hid wild animals, enemy patrols and snipers who could pass within a few yards without being detected, so travel between camps was never without risk. Depending on where they were, Dad walked or rode his horse. He would relay requests for supply drops for the regiment, pick up orders for advancing, get the news

of other units operating in the region and, somehow, send messages to have orchids and bracelets and scarves delivered to Mom.

On one such visit to headquarters, Colonel Smith assigned a lieutenant named Trostle to the 66th. They were in an area of active enemy patrols and snipers, and Dad elected to wait until the next day to return to his unit with Trostle. At that time, there was a supply unit, a group of Chinese bearers with an armed escort, carrying provisions to the regiment, and the two officers could travel in the relative safety of a group.

In the meantime, Dad learned several interesting things about his new lieutenant.

One, Trostle had brought into the jungle an emblem of American civilization: a bag of M&Ms. *Chocolate.* Chocolate was hard to come by in the jungle because it didn't keep in the heat. Dad loved chocolate and Mom even sent him a box of chocolate pudding mix one time, which of course was useless. So he envied Trostle his M&Ms.

Two, Trostle had some specialized skill for this assignment.

"He had been to the Berlitz school, and he spoke Chinese. The only thing was, he spoke Chinese too well. He spoke proper Mandarin. Not this coolie talk, you know. The coolies had a vocabulary of a few hundred words, and they'd just roll them around any kind of way. But Trostle didn't last long, 24, maybe 48 hours."

Killed? the peanut gallery asked breathlessly.

"No, he got his toe shot off."

The armed guard and the Chinese with their "jimmy sticks"—sticks with a basket on either end—led off down the narrow path, and the two officers followed. A few miles out, they were ambushed. As snipers opened fire, Dad rolled over behind a log and Trostle jumped into an old foxhole. They returned fire, but in the melee, Dad heard Trostle groan and knew he had been hit. As the snipers were driven off, Dad scrambled to Trostle's side

and saw his boot was a bloody mess. A piece of shrapnel had taken off part of his boot and one of his toes. Dad pulled out the first aid pack they all carried, opened the dressing pre-treated with antiseptic powder and put it on the wound.

The detail backtracked to headquarters, carrying Trostle on a stretcher. Trostle's war was over. He would be shipped back to the States. Having done his duty to his brother-in-arms, Dad turned his attention to one last detail. Leaning over the wounded man on the stretcher, Dad said, "All right now, lieutenant, you've got a ticket home, but you've got that bag of M&Ms, and you can't take those with you. They stay here." So Dad relieved him of his bag of M&Ms.

Sometimes it's the little things that get you through the hard times.

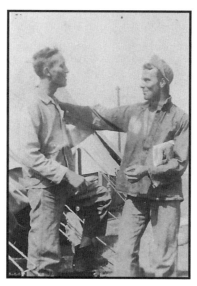

Dad (R) in camp. (1944)

CHAPTER 26

CAMPING OUT

My great-uncle Buford Buzardt kept a diary of his service in the War Between the States. It is a depressing document in so many ways, not least of which is the almost daily description of marching in the mud and sleeping in the sleet. Memoirs of the war in Burma are similar, in that there are daily references to miserable conditions: rain rain rain mud insects steamy heat more rain and mud.

Sometimes fourteen inches of rain per day.

"It would rain like hell and you'd get soaking wet. Then it would stop and the heat would dry your clothes after a bit."

Dad was fortunate not to run into typhus mites that sent so many of Merrill's Marauders to such a painful death, but he picked plenty of leeches off his arms and legs. He said the tribal people of north Burma had scars all over their bodies and limbs where leeches had left a sore place that subsequently got infected by some kind of jungle rot.

Once Dad left his cozy *basha* outside Ledo, he spent the next five months sleeping in a hammock or, if the division bivouacked for a long enough period, a subterranean chamber constructed by Chinese "engineers" who dug a bunker and covered it with branches and dirt for Dad's safety and comfort.

The hammock came equipped with a canvas roof of sorts with mosquito netting on the sides. Although the netting could be zipped closed, Dad felt it prudent, in a war zone, to leave the

zipper undone. Whenever the enemy started lobbing mortars at the camp overnight, he simply rolled out of his hammock into the foxhole below. Although he worried that one night he might fall into the foxhole with a snake, he decided that was the lesser evil.

The three thousand soldiers of the 66th Regiment would make camp for themselves, and the civilian laborers of the Chinese Labor Corps would set up the mess area and sleeping quarters for the regimental staff and the liaison team.

"Colonel Ch'en provided me with my food and a place to sleep. I ate rice twice a day with chop sticks, just like they did. Occasionally you would have something to put in it but a lot of times you didn't. I ate over at the regimental headquarters with about six officers. You had Colonel Ch'en, who was the regimental commander, and you had the vice commander, Colonel Wong. Then you had the commissar. He was a political guy Chiang K'ai-shek had in every regiment. They called him 'Colonel' too, but he wasn't military. And of course I had my Chinese interpreter, because they didn't speak any English, except Colonel Wong. Colonel Wong was learning to speak English and I was learning to speak Chinese. He was always asking me to tell him jokes, but he couldn't understand them. He'd laugh and say, 'Major Traywick, you so humor.' He had a whole mouth full of gold teeth, which was a big status symbol.

"My orderly, Sam, would go with me. He had my rice bowl and my chopsticks and he had a sort of washcloth. When I'd get through eating, he'd take that cloth and drag my chopsticks through it and wipe out my bowl."

Here Dad would cringe and pull his lips back in disgust at this dishwashing protocol. Raised by a doctor with a deep fear of sepsis, Dad expected death by germs at any moment.

For Dad, as with most soldiers, surviving war went far beyond just not getting shot.

CHAPTER 27

LOST

Technology changes how wars are fought, especially the ability to track the enemy's movements and listen in on his tactical planning. Today, smart phones, GPS maps and tracking apps make it hard for anyone to hide—or get lost, even in a strange country.

But by depending on outdated paper maps and magnetic compasses to know where they were, and relying on scouts to know where the enemy was, Stilwell's troops had hardly progressed from the Revolutionary War.

The availability of air surveillance improved the situation in World War II, although the CBI wasn't the best example. People could hide and tanks could be camouflaged, and they could move many miles between surveillance overflights. Added to that, in Burma there's the cloak of the jungle.

In the jungle, where often no path is visible and an enemy soldier can pass, unseen, within ten feet, tactical plans are easier to describe than to execute. In jungle warfare, as American soldiers in successive wars in Southeast Asia were to learn, there are no battle lines in the traditional sense. There might be a wide engagement area, and pockets of troops might be in front of or behind their opponent's position, often without knowing it. Jungle warfare is the proverbial shot in the dark.

In Burma, the value of air surveillance was mixed, owing to the undifferentiated canopy below. Pilots flying bombers or dropping supplies could and did make crucial mistakes. On one occasion, General Stilwell and General Liao, the commander of the 22nd

Chinese Division, narrowly missed being hit by friendly fire when an American bomber crew, peering down at the jungle canopy, mis-identified the section of road they were to hit.

In February, Dad's regiment went forward to find and capture the village of Yawngbang Ga on the way to the larger prize of Maingkwan. But without Google Maps, who could tell one clump of elephant grass, one cluster of huts from another?

Progress for the troops and their equine supply train was slow due to the unseasonable rain and the heavy going. Although it was the "dry" season, rain fell on twelve days in January and eighteen days in February. Sometimes they moved only two or three miles in a day as small groups of men would take turns chopping a trail.

How did you know which way to go? the peanut gallery asked.

"Didn't know. There weren't any maps. You just had to follow your nose or your compass in the jungle. Sometimes we'd just be lost."

The 66th Regiment did indeed get lost in mid-February during its assignment to encircle the enemy and prevent a withdrawal from Yawngbang Ga. After wandering around the jungle for awhile, Colonel Ch'en simply sat down and refused to move, despite the proximity of Japanese units and the entreaties of the liaison officer. Out in front a small unit of Japanese blocked the way, probably no more than a platoon, Dad thought.

Dad didn't know exactly where they were nor was he privy to Stilwell's deployment of other units, but he knew damn well it

was important for the 66th Regiment to carry out its assignment on time. So Ch'en's refusal to engage the enemy as directed created a lot of anguish for the liaison officer. "One morning we had orders to attack and didn't. Colonel Ch'en said he was going to attack at eleven, but eleven o'clock came and he didn't. He told me he was going to attack the next day at eleven. There wasn't anything I could do."

The camp was taking fire from the enemy in the form of an occasional mortar round, so Dad retreated to his dugout and caught up on the news with a three-week old copy of *Time* magazine that he had just received.

Late in the afternoon, a strange American voice wafted down the hole, "Hello in there?"

Dad called back, "Hello! Come on in."

The voice said, "You come on out."

Something in the voice bespoke authority and Dad quickly stepped up and out to find himself face to face with the Deputy Supreme Allied Commander of the Southeast Asia Command and Commanding General of American forces in the China-Burma-India theater, Major General Joseph W. Stilwell. The scrawny general, five-nine and 140 pounds, wore a World War I campaign hat, mud-spattered khaki shorts and boots and a sweaty shirt with no insignia, but there was no mistaking his identity. Behind him stood several officers and his well-armed bodyguard, Darra Singh.

Goh-lee Moses. Dad sucked in his breath and saluted smartly. "Good afternoon, sir!"

Over the preceding week back at headquarters in Shing, General Stilwell had attempted to direct a battle plan that, if successful, would encircle and destroy the bulk of the 18th Japanese Division and open up the Hukawng Valley. But by February 15-16, he had become frustrated by the failure of the 66th Regiment to attack where he had directed, and it became clear from radio dispatches that the unit was lost. To the horror of his staff, Stilwell

decided to walk up to the front and find out for himself what was going on. The general and his aide, Colonel Thomas McCabe, the divisional commander of the 22nd, General Liao, and one or two others set off early one morning through the jungle. With the general pushing the party at his customary one hundred and five paces per minute, they crossed steep ridges, clawed through jungle and elephant grass, avoided enemy ambush and stumbled upon the regiment late in the afternoon. They had walked about ten miles through territory held in large part by the Japanese.

"Why haven't you moved out against these Japs?" the general demanded.

Dad gulped, but there was no beating about the bush. "Colonel Ch'en is just holding up. Says he's going to do it tomorrow morning." He'd done all he could do but he felt embarrassed nonetheless.

Stilwell glanced around the camp and said, "He's going to do it right now. Where is Colonel Ch'en?"

"He's right over here," said Dad, leading the angry general and his party through the camp to Ch'en's tent. Dad's rudimentary Chinese got him through the introductions, during which Ch'en showed no emotion beyond the customary elaborate courtesy. Stilwell, fluent in Chinese after many years of diplomatic service there in the 1930s, told Ch'en, "I want to see you privately."

Dad tactfully withdrew and herded the general's party to the mess tent for some refreshment after their hike. Meanwhile, Stilwell blistered the colonel and relieved him of his command. Despite his volcanic anger over the disobedience to orders, Stilwell retained enough composure to conduct the dressing-down in private. The others all knew what was going on, but relieving Ch'en in front of the liaison officer or any of his staff would have caused irreparable loss of face.

As they waited, Dad sized up the general's hiking companions. General Liao commanded the 22nd Division, of which the 66th

Regiment formed a part. A Chinese warlord, Liao passed the time looking over the encampment and interviewing the field officers.

Colonel McCabe had been Stilwell's aide for several years and had walked out of Burma with the general when the Japanese overran the country in May 1942. He was an attractive, easy-going officer who chatted with Dad, inviting him to share with him how well—or not—the job of liaison officer was working out and why.

And then there was Dara Singh striding up and down outside the regimental commander's tent bristling with weapons. A former prizefighter from Singapore, Stilwell's personal bodyguard stocked a Thompson automatic rifle, a carbine, a Mauser pistol, a Colt .45 automatic and plenty of extra ammunition. He looked like a cartoon figure.

Stilwell emerged from Ch'en's tent and consulted briefly with Dad about the battalion commanders. Dad assured the general that Major Yu, with the 2nd Battalion, was the most aggressive officer in the outfit. Stilwell then ordered Yu to take out the enemy firing the mortars. In thirty minutes, Dad said he and the visiting officers heard an impressive amount of firepower in the jungle down the trail. In less than an hour, they were walking among trenches holding the dead bodies of Japanese.

The Japanese had held up the Chinese regiment for nearly a week with a thirty-five-man platoon, allowing their battalion to retreat south. Later, among recovered documents, they found a message telling the Japanese to pull back from Yawngbang Ga to Mainkwan, a message sent just twenty-four hours before Major Yu's attack. Colonel Ch'en's delay had cost the Allies the opportunity to surround the 18th Japanese Division and inflict major damage.

The general and his little group spent the night with the regiment, and McCabe bunked with Dad in his dugout. Dad found the visit memorable for his close-up view of the general as well as the appearance of certain creature comforts. Amazingly, the general's

party had arrived provisioned with whiskey, if little else. Dad enjoyed a drink with McCabe, who generously left him the rest of his fifth of Canadian Club. It was almost enough to assuage his feeling of disappointment at his failure to keep Ch'en moving. It was little consolation for Dad to learn, after the war, that Stilwell frequently hiked to the front to find errant units, put them on course and prod them to attack.

Energized by the general's visit and clearing the enemy blockade on the trail, the 66th marched forward as smartly as the rain and the muddy trail would allow, capturing the lightly-held Yawngbang Ga and pushing on to the outskirts of Maingkwan. The successful firefights raised everyone's spirits but Dad remained nagged by frustration that he had been unable to keep the 66th on course.

Maj. Traywick

CHAPTER 28

SURROUNDED

Robert E. Lee famously said, "It is well that war is so terrible, otherwise we should grow too fond of it." Dad seldom mentioned actual fighting. When pressed about it, he pointed out that he was a field officer, not an infantryman on the front line. And furthermore, he was a liaison officer, an adviser to the Chinese regiment that was doing the actual fighting. Nevertheless, there were times when he had his carbine in hand, ready to fire at the enemy.

And yet, when my brother as a child asked excitedly, "Did you kill any Japs?", Dad answered almost apologetically, "I don't know for sure. I fired at some. But don't forget, those men had families back home, too, and some of them had little boys like you."

Of course, Dad's humanitarian qualms in later years did not keep him from trying to kill the guy who was trying to kill him at the moment. Memories of being cut off from the regiment and surrounded by enemy soldiers eclipsed the compassion he felt in later years back home. "I was going to shoot him before he shot me," Dad said, the grim intensity of the moment evident in his voice fifty years later.

By the end of February 1944, Stilwell's Chinese troops had gotten some fighting experience and enjoyed the confidence that comes from success. They were preparing to take Maingkwan, the Japanese base for northern Burma. Ten miles below Maingkwan lay Walabum, a pathetic cluster of huts valuable only because of its

strategic location. Capture of these two villages meant control of the Hukawng Valley, the halfway mark in reclaiming north Burma.

Stilwell devised a multi-pronged plan to attack both Maing-kwan and Walabum in the first major battle of the campaign. Dad's unit, the 66th Regiment, was assigned to flank the enemy on the right and cut the road behind him, cutting off both his supply and his escape route.

Shortly before the expected battle on the first of March, with the units moving into position, the 66th Regiment received a supply drop that included a package of mail for Dad. He was almost as excited to receive a month-old copy of *Time* magazine as he was the letters from Mom.

The regimental Headquarters Company remained halted by a creek as the fighting units moved forward. Dad, attached to the Headquarters Company, decided before the action started that he would take the opportunity to attend to some personal business. Reasonably confident that the enemy had left the vicinity, he took his magazine off by himself a good little ways.

Privacy, always at a premium in wartime, is easy to come by in the jungle. A soldier seeking a small place for nature's call can easily conceal himself among the nine-foot clumps of elephant grass or the tangle of bushes and vines that seethe and boil in the half-light of the jungle floor. He can squat under concealing fronds and read a magazine from home, certain that no one can see him - except perhaps the enemy sniper taking equal advantage of the jungle's cloak.

No sniper picked Dad off, but as soon as he returned to the safe circle of his colleagues, all hell broke loose. The rotten floor of the jungle exploded in spurts as Japanese mortars fell like giant hailstones. Rat-tatting gunfire filled the air between the pop and *whrrr* of incoming mortars. Simultaneously he and the men nearby flung themselves to the ground or dove behind trees. *What the hell...?* thought Dad as he and his carbine hugged the sodden

ground. He ducked lower as a shower of mud and branches pelted his helmet.

He could hear Japanese .25 caliber bullets *slap* in the bamboo above him and his next thought was, *They missed me.* The memory of his recent vulnerability sucked the breath out of him. *They had me cold turkey out there. They could have had me easy.*

As he relived the moment for the peanut gallery, Dad would close his eyes in gratitude and wonder at his unfathomable escape.

Trained in survival skills by the British jungle warfare school, Dad had in turn trained thousands of soldiers to camouflage themselves in the undergrowth and generally avoid getting killed by enemy soldiers. Now as he lay on the fetid floor of the jungle, the familiar odor of jungle rot crammed in his nostrils, he assessed the situation. After the initial attack, the firing had ceased.

He lay inside the edge of the jungle with a wide tree-less area in front of him. Peeping through the leaves, he saw at a distance of three or four hundred yards—about the range of his M-1 Garand—Japanese soldiers moving across his line of vision. They were not advancing on him but seemed to be moving south. Over beyond the Japanese somewhere was a trail that led north to the town of Maingkwan. Further south down the trail, he knew, 2nd Battalion of the 66th had blocked the road. Off to his right, 3d Battalion was operating. And now these Japs had come from God knows where. There didn't seem to be many of them, but they had cut through Headquarters Company, effectively pinning down half the unit.

Withdrawing further into the jungle, Dad slipped around and took inventory. With him were his aide, Lt. Metcalf, his radio team led by Corporal Foreman, a doctor and forty or fifty Chinese laborers who carried no arms. The radio team of three Americans each had a lightweight M-1 carbine. Lt. Metcalf and Dad had M-1s and pistols and whatever ammunition they carried with them. It was hardly an arsenal with which to counter an attack.

The Headquarters Company had stopped at a recently-vacated Japanese encampment. While the location offered a few ready-dug holes, it had the disadvantage of being known to their attackers. As Dad directed the group to find cover, the Japanese began dropping "knee mortars" on them again.

The Japanese had developed a one-man, spring-loaded grenade launcher called a knee mortar because the soldier kneeled down to fire it.

Night was coming on and with it the prospect of a sneak attack. The Japanese, in their former camp now occupied by Major Traywick & Co., had conveniently left a machine gun position. The semi-circular trench about six or eight feet in diameter was designed so that a soldier could set up a machine gun on the perimeter of the camp and fire it from different angles. Running alongside the gunnery position was a shallow creek about twelve feet wide.

"Let's bunk here," Dad said to his aide, and Metcalf dropped into the curved trench.

Turning to his radio team, he said, "Foreman, you and the others get in a hole and stay there. Don't come over here tonight, because anything I see moving, I'm going to shoot."

Dad got in the end of the gunnery position opposite Metcalf, each man looking out over the other's head. Nearby, they heard some of the Chinese laborers digging holes in the bank of the creek. *That's probably the safest place to be*, he thought as he hunkered down for a long night in the eerie blackness of the steaming, teeming jungle. He scraped some mud off the edge of the trench and smeared it on his face. Cheap camouflage. Insect repellant. Metcalf did the same. Although the men had lived and camped outdoors in the tropics for the past month, they carried no tan, screened from the sun as they were by the towering jungle. Nor were they white. Daily doses of Atabrine to ward off malaria had turned their skin a putrid yellow. A smear of mud would take the shine off their faces at night and perhaps dissuade a few of the mosquitoes that tortured them.

As the dark minutes ticked by, the two men held their weapons ready and sweated blood, swiping insects and straining to pick out human sounds among the noises of the jungle. In the past few months, Dad had gotten used to the sounds of the screaming birds, shrieking monkeys and soughing treetops, but he flinched as some night creature flew past with a *whoosh* as scary as a mortar.

The Japanese were known to slip into the enemy's trench and slit a man's throat as he rested next to his companions. Dad shifted his grip on his rifle and peered through the darkness. His adrenalin level, elevated for the past few weeks, had reached a new height. But it was not enough to banish his thirst. And he found himself longing for a bowl of rice, the boring meal he had grown to despise. He forced himself to focus on his survival instead of his personal comfort, but hunger and thirst intruded. Then cramped muscles, as he crouched in the mud. Then speculation about leeches feasting in his groin. He ran his hand around each calf where he had tucked his pants leg into his canvas-and-rubber jungle boot to baffle the voracious blood-suckers. Removing leeches was a daily ritual for Dad, who, as he enjoyed an after-dinner smoke, singed the fat slugs on his arms and legs between puffs.

Out of habit, he reached for a cigarette, but he jerked his hand away as soon as he touched the pack. *That Jap sniper, he's just waiting for me to light up.* Denied cigarettes, he became fixated on smoking. When a man went through three packs—sixty sticks—of unfiltered, uncharcoaled, nearly pure nicotine every day, it meant having a cigarette in his fingers at all times. His empty hands twitched.

"Metcalf," he said softly.

"Here."

"Don't even think about firing up."

He breathed deeply to steady his nerves.

A couple of mortar rounds interrupted his thoughts. As he

ducked, he heard cries as shrapnel cut into the men holed up in the creek nearby. He cursed the Chinese officers who had chosen to stop at an old Japanese position. *Now the Japs know where we are. They know exactly where we are.* Flexing his jaw muscles, he thought, *I don't want to die down here in this goddamn stinking jungle.*

As the jungle and the Japs closed in, he slid his finger over the smooth metal trigger of his carbine and muttered an obscenity.

As early light crept through the trees, Dad saw a Japanese soldier jump up out of a hole, run across and jump into another hole. After a few minutes, he saw another one. Despite the sporadic mortar barrage, the enemy seemed disinclined to attack.

Quietly, Dad and his aide slipped out of the machine gun trench and took stock of their group. They found the medical team in the creek, tending to the casualties. When the shelling paused and they could move, Dad directed the group a short ways to a new position. Foreman attempted to radio news of their situation.

Even in the midst of attack, the Chinese were mindful of the face to be lost should anything happen to Major Traywick, so they made a dugout with a camouflaged roof for their distinguished liaison officer. Dad accepted the shelter gratefully but got little rest the second night, either, as mortars continued to fall around them.

Stepping up from the dugout the next morning, Dad was aghast to find a hand grenade on the lip of the roof. Somehow it had failed to explode. *If that thing had dropped in and gone off...* The image took his breath away.

The mortars had ceased during the night. Scouting their perimeter that morning, the stranded group found the enemy had moved away. Retracing the trail, they were reunited with the main body of the Headquarters Company. As he exhaled in relief, Dad felt he had already survived the war, but the battle of Maingkwan had just begun.

Chapter 29

Maingkwan

Fighting around Maingkwan went on for several days, but in the mop-up on March 5, the 66th Regiment had the distinction of being the first Allied unit to re-occupy a Japanese base in north Burma.

General Shinichi Tanaka, commander of the once-mighty 18th Japanese Division, conquerors of Singapore, Malaya and Burma, had cleverly deployed his units to stave off encirclement and sent desperate messages to his command, which had neither supplies nor manpower to relieve the unit. Finally, sensing the noose was tightening, Tanaka decided to pull back, but it was too late. As the Japanese poured out of Maingkwan, the 3d Battalion of the 66th Regiment lay in wait on the trail with machine guns, mortars and riflemen. When the retreating enemy hit the roadblock, the Chinese slaughtered them.

Stilwell was ecstatic about the success of his Ramgarh-trained troops. After the embarrassment at Yawngbang Ga, Major Traywick was even happier.

Redemption is sweet, he thought.

Yet as he surveyed the battlefield, he was repelled by the carnage. The Chinese swarmed over the dead Japanese bodies, ripping open uniforms and satchels, searching for trophies. A dozen pack horses lay among them, packs scattered, bodies torn open. An animal-lover, Dad often spoke of the suffering of the mules and horses that had been pressed into service.

Even though Colonel Ch'en had been reinstated by then, it was Major Yu who approached him. At his side was a soldier carrying two samurai swords. "Major Traywick?"

"Major Yu. Congratulations on a great victory."

The Chinese officer bowed. "The men are brave."

"General Stilwell will be pleased. It is an honor to capture Maingkwan."

Yu smiled. "We would be most honored if the major would accept these emblems of our victory." Here the soldier proffered the two samurai swords and a Colt .32 pistol.

Delighted, Dad graciously accepted the gifts. The swords were sheathed in scabbards with intricate engraved designs and decorated with knotted silken cords. The pair was among thirteen such swords captured by the victorious troops.

Additionally, Yu presented him with a blood-stained Japanese flag and an embroidered sash. The sash, referred to as "a thousand stitches," contained rows of tiny stitches, each of which represented a wish by the seamstress for her lover's safe return. The flag was a favorite trophy among the Chinese. Each enemy soldier was known to carry a small Japanese flag to remind him of the emperor for whom he fought. The Chinese soldiers gleefully collected the flags from the bodies of their despised enemy and, as a pointed insult, used them to clean their rifles.

Dad sent these trophies to Mom, asking her to distribute them to various people. One of the swords was to go to his Uncle Willie Crute, Miss Janie's older half brother who was a Texas oilman. Dad had cabled Uncle Willie on his way to San Francisco in the fall of 1942, and they met at the train station for a brief visit. Uncle Willie was the wrong age to participate in any of the wars of his lifetime, but he well knew the sadness and sacrifice to come. As Dad prepared to re-board the train, Uncle Willie spontaneously removed his expensive wristwatch and gave it to him. Then he emptied his pockets, handing Dad wads of cash, hundreds of

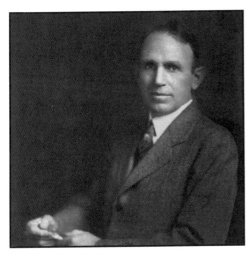

Miss Janie's brother Willie Crute, a Texas oilman, gave Dad a good send-off when he left for war.

dollars. As Dad protested, the 75-year-old man said, "I can't do anything to help. Just go have a good time in San Francisco before you leave."

To celebrate victory in the first major battle of the Second Burma Campaign, Lord Louis Mountbatten, the Supreme Allied Commander for SEAC (South East Asian Command), flew into Burma from Delhi to review the troops on March 6. Mountbatten, a British officer with a keen sense of public relations, arrived with an escort of sixteen fighter planes, twelve more than Stilwell had used in the actual battle. Stilwell met him with a driver and jeep, but the image-conscious Mountbatten wanted to drive to the battle site himself. An amused Stilwell sat in back and let Mountbatten chauffeur him around, while the driver, Corporal Windam Braud, silently cursed as Mountbatten ground the gears or choked out.

With Sam Wu's help, Major Traywick turned out in clean fatigues for the generals' visit. As liaison for the victorious 66th Regiment, he managed to attach himself to the group around Stilwell during the tour of the battlefield. The press corps darting around the generals included a photographer taking footage for the newsreels that were shown in the movie theaters back home. Dad knew his family went to the movies to watch the newsreels, looking for him and his brother, and he stayed close to Stilwell.

The area was littered with more than two hundred Japanese corpses, which had been lying there in the hideous heat for two days. The stink was so horrible that Mountbatten leaned over the side of the jeep and threw up. Barely had he recovered when the group was startled by an explosion: a dead body, swollen with

gas in the heat, had blown open with a sound grossly like a mortar shell. Almost immediately, another one exploded, shaking the visitors, who hastened to depart.

Five days later, as the 66th marched past Walabum, Dad saw a killing field even greater than Maingkwan: Overturned vehicles, scattered body parts, disemboweled mules, dead enemy soldiers whose uniforms and packs had been rifled, hundreds and hundreds of bloated bodies that repelled him with the stench and startled him with explosive pops.

The unit was resupplied by air that evening in preparation for continued pursuit of the enemy, and Dad was surprised to see that the air drop included a ration of beer. The beer was warm and it wasn't going to get any colder, so Dad and Metcalf shared the lot. Relaxing in a rare moment of security, the men became quietly drunk and slept the sleep of the just. The next morning, Dad fell in with the troops marching south. The sun beat down like a gong on the open road, and Dad, nursing a massive hangover, began to long for the twilight of the jungle. Even a sudden shower would be welcome. He paused as the troops crossed a bridge, leaned against an abutment and drank long from his canteen, the lukewarm water a pitiful antidote to the fire in his gut.

A jeep approached from the north and stopped. *Goddamn,* he thought, capping his canteen. *Not again.* Painfully pulling himself to attention, he saluted General Stilwell.

"Good morning, major."

"Good morning, sir."

"Nice work back there."

"Thank you, sir." He tried to make his brain work. "They're, uh, doing well. The Chinese are good little soldiers."

The general nodded. "I think you're right. We'll need them at the next stop, Jambu Bum. " He glanced along the column of

men laden with packs and rifles, tamping down the mud as they marched, then turned back to Traywick. "What is your order of march, major?"

Despite the post-alcoholic fog, Dad had the self-discipline to maintain a poker face. He had no idea what the order of march was. They could have monkeys and tigers leading the column for all he knew. Headquarters Company was somewhere in the middle. The packhorses were in the rear. Better to guess which unit was leading than to admit he didn't know. "Uh, I believe 2nd Battalion is leading, sir."

"Right." Without another word, the general signaled the driver and the jeep sped away.

Wilting in steam rising from the mud, with a mariachi band playing in his head and fireworks in his belly, Dad was too miserable to care whether he'd screwed up with the general or not.

CHAPTER 30

INSTINCT FOR SURVIVAL

No one wants to die in war, or anywhere else, really, but Dad had an especially highly-developed sense of self-preservation. The ability to flood his system with adrenalin and perform superhuman feats pulled Dad out of many tight corners. He apparently had a bottomless reservoir and when the situation demanded, adrenalin would practically squirt out of his ears. In Dad's retelling of various close calls in Burma, he would always grit his teeth and say, "I was not going to die down there in that God-damned jungle."

And for Dad, daily life in Burma was all about survival. He did his job but he kept his head down. You couldn't let down your guard for even a moment against the Japanese.

Aside from being a formidable opponent, the Japanese commanded every Allied soldier's respect for their bravery and their cruelty. To a man, they did not fear death. Inculcated early on with the belief that the most honorable life involved fighting and dying for the emperor, the Japanese infantryman fought to hold his position and kill the enemy until his unit was victorious or he himself was dead. Often wounded Japanese soldiers would fake death, only to detonate a hand grenade when an Allied soldier inspected the body. Capturing a Japanese position usually meant killing all but four or five men, who would then kill themselves.

To make matters worse, by 1944, the Japanese supply line to Burma had run out. The troops knew there would be no reinforcements, no supplies and no retreat. Reduced to a remnant, the

ragged, starving troops continued to attack and slow the Allied advance with the fury of self-sacrificial fanatics.

Rumors ran wild among the Chinese troops about the horrific treatment by the Japanese of their captives. Unfortunately, many of the stories were true. When the Japanese overran a tribal village, they gang-raped the women, mutilated and tortured the men and boys and burned the village to the ground. Captives were often tied to a tree and used for bayonet practice, before being finished off with a screaming bayonet to the throat. Such brutal treatment of the indigenous tribes of north Burma turned the Kachin, Karen and Naga people into a small army of highly effective guerilla fighters aiding the Allies.

The Chinese had their own basis for hatred of the enemy: the Rape of Nanking. The Japanese had been occupying northeastern China since the 1930s, and in December 1937, they overran the picturesque and cultured city of Nanking. For the next four weeks, in one of the worst wartime atrocities ever, as described by Barbara Tuchman in "Stilwell and the American Experience in China", the Japanese systematically raped, burned alive, beat, hacked, tortured and slaughtered more than 40,000 civilian residents of the city. Feral dogs grew fat on the corpses and the blood and guts of the bodies fed the fish and crabs of the river.

Hearing these stories only heightened Dad's sense of self-preservation. He had no illusions about what would befall him if he were captured. American officers all had a bounty on their heads. So, while snipers remained the number-one danger, the prospect of capture ranked close behind. And then there was the gut-check fear that came with an actual battle. There were, I'm sure, countless occasions in 1944 when the fear of death turned Dad's adrenalin spigot on.

One of those came at night during the battle of Jambu Bum.

CHAPTER 31

THE BATTLE OF JAMBU BUM

Although the Japanese had withdrawn from Maingkwan-Walabum, leaving a couple thousand of their comrades behind to be slaughtered, they holed up in the Jambu Bum—the Jambu Ridge—a line of hills marking the lower end of the Hukawng Valley.

Stilwell sent Merrill's Marauders hooking around to the left below the ridge, leaving the Chinese troops, led by the 66th Regiment, to push the Japanese across the thousand-foot crest and into the Marauders' net. The fighting in the Jambu Bum, which lasted ten days, was reported in the Japanese press as some of the fiercest in all the Asian campaigns, as the Japanese made *banzai* charges and the fighting deteriorated into man-to-man combat.

Among Dad's duties as chief liaison were coordination of medical treatment of casualties and evacuation of those seriously wounded. For this he had at his disposal the L-5, a two-seater plane modified to carry two stretchers—a precursor to the hospital helicopters used in Korea and Viet Nam. The L-5s moved the most seriously wounded men back to a staging area where they were treated in a field hospital and, if necessary, transferred by larger planes to the 20th General Hospital in Ledo.

In preparation for the battle at Jambu Bum, Dad directed the construction of an improvised landing strip in the rice paddies on the north side of the ridge. The paddies were banked by dams about two feet high to hold the water. At his direction, the Chinese sent in laborers with hand tools to flatten the dams and drain the paddies.

The L-5 had a powerful engine so it didn't need a long runway. However, taking off from a small clearing or a short runway involved the coordinated effort of a ground crew. Three men would encircle the plane, each one holding a wing strut or the tail to keep the plane level. Meanwhile the pilot would rev the engine till the entire plane shook. A fourth man off to the side would await the pilot's signal, then he'd wave a handkerchief and everybody would turn loose. The plane would shoot to the end of the clearing and the pilot would pull it up, often just barely getting over the trees.

With the evacuation situation arranged, Dad moved on to his next assignment: Stilwell wanted a prisoner to interrogate. This was a difficult order to fill. For one thing, the Japanese would not allow themselves to be captured. They'd kill themselves first.

For their part, the Chinese were not keen on taking prisoners, preferring to vent their fury on any of the despised enemy they found alive.

Still, Major Traywick, through his interpreter, told Colonel Ch'en that headquarters wanted a prisoner. Alive.

Although Colonel Ch'en agreed, Dad was not optimistic. However, a day or so later Ch'en sent word that they had a prisoner. Two or three soldiers dragged the wounded man into his presence. If he could stand at all, Dad thought, he might make it to headquarters. Pleased that he could provide the rarity of an enemy soldier for interrogation, Dad opened a first aid kit and began treating the soldier's wound with penicillin powder and a first aid patch.

When the Chinese growled in anger at his treatment of the prisoner, Dad sternly reminded them General Stilwell wanted to interrogate the man.

Dismissed, the soldiers jerked the prisoner around and dragged him off. Dad was not surprised the next day to learn that the prisoner did not make it to headquarters. "He bled to death," the Chinese explained blandly.

Dad looked at the peanut gallery and shrugged. "I had a time explaining to the Chinese that General Stilwell wanted a *live* prisoner to interrogate."

One night soon after, Dad found himself in the thick of the fighting. Foreman and the radio team crouched in a dugout on the slope of the Jambu Bum, desperately trying to get a message out as the fighting raged all around them. One young soldier held the radio generator while the second one cranked for all he was worth. Foreman was on the key, tapping, trying to get a message out, as Dad called to him over the din, "Any contact?"

"No, sir! I'm trying, sir!" Foreman shouted as mortar shells landed on either side of them, blowing muddy roots and snarled vines all over them.

Dad scanned the dark hillside, ready to shoot the encroaching enemy whenever artillery lit the area. "Try receiving," he called. The slope suddenly brightened and he fired at the enemy scuttling across the ridge above him.

"No contact, sir!" Foreman reported again.

Adrenalin pumping, Dad constantly reassessed their situation. They were supposed to be well behind a line of Chinese troops but clearly there was no one between him and the enemy soldier he had just fired at. The Chinese must have been driven back or killed. The Japanese seemed on the verge of overrunning their position, a half-dugout, half-hole that provided the four men only the barest cover. Keep cranking the radio or prepare to repel incoming soldiers?

They desperately needed to contact headquarters, but first they had to survive. Beating off the enemy at close quarters took precedence. "Check your weapons!" Dad shouted, scanning the ridge in another flash of light. The radio team grabbed their weapons and aimed uphill in the darkness, awaiting another flash. Far off to the side, they heard foreign voices, then an explosion lit up the ridge. Chinese or Japanese? Cheers from the foreign soldiers

were followed by the sound of troops moving up the hill, their progress marked by hand grenades exploding in a ragged line.

"Hold your fire!" Dad shouted. "Friendlies!" Even in the din of battle, he could distinguish between Chinese and Japanese chatter—and he wanted to make sure the good guys didn't shoot each other. A mortar landed somewhere between the radio team and the troops moving uphill, but he felt the tide was turning in their favor. "Crank that radio!" he ordered.

Without shifting his attention away from the ridgetop, he listened for Foreman's report. The action seemed to be fierce along the ridge above them. And now, was it moving away? Beside him, the radioman cranked with adrenalin-induced power while Foreman tapped futilely on the key. "No contact, sir!"

The fighting was definitely receding from their position and Dad spared enough attention to realize the blood was pounding in his ears like a parade drum. He hardly noticed the rain drops on his helmet. The radio team hastily covered the equipment with a tarp, and the men huddled in the hole while a sudden shower swept over them. In fifteen minutes, it was over, and so was the battle.

Clearly reliving those long moments of fear, Dad exhaled, gazing at the rapt faces of the peanut gallery. "Man, I thought they had us that time, but they didn't get us.

"They didn't get us."

15 April '44
Dearest Mama and Daddy,

Almost 16 ½ months here now and not much chance of getting home for a long time yet. I miss you all so much and I sho want to see my girl. When I get back I'm going to be a home-loving man—always have been, but more so now.

Still in this thing and looks like I will be for a long time yet. Haven't had any more close calls lately. Hope I don't have any more. It's a bad feeling to be scared, and I have

been on a few occasions—none of us mind admitting it either. It's not like being afraid of the dark as a kid.

Tell Doc if the colt is a [filly] to name her Flo for me.

In case I find out I'm coming home I want you all to have me a blue convertible - not Ford, Chev or Plymouth - anything else that's 1942. Most every penny I make is allotted [sent home] so if during the rainy season I get a leave I'll stop my allotment for that month so I can go. The few bucks I get here goes for P.X. supplies, cigs and orderly fee.

I listen [to the musical revues] on the earphones of one of my radios sometimes. They are rebroadcast. Some of them are pretty good.

Got a big Jap flag yesterday. It's a company flag and it has no writing on it but it's good silk so I'll keep it.

Send me the "Cameron news" when you can. It's a lot of fun. Uncle Willie owes me a letter now but I owe him a sword. Give my love to all and write when you can. Mail lately has been mighty slow.

Love to you and Doc.

"Bo"

CHAPTER 32

NO GORE IN WAR

While Dad walked through exploding corpses at Maingk-wan, Mom and the rest of the country saw a largely sanitized version of the blood and guts of the battlefield. In those days before television and live video streaming, the folks back home got their view of war from the newsreels that preceded movie features and from still photographs in newspapers and weekly magazines like *Life* and *The Saturday Evening Post.* The ten-minute newsreels showed a printed headline, much like the pages of text in a silent movie, followed by film clips of airplanes, ships or soldiers in action, with a thrilling voice-over. Each week, Americans flocked to the theater, paid their quarters and scanned the screen for news from the front or, blessing of blessings, the sight of a loved one overseas.

Mom was a regular at the movies, always on the lookout for Bo's face in the newsreels. She had to content herself, though, with his letters and a photograph of him in front of his *basha* in India. However, one glorious day Doc and Miss Janie were thrilled to see Bo with General Stilwell. They sat through the movie and watched the newsreel again, treasuring the few seconds of film that proved their son was all right.

Although the newsreel narrators referred to "tough fighting" and soldiers slogging through snow or mud, the war was mostly portrayed from afar: photographers in Allied bombers showed bombs falling away to the tiny little bloodless targets below; other shots portrayed destroyers and carriers cutting through the waves, perhaps firing their big guns at targets over the horizon; if you saw a ship on fire, it was likely an enemy ship hit by a

torpedo; action shots on the ground tended to show jeeps and tanks rolling victoriously into the ruins of a town or muddy GIs trudging along a road.

Then, in 1943, *Life* ran a photo showing three dead American soldiers on the beach at Buna, Papua New Guinea. By today's standards, the black-and-white photo looks somberly artistic, but for a nation accustomed to seeing war from 20,000 feet, the photo created a controversy about whether such graphic depiction of war was appropriate. It was the beginning of a dramatic shift in how war was covered by the press and how people on the home front responded to it. Just twenty-five years later, Americans would be stunned and repelled when gory, frontline action from Vietnam streamed into their living rooms every night.

Even without Technicolor images, the grinding maw of the war became increasingly evident as America entered its third year of fighting. Mom tried to banish the thought that each time a beau said goodnight and left, he might never come back. That a man she danced with might be killed in action was a theoretical fear until Ensign Charlie Dodd, a ferry pilot, wrote her this letter from California.

> Jan. 7, 1944
> Dear Flo,
>
> How are you by now? I am doing just fine I guess, I finally made the west coast. It only took me 43 days to make a trip east and back, they gave me a medal for setting a new record for going to New York and back.
>
> I lost a very good friend today whom you know. Though you met him, you would have to be around him for awhile to really appreciate his humor and wit. Ernie Reynolds was killed here at the station to-day. A F4F quit on take off and he cracked up into a rock pile and then the plane went into the water and mud and burned, he wasn't burned so bad but he drowned before they could get him out. Last night he and I went to a champagne party in Hollywood and I

really had rather any thing in the world have happened than that…

Love
Charles

The graphic description of Ernie Reynolds' death must have had a sobering effect on Mom. She had hugged so many young men as they left for war, danced one last dance, gently turned down their proposals, at the Naval Academy's June Week, farewell parties at Ft. Myer, graduations at Ft. Benning. Boys she had grown up with, midshipmen she had danced with, officers she had met on the train—there was her whole generation with guns in their hands all over the world, fighting the ferocious enemy, fighting and dying. Now someone she knew, someone her own age had died. It must have deepened her fear for all the men she knew: Bo, Steve, Don, Toni and a dozen others she wrote to.

As a pretty, vivacious teenaged girl, Mom contributed to the war effort in perhaps the best way she could, by being a symbol of innocence, beauty and wholesomeness, the sort of ideals a man was inspired to fight for. When they were with her, men could joke about the dangers ahead, and when they had gone overseas, they could imagine returning to an emotional welcome home.

But all she could do was laugh and flirt with them on the dance floor and worry about them when they were gone. Live for the day. Live for the moment. That was the mantra of her generation.

Chapter 33

The Moguang Valley

On the nineteenth of March, the 66th Regiment took the ridgeline of the Jambu Bum, consolidating Allied control of the Hukaung Valley and opening the door to the Moguang Valley. General Stilwell marked the date in his diary with the satisfied entry, "At least we got JB for my birthday." He was sixty-one. Somehow, down in the jungle, someone produced a chocolate cake for the general, who cheerfully passed out pieces to the troops marching past. Dad did not get any.

Four days later, on the twenty-third of March, the 66th picked its way through the mines the Japanese had thoughtfully left for them on the road going down the south side of the Jambu Bum. That evening, Dad took advantage of a lull in the fighting to celebrate *his* birthday with a bowl of rice, working the chopsticks with unconscious expertise. He was twenty-six. He had lived with the Chinese in the jungle for several months now, nearly every day of which they had been under fire from the enemy. The tension and fear had become part of his daily routine, along with removing leeches, smoking cigarettes and trying to divine the Oriental mind. Recalling his birthday, Dad said, "I was just glad to have made it that far."

Stilwell and his Japanese opponent, Shinichi Tanaka, both had their eyes on the calendar. The monsoon would begin in earnest the first week in May. Fighting and road-building would come to a halt for three months as rain fell in torrents. Each commander had important tactical goals to be achieved by the first of May, most of which involved either capturing or defending towns like Myitkyina, Shadazup, Warazup, Kamaing.

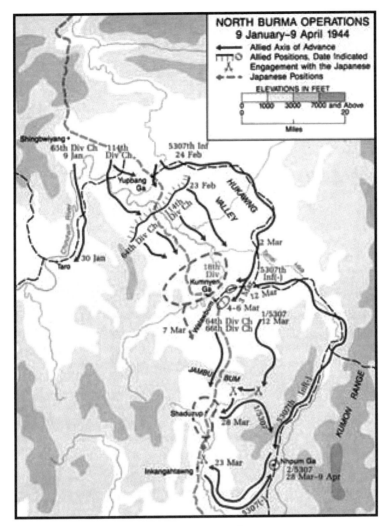

North Burma operations,
9 January - 9 April 1944 *(National Archives)*

For liaison officer Major H. V. Traywick, there were no such broad exigencies. Each day was a grind.

After Jambu Bum, the days and towns ran together as the string of villages with unpronounceable names became a blur. The value of the next day's target was always high. The daily hike through the jungle or the marshland was boring, nerve-wracking, the nights in his hammock hardly restful. On the march, he ripped open K-rations for lunch, swallowing the biscuits, the canned

"meat product" and the fruit bar, reminding himself to be grateful for the respite from rice at breakfast and dinner. The radio messages from division headquarters seemed repetitive: *Move on to the next objective. Keep the units on attack.* The orders made him feel like a drover on a cattle drive. The mind games he and Colonel Ch'en played with each other seemed childish, except there was so much at stake.

Wearied by the whole business, Dad wrote his family to vent.

1 May '44
Dearest Mama and Daddy,

To-day I trimmed my mustache and parted my hair for the first time in 3 ½ months. Haven't had my mustache but about a month now.

This snapshot was made during a short rest we had. It was developed in an aerial photo outfit as you can tell. Flo is getting one too.

Haven't been shot at much lately. Sure is a pleasure. That stuff sho gets on a fellow's nerves after so long a time.

A photographer caught me yesterday, took my name and state and said my picture would come out in a paper at home—I reckon *The State.*

Just heard a few days ago that we would get a month off during the rains...My job is driving me nuts. The boss knows it and that's why he's giving us a month.

Lt. McLean of Clemson and Blythewood, S.C. and Capt. [Jeff] Davis of Clemson and Albany, S.C. both work for me. I don't have a Northerner in my outfit. Davis has a lot of pictures we made but can't get developed yet. I have had many pictures made with the boss [Stilwell]—not the one that wrote you [Boatner]—but I can't get my hands on them.

Haven't seen a female since mid Jan. I'd really like to have a date and go dancing.

The packages haven't started to arrive yet but they haven't had time. Don't worry 'bout them.

Looks like I can't get a promotion. I'm supposed to have at least 16 months in grade as a major but that seems mighty long. I've just had a year. Maybe I can get it before I come home. From the looks of the way this rotation plan is working, that won't be for the duration [the end of the war]. Don't tell Flo tho. She seems to expect me on the day 2 years are up or before.

I haven't lost much weight. I never did fluctuate much…

I've taught my orderly [Sam Wu] to drive my jeep and he is really a happy fellow. That reminds me, it's payday and I haven't paid him yet.

Haven't heard from [sisters] Hope or Bruce for several weeks now. I enjoy their letters very much but seldom have a chance to write them. You can name the colt Flo if it's a [filly]. How 'bout that? Give my love to all and write when you can. I never hear from [brother] Joe. How's he doing?

Love to you and Doc,
"Bo"

The opening day of the monsoon arrived, multiplying the difficulties of fighting and keeping the troops supplied for the assault on Kamaing. The Japanese had orders to hold Kamaing at all costs, and the Allies were forced to slug it out in the mud between showers.

As the 66th Regiment moved off one morning, Dad felt a sudden, urgent call of nature. He made his way quickly to the latrine trench and then set off with the column. But within an hour, he was hitting the bushes again. And again.

Dysentery.

It could have come from anywhere: Sam's filthy rag wiping his rice bowl. Water improperly boiled or purified. Eating with hands impossible to sanitize. Rice or other food fouled by the cooks' germy hands. It was amazing that he hadn't succumbed sooner.

He was careful to add a couple of Halozone tablets every time he filled his canteen, waiting thirty minutes to let the purifying chemicals work before taking a swig. But the Chinese sometimes swallowed a tablet and then drank from a stream. It was the same with Atabrine, the quinine substitute used to ward off malaria. Instead of taking a pill daily, soldiers often waited for an attack, then vainly swallowed a handful of pills.

Dad soldiered on, but in his weakened state he was struck with recurrent malarial fever, attacks that lasted two or three days and rendered him shaky and delirious.

"It makes you feel sick as a dog. You're dragging bottom for half a day, then you start having chills. The chills last an hour or two. Then the fever comes on and it goes up real high. For 24-48 hours, you have a high fever. I'd just lie there in a hammock or wherever I was and sweat."

By late May, he could barely function. He crawled out of his fever bed long enough to stagger to the slit trench where he passed pus and blood. Colonel Smith ordered him evacuated to the 20th General Hospital in Ledo. Gratefully, he climbed into a C-47 at Warazup for the short flight to Ledo. Ironically, Dad flew back to Ledo in an hour from a point in the jungle that it had taken him five months to reach.

He had left home two years earlier in full health, weighing one hundred seventy-five pounds. The 20th General Hospital checked him in at one hundred forty-one pounds. But there was a bright side.

At least I won't get shot at for awhile.

CHAPTER 34

COMMITTED VERSUS WARY

Dad had wide ranging interests and curiosity, but he wasn't fickle. Once he made up his mind that he wanted something, he was like a dog with a bone. When Dad sat up in front of the stack on the *Ile de France* and made up his mind "that Flo gal is the one I want to be my wife and the mother of my children," it was a turning point in his life. And it was a commitment for life. Despite dalliances overseas, Dad focused on his campaign to win Mom back nearly every day of the two years he was gone.

Mom, on the other hand, was a bit wary. After all, she had been hurt by this man's ambivalence in the summer of '42. While part of her - maybe a big part of her - was still deeply attracted to him, she was keeping her options open until he stood in front of her and put a ring on her finger. But she could hardly forget him: Throughout her scrapbooks we see reference to a letter from Bo, a bracelet from Bo, an enormous orchid corsage from Bo, paper scraps of Japanese and Indian money from Bo. Bo sends his battlefield souvenirs to Flo and asks her to distribute them among his relatives. Even from a distance, Dad insinuates himself in every part of Mom's life. It is all part of a campaign to keep his image bright, even while she is dancing with other men. And the plan works, as Dad is the one Mom finds herself consulting about decisions like whether to go back to college.

In the course of discussions about the engagement ring and its return to Lynchburg, the Traywicks invited Mom to visit them in Cameron and Dad naturally encouraged her to go. She made the visit in February 1944, during a winter break from school. She

was charmed by Dr. Traywick and Miss Janie and the feeling was mutual. Doc gave her a box of candy for Valentine's Day. They exchanged news of Bo, and Mom lingered over the family photographs of him as a boy and a young man. Miss Janie gave her a photograph of Bo from his senior year at Clemson. Meeting Dad's parents and staying in his home added substance to Mom's memories. "It was almost like being with Bo," she wrote in her scrapbook.

Still, she maintained an active social life.

Throughout the spring of '44, Mom squeezed college classes at Randolph-Macon Women's College in between evenings of volunteer "work" at the local canteen for ferry pilots and weekends of socializing in Washington, where she stayed with her sister Betty, whose husband Ed was stationed at the Pentagon.

Other than the absence of men of a certain age, Lynchburg was initially untouched by the cataclysmic conflict sweeping around the globe. But eventually, the global conflict reached even to Lynchburg. Preston Glenn Field was a stop for the men who ferried new airplanes from Floyd-Bennett Field in New York to Pensacola Naval Air Station. It was kind of a shake-down flight for the plane. The ferry pilots would R.O.N.—Remain Over Night—at the Virginian Hotel. An Officers' Club was established there, manned and managed by the townspeople. The club was more of a canteen, a room set up as a lounge with a record player, Co-colas and local girls acting as hostesses.

Barbara Gough organized the hostesses. She joked that she'd hear the drone of planes, go outside and count, "1-2-3-4-5-6-7..." then go call six girls to meet at the canteen. Barbara often called Mom and her friends and after awhile, the girls got to know the pilots who came through regularly.

A pilot from Michigan named Bill Bay took to calling Mom whenever he came through. He flew the new Grumman F6F Hellcat, a fighter plane based on aircraft carriers that became the Navy's workhorse, successfully taking on the Japanese Zero and

helping reclaim the Pacific. Whenever Bill Bay came to town, he would buzz the Neher house to let her know he was there. The next morning, as Mom sat in class at Randolph-Macon, she could hear Bill buzz the college to let her know he was gone.

Sadly Bill was one of her beaux who never came home. Mom hadn't heard from him in awhile, and one night at the canteen, another pilot told her his plane had gone down in the Caribbean.

Other beaux visited Mom in Lynchburg or invited her to Washington or Annapolis or New York, occasionally encroaching on her school schedule. After one weekend in New York, she cabled her parents to meet her train at 4:30 a.m. Monday, leaving her a few hours to catnap before her first class.

Springtime also included teas, rehearsal dinners and weddings for her friends, several of whom married ferry pilots.

The occasional letter from Steve Thornton from who-knows-where in France gave her a flutter.

But gifts and letters from Dad gave her the most pleasure. How he arranged this from the depths of the Moguang Valley, I'll never know, but for Mom's twentieth birthday on May 9, he sent her a beautiful string of pearls. Just for fun, she took her engagement ring out of the jewelry box and preened in front of the mirror with the pearls and diamonds from Dad.

Oh Lord, she prayed, *bring him home soon.*

CHAPTER 35

MALARIA – 20ᵗʰ GENERAL HOSPITAL
MAY 31 – JUNE 10, 1944

The nurses at the 20ᵗʰ General Hospital at Ledo never looked so good to a sick and debilitated Major H. V. Traywick. After a shower and clean pajamas, he fell gratefully into a real bed while nurses—women!—brought him trays of food with nary a grain of rice! It was glorious, but despite his illness and exhaustion and despite all the comforts of a civilized hospital, Dad didn't sleep well. His mind, trained to remain alert to the sound of creeping enemy soldiers or distant firefights, would not surrender to the kind of deep restorative sleep he needed. He dozed fitfully, starting at the sound of a door closing or a nurse's footsteps.

The next morning, he awakened to a nurse's voice booming, "Butts up!" It was time for the morning round of injections for the patients on the malaria-typhus ward. He dutifully rolled over so the nurse could give him a shot in each cheek. Each morning for ten days, Dad received a shot of emetine and one of carbazone. Emetine is a cumulative poison leading to heart damage, as he had learned in Ramgarh. He hoped this was his last bout.

Word had gotten out that Major Traywick was in residence at the hospital, and a steady stream of WACs and nurses filed through the ward to feel his forehead and hold his hand. As he wrote home to his parents, "I have lots (about 6 a day) of visitors. So far there have been no run-ins—the timing is real good." He told his parents that he wasn't terribly sick, which they took with a grain of salt. However, his manifest interest in female visitors reassured them.

Being young and basically healthy, Dad responded well to the treatment. Two days in the hospital put him on his feet again, thin and weak but ambulatory. The doctors declared him a walking patient: after his morning shots, he could go wherever he wanted the rest of the day. He picked up his mail and found a stack of letters from his mother and joy of joys, a handful from Mom. He responded by sending her flowers.

While Dad was at the 20th General Hospital, the floor filled up with evacuees from the fighting at Myitkyina—"Mitch."

Supported by 4,000 Chinese troops and 600 Kachin Rangers, Merrill's Marauders had taken the Myitkyina airport two weeks earlier, on May 17. Myitkyina was the biggest prize in north Burma, the key to controlling the air, and therefore the battle-ground of north Burma. They shocked the lightly-held garrison by attacking from the north after a horrific march

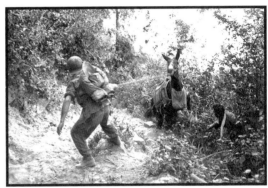

Merrill's Marauders crossed the lower Himalayas with mules for a sneak attack on Myitkyina in 1944. *(Photo by Daniel Novak, US Army)*

with pack mules over 6,000-foot mountain passes, a march reminiscent in its audacity and suffering of Hannibal's crossing the Alps with elephants. But success came at a high price.

The ward full of groaning, restless men proved to be the last remnants of the famed commando unit, decimated by the horrendous trek. The ploy, while successful from a battle standpoint, destroyed the weary troops, exposing them to a nest of typhus mites. The already-depleted unit suffered great losses from typhus, a painful, often fatal disease. Nurses wrapped the men in cool wet blankets and turned floor fans on them to bring down their high temperatures.

One night, Dad was alerted by a flurry of activity around a colonel who lay in the bunk diagonally across from him. The officer, suffering the excruciating pain of typhus, had slit his wrists, but the nursing staff saved him.

The rest of the night, Dad lay in bed thinking about the level of desperation that would drive a man to cut his wrists.

One afternoon a few days later, he noticed the colonel was gone. This time the man had cut the artery in his groin and bled to death in his bed.

"Man, he wanted out of there," Dad told the peanut gallery. "That typhus must be a terrible thing." Dad had a highly-developed instinct for survival and the incident of a man taking his own life made a lasting impression on him.

In the next ward over, there were six typhus cases that had come in just a day or so earlier. One of them, Lt. Sam Wilson, suffered from malaria and dysentery as well as typhus. By the time Dad was released, only one of the six remained: Wilson, a twenty-one-year-old Virginian whose heroism with the Marauders would be chronicled in books and film. Wilson later became president of Hampden-Sydney College, and Dad had lunch with him one day to reminisce about the war.

When his ten-day treatment was complete, Dad went to *shwebu*—headquarters—to find out when he could expect orders to return to the 66th Regiment. To his surprise, the clerk told him he could not rejoin his unit until he went on R&R. Horrified by the condition of men evacuated from Merrill's unit, the hospital director, Colonel Isidor Ravdin, refused to release infantrymen directly back to the front.

Dad always chuckled about the conversation. "So I said, 'Okay, give me some orders so I can go on R&R.'"

The clerk layered a piece of carbon paper between two copies of an Army form and rolled them into his typewriter. After typ-

ing a few sentences, he yanked the papers out, stamped and dated them, initialed them and handed a copy to Dad.

Sixty years later, Dad could still recite the orders: "Proceed to your destination on temporary duty and upon completion of that duty, return to your proper station." He was tempted to laugh. "What does that mean?"

The clerk shrugged. "Well, you can't go home, but you can go anywhere else you want. In the theater. Take another week or ten days and come on back."

Dad would have fit in well with the Millennial Generation and their passion for experiences. He was always attracted by the chance to have a new experience and, within reason, an adventure. Since war is chiefly characterized by adventure and the chance to have new experiences, Dad got plenty of both, just not always in the doses he preferred.

Whenever the peanut gallery reminisces about Dad's adventures overseas, Mom is sure to chime in with the somewhat bizarre comment, "Oh, your father had a grand time in the war!"

At virtually every stop on his global travels during the war, Dad sought a drink and someone to socialize with, but he never lost sight of the fact that his presence in each foreign country was temporary and unlikely to be repeated, and he put his drink down long enough to visit the local cultural and historical sites.

So when the clerk at *shwebu* typed out Dad's orders for R&R, giving him a blank check to travel, he couldn't have been more pleased.

CHAPTER 36

R&R - INDIA
JUNE 11-24, 1944

Armed with government orders enabling him to hitchhike by air or rail, Dad set forth to take full advantage of his required period of Rest & Recuperation. He drew some pay and caught a ride to the airport, intending to fly to Calcutta on the "meat plane," a plane that brought in food and supplies for the base and the hospitals every morning. He was excited about the prospect of roaming around India, going to see the Taj Mahal, maybe finding a place that would serve him a scotch-and-water, but his vacation started with an unsettling episode, one he clearly relived as he recounted the story.

As he waited at the airport, he was surprised to see Captain Robert Kadgihn get off a plane with a group of officers and men. Dad's face lit up when he saw his roommate from Ramgarh. "Hey, Kadj, where are you headed?"

They quickly exchanged stories: When Dad was sent to Ledo in December of 1943, Kadgihn had remained in Ramgarh with Gunther Shirley, and the two continued to train successive classes of Chinese troops.

Kadgihn, whose natural military bearing Dad envied, drew himself up and said, "Myitkyina. We've been called up to relieve Mitch."

After the initial success of the surprise attack on the Myitkyina airport, the fight to control "Mitch" quickly degenerated into a protracted siege. The Allies held the airport but faulty intel-

ligence and a series of blunders by the Allies gave the Japanese a chance to fortify the town itself from about seven hundred troops to more than 5,000.

Allied troops were so exhausted that officers reported their men fell asleep even while under fire. Stilwell had no troops in reserve. In desperation, he resorted to calling up untrained engineers working on the Ledo Road, staff officers who had never been anything but desk jockeys, and various other support personnel.

Dad's face fell. Kadgihn was a topnotch instructor, but as he himself had learned through terrifying lessons, teaching weaponry had nothing to do with survival in a jungle war. "Oh man, Kadj, that's a hellhole. Look, why don't you come back with me?"

Kadgihn looked almost offended. "Bo, I can't do that. They need us." He jerked his thumb at the troops exiting the plane. "We had to teach these guys how to load a rifle while we were coming out on the plane."

Aghast, Dad said, "Listen, Kadj, this jungle is something different from anything you can imagine. Living in a damn jungle with Japs all around, it takes getting used to. I can ask for you right now and you can come with my unit until you learn something."

"We're going up there and take Myitkyina," Kadgihn said, his eyes burning.

Dad always paused here, his face grim as he recalled Kadgihn's passion. "He was a handsome man," Dad would tell us, "and he looked like an officer. He just had that military bearing, you know? I tried to get him to come with me and learn a little bit about the jungle. But he was offended. He wouldn't consider it. He wanted to go kill all the Japs and win the damn war." Dad would stare across the room, seeing the handsome captain again.

Dad stuck out his hand. "All right, buddy, take care of yourself."

Kadgihn shook his hand vigorously. "I'll see you when we get back. We'll meet at the O Club."

"You bet."

Dad had seen the remnants of Merrill's Marauders in the hospital and now he saw how desperate Stilwell was for reinforcements. "They got people from Delhi and Ramgarh who had never been in combat. And they loaded these boys on the planes with engineers, cooks and people from the supply quarters, showing them how to load rifles and machine guns *on the airplane*, flying up there."

Myitkyina was important, but that was crazy.

Dad took his bag and walked across the tarmac to the meat plane with a knot in his stomach. He felt strange taking a vacation when such desperate fighting was going on, but by God he'd earned his break.

Dad could have spent his R&R in Calcutta at the Grand Hotel, eating, sleeping, drinking, partying, a blotto respite from the war, but he had a restlessness and curiosity to see what India was all about. At each stop, he consulted with other officers about what there was of interest to see.

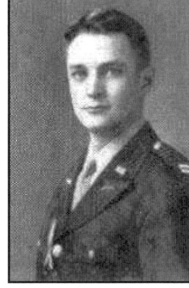

Capt. Robert C. Kadgihn, Dad's roommate and colleague from Ramgarh. "He looked like an officer." *(Iowa City Press-Citizen)*

Dad's impression of Calcutta, which he had visited on leave from Ramgarh the year before, was that it was hot and dirty, like everything else in India. The frenetic competition among cars and foot traffic dismayed but no longer shocked him. The beggars besieged him. The famine was just as deep, the city just as dirty, the people just as impoverished as before.

Calcutta is in the delta of the Ganges River, which Dad dutifully went to look at. He saw funeral pyres on the banks and women bathing in the muddy water. The people shared the river

with giant turtles, some of them almost as big as a table, Dad said, making a circle with his arms. "Some of them were huge." He was incredulous when told that dead babies were consigned to the waters and the turtles would dispose of them, eating all the flesh in minutes.

Everywhere he looked he saw starvation and sickness. There was no food and no medicine or medical care. The poorest of the poor back home in Cameron didn't suffer like this. He was awed by the scale of the suffering.

It was hardly a refreshing way to spend his time off from the war, and he decided to go to Agra. Agra had a big air base with good accommodations, a regular mess hall and a bar. If he went to Agra, fellow officers told him, he could get a drink or even a Co-cola.

At Dum Dum Airport outside Calcutta, he met the aide to some general who offered him a lift as far as Agra. Thinking how nice it would be to visit with the general on the flight across India, Dad climbed on board the old DC-3. But he found himself riding in the back of an empty plane while the pilot, the co-pilot, the general and his aide sat in the cockpit together. The cargo plane had been configured to carry troops, so the otherwise empty fuselage had a rainforest of webbed slings hanging from the overhead. Dad settled into one and rocked along to the drone of the engines and the *whop-whop-whop* of the propellers for the five-hour flight, dreaming of whiskey and Flo.

Dad was an engineer at heart, and he was impressed by the ingenious semi-air-conditioned pyramidal tent he was assigned at Agra Air Base: One of the sides had been rolled up about four feet, and a woven hemp mat hung across the opening; along the top of the mat ran a perforated pipe, trickling water down the mat while a blower wafted the cooled air through the tent.

"The jungle wouldn't have been so bad if I'd had one of those rigs," he said.

The Taj Mahal in 2011.

Following a visit to the bar, where he enjoyed a scotch-and-water—no ice, of course, this being British India—and a nice meal, he caught a taxi and went to see the Taj Mahal. The world-famous landmark had no official presence, no guides, no ticket sellers. He wandered alone through the 17th century mausoleum and around the grounds, marveling that such a beautiful creation would be desecrated by trash and filth everywhere.

The next day, after asking for other sightseeing suggestions, Dad took a taxi out to the edge of the Indian desert. "India has a hellacious big desert," he told us in a tone of voice that suggested his eighth grade geography teacher had skipped a few things. The driver drove him to a picket line of camels and, with many gestures and exhortations in Hindi and a few words of English, urged him to hire a camel and ride out into the desert. This seemed like an unusual opportunity and Dad readily accepted, contributing a few extra rupees to the local economy. He eventually adjusted to the camel's gaits, but the desert view quickly palled. "Fifteen minutes and you've had the tour."

Picking up more tourist advice at the base, Dad decided to fly to New Delhi and see the ancient walled city of Old Delhi. He took a rickshaw ride powered by a scrawny brown man clad

in a loincloth and found squeezing through the crowded, honking streets more nerve-wracking than being jerked around in a taxi. Traffic bent around a cow, chewing its cud in the road. At intersections, the foot and wheeled traffic meshed with no apparent pattern but no apparent injuries either.

Delhi is said to be built on the site of seven previous cities and has over the centuries been home to various heads of state. Several of these centered on the Red Fort, built in 1052 with great walls made of enormous red blocks and surrounded by a dry moat. By 1803, the British had moved in, but Dad noticed they had barely cleaned the place up.

He wandered through the trash-strewn Red Fort and nearby Chandni Chowk, the bazaar, taking in the vendors squatting over tiny grills, the eye-dazzling swaths of blue and red and yellow silk, the wretched often hairless dogs nosing about, the large white eyes in the small brown faces of the urchins who pulled at his uniform begging for an *ana*. The stew of curry, cow dung and incense nearly overpowered his American nose.

Lacking a wingman, Dad found his tour of India's prominent sites vaguely unsatisfying. One site he skipped was the U. S. Army headquarters in Delhi. Dad had a field officer's contempt for desk jockeys. He never mentioned Delhi headquarters without muttering, "Bunch of jerks in there."

Dad's R&R took a decidedly pleasant turn when he recalled that there was a resort at Masoori, a summer hill station in the Himalayas north of Delhi. He rode the train to Ghaziabad, where he caught a bus to a staging area halfway up the 6,000-foot mountain, then switched to rickshaw. The road was so steep, it took five men to convey each rickshaw to the top, two pulling and three pushing.

At the crest of the mountain, he found a narrow road servicing bungalows and resort hotels frequented by the British during the hot summer months. Wrapping around Masoori on three sides was a splendid view of the Himalayan Mountains.

"It wasn't plush like the Greenbrier, but they were nice hotels. From the ridge along the top of the mountain, you could look over at Tibet. After the war, when the Dali Lama left Lhasa and came out of Tibet to escape the Chinese Communists, he went to Masoori." Tibet was a land of mystery at the time, and Dad counted himself lucky to have the rare experience of seeing, even at a distance, the remote, exotic country.

After the privations of the jungle, the awkwardness of life with the Chinese and the depressing conditions of Delhi and Calcutta, Dad was ready to socialize with cultured, English-speaking people. First he met a British officer's wife who made him feel welcome. Next, in keeping with his habit of skimming the cream off the top of the milk pan, he struck up a friendship with the local royalty.

In the bar one night, he noticed a uniformed young man of Indian lineage. Dad had learned to distinguish between the British and Indian uniforms, and this man was a 2nd lieutenant, British Crown. He struck up a conversation and the two men had a drink together.

"Where are you assigned?" Dad asked.

"I am with the British office in Delhi," the officer said, "where I have been for the past eight years." He shrugged in mock weariness.

"Eight years? And you're still a 2nd lieutenant?"

He laughed, "Yes! My father told them not to promote me because it might show favoritism."

It turned out his father was the acting raj for the nearby state of Mandi and Dad's new friend was the prince. "My grandfather," he told Dad, "was the maharajah but he has retired."

Here someone in the peanut gallery would say, "Who knew that maharajahs retired?"

Dad had at last found something interesting to do on R&R. During the following days, he socialized with Prince Mandi several times, talked with other guests in the hotel and of course, did his best to keep the British officer's wife entertained. One evening the prince invited him to a cocktail party in his suite. We never heard who all was there other than some "beautiful women" who were "the upper crust".

Dad always felt comfortable in any company, from the lowliest Chinese coolies to foreign royalty, and it seemed natural to him, when he got home to America, to want to return Prince Mandi's hospitality. Accordingly, one day he said to Mom, "I think it would be a good idea to invite Prince Mandi over." Given that they were living in an attic apartment with a new baby and no furniture, Mom said, "I don't believe our lifestyle is what he's used to." But Dad issued the invitation anyway and a few weeks later a letter on heavy vellum arrived by diplomatic service, not through the regular mail.

"Fortunately," Mom said, "the prince declined."

Mandi.
Himachal Pradesh, India.
21st August, 1948.

My dear "BO" Traywick,

Thank you ever so much for your kind letter. I am very sorry that such a long delay has occurred before I could reply to you. But the truth of the matter is that I have been away in Europe for quite a long time and have only recently returned. Your letter unfortunately was not forwarded to me. It is indeed very kind of you to renew your invitation to me to stay with you when I come to the States. I am sure your new house must be ready by now.

As to the question of rugs, I will certainly try my best to send you some when I am next in Bombay which ought to be in the very near future.

Ofcourse my coming over to the States is not very easy as you will know because of all these restrictions on exchange. If you can give me any in this respect I will be very thankful.

With best regards to you and your wife. Hoping to hear from you soon.

Yours sincerely,

PART V – THE END OF LOTS OF THINGS

CHAPTER 37

BIG SUMMER ON THE HOME FRONT
SUMMER 1944

By the summer of 1944, tension about the war had heightened unbearably. The United States was well into its third year of all-out fighting. More than three hundred thousand Americans had already been killed, and who knew how many more lives would be taken. Despite the concerted will of the Allies and the enormous resources being directed to supporting the fighting, there was, as yet, no clear picture of what the outcome might be. Every aspect of the American economy was devoted to production of supplies for the war, as factories produced the 88,410 tanks, 1,410 warships and 325,000 aircraft needed for the effort. Ultimately, this ability to produce more and better equipment to replace that lost in battle would win the war for the Allies.

Periodically, President Roosevelt, Prime Minister Churchill, Premier Stalin, and, on occasion, Generalissimo Chiang K'ai-shek got together to argue about how to prosecute the war. Churchill, for instance, insisted on a two-pronged invasion of Europe to defeat the Germans. He wanted to finish the war in Europe before dealing with the Japanese in the Pacific. The United States and China wanted to open the Ledo Road to China and re-capture some more islands in the Pacific in preparation for an invasion of Japan. Roosevelt also wanted to invade France as soon as possible

and was frustrated by Churchill's delay. Stalin wanted the others to invade France while Russia fought the Germans on the Eastern Front; privately, he wanted (and got) a free hand to influence Eastern Europe following the war.

The Normandy invasion took place on June 6, 1944, while Dad was in the hospital with malaria. The tremendous casualties from the invasion of Normandy and the subsequent push across France were sobering but rationalized as the price of defeating a brutal and determined enemy. The progress across France, though costly, gave hope to all that an end to the struggle was perhaps in sight. At the same time, U. S. troops were reclaiming the Pacific: Saipan, Guam, the Philippines—also at great cost, but also inspiring hope. Major battles were being fought in every theater around the globe in the summer of '44: Normandy, Minsk, the Philippines and Myitkyina. Success in Normandy and Minsk would, it was thought, ultimately lead to the defeat of Germany. Success in the Pacific battles and Burma would set up conditions for what military planners dreaded but expected to be necessary for victory: invasion of Japan.

Tucked away at Randolph-Macon Women's College in Lynchburg, Mom didn't feel the tension of the war as intensely as she had in Washington. Out of school for the summer, though, it was necessary to run madly about the social circuit in order to keep from dwelling on her fears for Bo, Steve and all the rest. In early June, Mom embarked on a dizzying round of visits and socializing from Washington, D.C. to Atlanta. The Lynchburg paper faithfully reported her travels with information provided by her mother. Notably, Nana described Major Traywick as Mom's fiancé, despite the private ambiguity between the principals. Of course, Mom did have the ring again, even though she wasn't wearing it.

"Miss Flo Neher and her guest, Mrs. F. M. "Cile" Moise, have left for [Cile's home in] Sumter, S.C., where Miss Neher will spend awhile and will go later to Cameron, S.C., to visit Dr. and Mrs. Paul Traywick, parents of her fiancé, Major Heber Venable Traywick, who is in [Burma] with the U. S. Army. From Cameron,

she will go to Fort Benning, Ga., to spend the greater part of the summer with her brother, Captain C. Richard Neher, member of the faculty and staff there, and Mrs. Neher."

And later…

"Miss Flo Neher, who has just returned from visiting her brother and sister-in-law…left last night for Washington where she will be the guest of Madame Louis d'Argy [Pat Neher's grand-mother] for the weekend."

Then…

"Miss Flo Neher is in Greenville, S.C., where she will be among out-of-town guests for the wedding this afternoon of Miss Emily Bull to Deas Manning Richardson. Later Miss Neher will continue to Fort Benning…"

At last…

"Miss Flo Neher, who has been visiting in the south, is expected home early next week."

- Exhausted, no doubt.

Mom continued to fill her scrapbook with corsages, pictures, postcards and programs from her summer travels. She also continued to collect love-struck beaux, something that would eventually create complications in her life.

One of these was Cile Moise's first cousin, "Big" George Levi. Big's family owned a cotton farm in Abbeville, S.C., and lived in the Secession House—the house where town fathers approved the state's decision to withdraw from the Union in 1861. Very taken by Mom, Big dominated her time during her visit and pursued her throughout the summer and fall.

Another soon-to-be problematical beau was Jim Browning, an old beau from West Point, class of '43. After leaving Big and stopping by Cameron, Mom took the train to Ft. Benning where,

by now, she probably knew more people at the Officers' Club than her brother did. It was there she reconnected with Browning, giving him a lot of her time. No sooner had she returned to Lynchburg than Browning called to say he was in Washington. She hopped the next train to say goodbye to Jim, who was being dispatched overseas.

At home at last, Mom found a thick letter from Dad that included the humorous menu for a "banquet" they held in the field: "Kachin Inn – Burma's Leading Night Spot, Wu & Wang, Managers, H. V. Traywick, Proprietor." She lovingly pasted the handwritten paper in her scrapbook: "Bo moves into rest area. Menu for a banquet they had one night. Celebration after weeks of rice. Aug. 1944."

<div align="center">

Kachin Inn
Burma's Leading Night Spot
The Venetian Room
July 27th
Dinner Menu
Fruit juice cocktail
Hot Tomato Consomme
Chili a la [censored]
Peas Carolina
Corn canned
Cheese, preserves, biscuits
Caramel Pudding
Coffee
Sweets

</div>

Wu & Wang H. V. Traywick
Managers Proprietor

Dad's letters had begun to speak of his coming home. He had been overseas for almost two years and would soon be due for some R&R stateside and a new assignment. The Army had established a point system for determining when an individual had earned a trip home. Points were accumulated for being married,

time served overseas, number of siblings in the service and other factors. Every soldier kept a close accounting of his points.

Dad thought he might be home for a break around the first of the year. Although nothing was settled, he and Mom were again talking about getting married. In a significant move, Mom decided not to re-enroll at Randolph-Macon that September. In those days, students paid tuition for the entire year. If you left midyear, you got no refund and no credit. If Dad showed up in January or February and wanted to get married, Mom knew she would drop out in a New York minute. So, why risk losing an entire year's tuition?

Mom's fears about Dad's ambivalence had clearly been assuaged, and she had met no one who could take his place. Her decision about school was the biggest indication that she was, in fact, eagerly awaiting Dad's return from overseas.

That did not mean she would wait for him at home, of course.

And there was still the matter of Steve Thornton.

CHAPTER 38

DAD AND THE BRASS

My father was a good military officer. He excelled at the military parts—leadership, training, weapons, outdoorsmanship, decision-making—and he was smooth enough to handle the parts involving personnel and politics. Dad's military history is replete with "excellent" and "superior" fitness reports and a half-dozen superior officers who sought to advance his star. Had he chosen to stay in the Army, he would certainly have had a nice career.

He got out because he was ambitious and impatient. Career advancement in the military depends on too many factors outside one's control. Some of those factors are big: Promotion slows down during peacetime, when fewer officers are needed. But some of those factors are small—petty, Dad would say. The negative opinion of a senior officer is difficult to overcome, even in a system putatively based on merit. Dad had tremendous confidence in himself to build a successful career in whatever field he chose, and he wanted to control that himself.

For the most part, he controlled his military career well.

Although Dad came within an eyelash of getting kicked out of Clemson for a prank and he was a casual student, at best, he did well as a military cadet. Among other things, he excelled at summer camp, and he was selected for the precision drill team, a predecessor of the Pershing Rifles.

As a Thomason Act officer in the Infantry, he played a key role in war games at Ft. Jackson, S.C. in 1941. His success-

ful execution of a diversionary maneuver with his platoon allowed Col. R. O. Barton's "enemy" team to capture the defending team's headquarters. That evening, Barton called 2nd Lt. Traywick to his tent for a follow-up report.

Dad recalled that the weather was cold and Barton's tent greeted him with a delicious cloud of warm air, courtesy of a pot-bellied stove. The colonel waved to a tray on the low table before them and said, "I'm having a little drink. Will you join me?"

Dad said he looked at the bottle of bourbon and made some quick calculations. He was twenty-two at the time and had almost no exposure to whiskey, but clearly this occasion called for him to join his host. "Thank you," he said smoothly, "I believe I will." He took the bottle and casually poured half a glass.

Barton stared at the glass a moment and said brightly, "If you can do that, I can, too." And he poured a matching glassful.

As the men sipped their bourbon, the colonel smugly related the day's victory, crediting Dad's diversionary actions as the key. "I'll tell you, we really had a successful day today. They advised me just now that I was promoted to bird colonel. Traywick," he concluded broadly, "you got me a promotion."

Not only that, Barton promoted him to 1st lieutenant.

Later, when Dad was at Ft. Benning, a sympathetic Major Temple G. Holland rescued him from orders to Panama and got him assigned to the Field Officers' School, where he came to the attention of Lt. Colonel Ted Wessels.

Growing up with a shotgun or a rifle in his hand, Dad, like many Southern boys, was a good shot. He also aced the written tests, leading to his appointment as an instructor in the school. Wessels called Dad in one day to say that his performance had enhanced Wessels' own reputation, leading to a promotion to full colonel. Just as Barton did, Wessels gave Dad a promotion. "When I get one, you get one," he said.

A few months later in Birmingham, General Bull gave Dad the prestigious position of general's aide and helped him get his chosen assignment to the China-Burma-India theater.

So by and large, Dad benefitted from superior officers who recognized and rewarded his talent. It was the ones who didn't who got his goat.

After his initial run-in with Colonel Smith at Ramgargh, Dad got along well with the man, earning high marks on his fitness reports, but the pettiness of the original event smarted.

And then he had a bizarre exchange with General Hayden L. Boatner, Stilwell's deputy for the Forward Echelon for the campaign in north Burma.

It's always hard to go back to work after a holiday, and in Dad's case, when he returned from R&R, it was especially so. He checked in at *shwebu* for news, then hitched his way down the Ledo Road towards Moguang.

The continued stalemate around Mitch left him anxious about his roommate Kadgihn. One of his radio teams was there, too. And on top of that, news of the D-Day invasion had reached his side of the world and he worried about his brother. He surmised that Joe was in Europe. Last he had heard from his mother, Joe was with Patton, and Patton was in Europe.

With a jeep ride here and a C-47 flight there, interspersed with stops at Shing and Shadazup to ask where his unit was, Dad made his way down into the dark dank world of north Burma. Leaving the Road below Warazup and hiking the Combat Trail through the jungle with a supply unit made him feel like an escaped prisoner being returned to jail. Late in the afternoon he arrived at a temporary post, established for the duration of the monsoon, alongside a tributary of the Moguang River. He sought out the officers' mess, which, he couldn't help but notice, contrasted poorly with the officers' mess at Agra. The mess consisted of a long tabletop made of woven bamboo strips supported by bamboo

posts in the ground. No sooner had he sat down than General Boatner came in with some of his staff.

As there were only about three dozen liaison officers in the whole CBI theater, few of whom were majors, Boatner recognized Dad. As they exchanged pleasantries, the general said, "I have recently come back from the United States and I wrote your parents and told them the last time I saw you, you were doing well."

Dad smiled. "Thank you, sir. I know they appreciated that."

Miss Janie had written him about the general's letter in February. Senior officers often took the time, when they were in the United States, to write or speak to families by phone. A secretary at the Pentagon would call the family of an officer in the general's command, and the general would get on the line to tell the family their loved one was doing well. It was a huge morale-booster for the family as well as the soldier. Boatner's letter to Dr. Traywick had included some breezy, cheery, hilariously misleading language about field conditions in Burma.

"…while there are leeches, snakes, insects, et cetera, around, they rarely bother us and certainly don't interfere with our sleep. Our food is truly excellent in every respect and is the best in the sector. True we don't have many oysters, lobsters and salads, but we do get fresh meat occasionally and chicken twice a week… In so far as health is concerned, although the country is quite rugged, we seem to have only the ordinary sicknesses that are to be expected in Oriental and jungle countries…So far we have had no special lingering effects from malaria."

Beneath his signature, Boatner had typed a personal note: "Your son was doing a fine job and was in good health and spirits when I saw him about three weeks ago."

Boatner offered Dad a drink, which he gratefully accepted. Things were going well and Dad was pleased to have the opportunity to chat with the Deputy Commander. As the two men talked shop, Dad gave the general a positive report about his unit and the

Chinese soldiers specifically. He mentioned the 66th Regiment's success at Maingkwan and Jambu Bum and worked in his own background on staff with General Wessels at Ft. Benning and as aide to General Bull. Eventually the conversation turned to the challenges of being a liaison officer and persuading the Chinese officers to follow Stilwell's directives. Noting that his opposite number, Ch'en, was a colonel, Dad said, "If I were a colonel, it might give me more leverage."

Here things turned weird. The conversation had been pleasant, but something about Boatner's demeanor began to rub Dad the wrong way. He and his flunkies, as Dad thought of them, displayed the arrogance of staff officers used to fighting battles on paper, and he felt the contempt that field officers often have for those who haven't experienced the privations of the front. As he did with Colonel Smith, Dad found himself forcing a respectful attitude towards a superior officer he wasn't inclined to respect.

Dad held his ground and finally Boatner reared back and spoke. "Traywick, you know, if I promoted you to lieutenant colonel, you'd be looking for a vacancy for eagles [full colonel] right away, wouldn't you?" The general laughed and all of his flunkies laughed.

Dad did not find this amusing but he smiled through his teeth and said, "Yes sir, I probably would." Why the hell not? He'd make a good lieutenant colonel and a good full colonel, too.

Dad could always laugh at himself and taught all of us children that same wonderful attribute, but there was a touch of public humiliation in this episode that always rankled him. "I didn't know what they thought was so goddamn funny," he told the peanut gallery. The next morning, determined to get the hell out of there, he found a boat going down the river to where the 66th was encamped. He just wanted to get in, do the job and get out.

"I was about ready for this damn war to be over."

But as it turned out, he still had a lot of war left on his plate.

CHAPTER 39

COPING

There was a lull in the summer while rains from the monsoon turned the land into a steaming lake. With little to do except report sporadic action by the patrols, Dad spent much of his time in his hammock reading cheery letters about Mom's cats.

He was pleased to learn that General Boatner had succumbed to malaria just a few days following their meeting. Not only that, Dad's old mentor, General Wessels, had taken Boatner's place.

At the end of July, on a visit to division headquarters, Dad learned that the Japanese commander in charge of the troops at Myitkyina had conceded defeat, ordering his remaining troops to withdraw and salvaging his personal honor by committing suicide. This was huge. After allowing time for cleaning up the rest of the valley, north Burma was essentially under Allied control. They had done their job. They had cleared the way for the Ledo Road and the trans-shipment of supplies to China.

Dad shared the excitement of the staff at headquarters with a shot of whiskey. The notion of *winning the war* was a heady feeling. But his pleasure was dashed when he learned that Kadgihn had been killed.

Burned in Dad's memory was the report from an officer who had been in Mitch:

"Those green troops up there…it was awful. They were in foxholes and the Japs were shelling them with mortars, and when

they let up, Kadgihn stood up in his foxhole to see what the situation was and *bang* he got it right there," the officer told him, tapping his forehead. "They were close."

Dad was always haunted by the missed opportunity to save Kadgihn. "I tried to get him to come with me to my unit until he learned a little bit. If he'd kept his head down two more days, he'd have made it. He was about the last one killed up there."

A few years later, when Mom and Dad went to Iowa to visit her grandparents, Dad called Kadgihn's parents in Iowa City. He took a bottle of whiskey and met Mr. Kadgihn in a motel room somewhere and spent the afternoon telling the bereaved man what a wonderful officer his son was.

"I didn't tell him how he died, though."

By the late fall of 1944, despite heavy fighting around the world, it was starting to look as though the Allies would win the war. Mussolini had fallen and the Italians had signed an armistice with the Allies a year earlier, and intelligence estimates of German and Japanese forces pointed inexorably to defeat. But they weren't there yet: Germany and Japan were both in the throes of fanaticism that seemed to grow even as their likelihood of success diminished.

Meanwhile deep in the jungle, Major Traywick could hardly see beyond the man ahead of him on the trail, much less the worldwide outline of the war. Resigned to grinding out the Burma campaign, Dad nevertheless remained on high alert. *I've made it this far, I'm going to make damned sure I make it the rest of the way,* he told himself over and over, continually scanning his surroundings for signs of the enemy, always alert for the telltale screaming of monkeys, adhering to the survival practices that had become second nature.

Reading wartime memoirs, you often find the authors coped with the stress of being in the field through camaraderie with the men who shared the same fears, the same privations and who, in large measure, shared the same background.

But Dad didn't have that luxury. His was not the band-of-brothers experience in war. He spent much of the war alone, even in the midst of an entire regiment. He lived in close quarters with thousands of people, yes, but they were people with peculiar customs and a strange language and who held curious views about the most basic issues of life. It required a great effort to communicate with them, both linguistically and culturally.

Like all creatures, Dad missed being with his own kind.

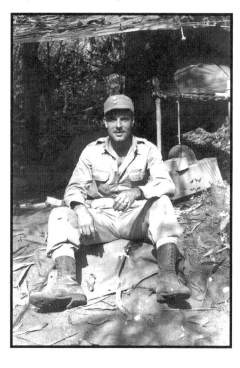

In reminiscing, Dad mentioned Lt. Metcalf, his aide, and Corporal Foreman of his radio team most often, but much of the time he seemed to be in the company of Chinese officers or riding back to division headquarters or withdrawing to his dugout.

Fortunately, Dad had a strong interior life. The psychological hardships of his situation toughened his already-strong psyche. That was undoubtedly the main impact of the war experience on him. He came home prepared to deal with stress in all its forms. No matter what the situation, he could always tell himself, *Well, no one is shooting at me.*

Chapter 40

The Horse Connection

In many of the letters Dad wrote home from overseas, he asked about the horses.

My father loved horses and was a good horseman. He had grown up riding his father's walking horses, horses with a beautiful natural gait called a run-walk, or a flat-foot walk, a motion so smooth they said you could set a glass of water on the horse's back and not spill a drop. Thanks to his father, Dad always had a nice horse and he rode in all the area jousting tournaments, a sport he continued to enjoy even after he married and moved to Virginia.

Doc loved horses and he frequently took a neighbor named Boyce on jaunts to Tennessee to "look at" horses, as he told Miss Janie. If he found one he couldn't resist, which was often the case, he'd ask Boyce to keep the horse for a little while until he could find a suitable time to tell his wife. Dad said Miss Janie knew all about Doc's arrangement with Boyce—it was a small town, after all—but she

Dad competed in jousting tournaments with his mare, Peggy O'Neal. (c. 1930s)

always acted pleasantly surprised when Doc mentioned he had a new acquisition.

Since they had horses in common, Dad begged Doc for a letter with news of the horses. Usually Miss Janie handled all the correspondence, writing both of her sons at war nearly every day. But finally Doc broke down and wrote a long "V-mail" letter, obligingly filling the pages with commentary on the horses.

A letter from Dr. Traywick to Bo, dated Nov. 30, 1943.

Dear Bo,

You know I'm not such a hot letter-writer, but since you asked for it, here's my answer. Janie is an expert letter-writer. Since she is always beating me to the news, I have just gotten out of the habit. It is pretty cold here tonight and I am over at the office waiting for Heber Edward and George Rast to come in for insurance examinations. I am too busy all day long in the office to do that kind of work in the daytime.

All the children have left us now. Bruce and her two gals went home last Tuesday. The little red head is a grand baby to have in the house. She laughs all the time and never cries. If you ever bring any in, she is the kind I want you to bring.

Bruce says [her husband] Bert is well-liked over at Sonoco and is meticulously exact in everything he does, and she expects him to hold down a good job over there.

[Joe's wife] Pat has just called. Hadn't heard from Joe in a good many days. She couldn't rouse Janie until I talked with her. She said the baby is fine. He really is a cute little fellow and makes friends with just about anyone. Can talk pretty well and will try anything you tell him to say.

This is the first V-letter I have tried, so I am using all the space there is on the paper.

By the way, I haven't told you about my horses. Shamrock was a Tennessee walking horse, but I have real Tennessee walking horses. Daisy May Allen is a pure Allen [a prominent bloodline]. She has three gaits: flat-footed walk, about as fast as the average buggy horse trots, foxtrot and a canter-lope. None of these gaits will spill water out of a glass. She was three years old the 10th of May. I am looking for a colt in April from a strawberry roan stallion Boyce brought back from Tennessee."

Then there is Margie Allen, 2 ½ years old. Janie has ridden her but she is not very well trained. I think I'll let her go eventually. I also have a pair of [foals] about 8 months old I acquired while out in Tennessee in September. A beautiful filly and a little stud colt, a son of Fisher's Wilson Allen that will make somebody's mouth water in about 18 months. I ride a little nearly every day and it keeps me feeling just fine after doing about two men's work a day. I'll try to keep a couple of them until you come home. I tried to send you the official yearbook of the Tennessee Walking Horse Association but it was returned from New York. It is called The Blue Ribbon.

I believe these horses will keep me young. You know I'll be 65 in January. I'm afraid I have bored you with all this. I've talked too much about myself, but Janie keeps you posted on all the news.

By the way, she was very much impressed with your girl [Flo]. Liked her fine.

Now if you are contemplating taking on a wife soon after you return, I'd save all the spare change you can, as it takes money to raise a wife. I know, for I've tried it, and it wasn't nearly as expensive then as it will be from now on. You don't have to make an impression on the right kind, just act natural and keep your feet on the ground.

Would like to have some snapshots of you, if it is permissible. Films and cameras are scarce and almost impossible to get, otherwise I would send you some. Most all the boys are gone from here, except the discards. Think of Laurie Taylor being in London town. Bub [Fogle, Joe's best friend] is over there somewhere, too, and Joe has written about going to England. I hope they don't put him in the Channel invasion, as he has been in lots of hazardous engagements, enough for one fellow.

The news sounds good for an early end to the European war, but I am afraid lots of heavy fighting will take place first.

Janie sends love.

Yours, Daddy

While the European Theater was marked by mechanized transport and supply, the undeveloped, unexplored mountainous terrain of north Burma saw widespread use of pack animals and resupply by air. The most adaptable animals were the native Burmese mules, small and

"I believe these horses will keep me young."
(Dr. Traywick, c. 1940s)

nimble enough to manage the steep, muddy mountain trails. The big Missouri mules handled the heavy supply packs but often fell to their deaths from narrow cliffside trails made slick by the rains. Dad always felt bad for the Australian ponies. "The Chinese loaded those ponies up with packs fit for big army mules. They'd almost knock those little horses to their knees." Although wiry and tough, they were too small to carry the big mule packs through such arduous country and those that weren't killed in battle eventually succumbed to exhaustion.

To his surprise, Dad had the opportunity to ride while over-seas - and not just elephants and camels. When a herd of Australian ponies arrived in Ledo, he selected the best of the lot and put his name on the little horse, riding him off and on throughout the campaign. He named him Pungyo, Chinese for "Little Buddy".

In May of 1944, down near Maingkwan, when Dad was so debilitated with dysentery and malaria that he could barely walk, Pungyo carried him along the trail. When he returned to his unit after treatment, Pungyo was waiting for him.

By late October, the 66th Regiment was approaching the Irrawaddy River and preparing to take the town of Shwegu on the far side of the wide river. After ten months on the trail, Pungyo had suffered as much as Dad had, and Dad had taken to leading the struggling animal through the rough, swampy terrain.

One day as they set off through a marshy area of elephant grass, Dad elected to ride his horse. Riding the horse was about the only normal thing in his life. Although the animal was nothing like the well-bred horses his father kept, he enjoyed the connection, tenuous as it was, to his memories of home. But the horse had some age on him and the burden of the campaign had done him in. On that day, the animal struggled through the swampy footing, lurching as he tried to keep his feet with the weight of a man on his back. Finally, the horse stumbled heavily and Dad stepped off as the animal fell to his knees and rolled on his side. Horses do not like to lie down, instinctively fearing the vulnerability of being off their feet. When the horse did not immediately try to get up, Dad felt the pistol on his hip, hesitated and called his orderly.

As Sam Wu struggled through the marsh to his side, Dad looked at the thin animal, his coat dull, his hips pointed like knobs, his head lifted slightly out of the mud. The horse finally made an effort to get up. Flailing around, he struggled to his feet, where he stood uncertainly.

"Sam."

"Yes sir, Major."

Pointing to the horse, he said, "Now Sam, I want you to take this horse over there and wait for the soldiers to come along. Have one of the fellows shoot him. Shoot him in the head, right here." Dad pantomimed holding a gun to a point below the animal's ear.

"Why shoot horse? Bad horse?"

"No. Good horse. Sick. Old."

Sam nodded and took the reins.

"Sam, you stay with him," Dad ordered. "I want this done right." He feared the man would simply turn the horse loose and the tigers would get him.

"Yes sir, Major. We shoot horse."

"You know where to shoot?" he asked, stepping close to the horse again. "Right here." He tapped the side of the horse's head. The horse nodded at the touch and Dad ran his hand down the scrawny neck. "All right, Pungyo, buddy," he said gently. He stepped back and turned to pick up his gear, fussing with the straps as he shouldered his rifle and splashed through the marsh.

Sixty years later Dad still worried about Pungyo. "I should have done it myself."

CHAPTER 41

CROSSING THE IRRAWADDY
NOVEMBER 1944

In late October, Stilwell sent the 66th Regiment on a special secret mission: cross the great Irrawaddy River and capture the town of Shwegu, a British outpost then controlled by the Japanese. It was the beginning of a magical period for Dad, as they moved out of the dark undeveloped north Burma jungle into the more populous river valleys, grass plains and teak forests of the country's midsection.

As they camped along a wide stream, Colonel Lo, who had by this time replaced Colonel Ch'en, told Dad the 66th was approaching the Irrawaddy just upstream from the town. It had been months since Dad had faced a serious battle, and he often said he worried more about Shwegu than any other. The difficulty of launching an attack across the enormous river, swollen by the summer rains, certainly gave him pause, as well as the fear of a preemptive ambush by the Japanese.

The Irrawaddy winds through tall teak forests and, fed by the monsoon rains, flows past Shwegu in a huge swath of water that may at times be more than a mile wide. The enemy was well entrenched in the town, prepared for the Chinese attack and sending mortars across the water in warning. The logistics would be daunting. After Dad and Colonel Lo agreed on a plan, Dad called in a supply drop. The next morning, dozens of brightly-colored parachutes blossomed like tropical flowers over the drop area.

Dad helped plan the attack, which involved a secret night crossing, and hiked through the elephant grass marsh to supervise

the crossing. As the twilight deepened, he watched the troops make the river crossing as he had trained them to do. Back and forth makeshift rafts quietly ferried soldiers all night. At dawn, the main body and the headquarters braced for an artillery attack while the forward company eased into the town. Dad paced as Colonel Lo waited serenely for news. The radio team called first, reporting - incredibly - that the enemy appeared to have withdrawn from the town.

Villagers confirmed the retreat and the company secured the town without a shot fired, to Dad's immense relief. He speculated that the sky full of parachutes bringing supplies over the course of several days had convinced the enemy that an overwhelming force was preparing to attack them.

The Chinese engineer corps built bamboo barges some twenty feet wide to ferry the rest of the troops and the supply train across the broad river. Dad spent two days on the riverbank, directing the loading of the barges. At previous river crossings, the wranglers swam the horses across, but the Irrawaddy was too swift and wide. Dad had the men tie bundles and boxes around the edge of each barge and then load the horses into the middle.

Here someone in the peanut gallery would say, *I'll bet that was a long day, loading horses on a raft!*

Dad always shared with the peanut gallery his wonder at how smoothly the operation went. "I would have thought so, too, but we didn't have a bit of trouble with them." The overburdened pack ponies were probably glad they didn't have to swim.

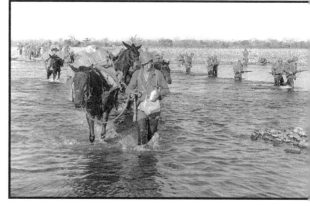

Horses and mules (and men!) seldom had the luxury of a bridge. *(photo by Daniel Novak, U.S. Army)*

Dad rode across with a load of horses himself, gazing up and down the wide waterway and packing away memories of the beauty of the scenery.

The enchanting scene continued on the far side. The town's weatherboard buildings were made of teak and shaded by towering royal coconut palms, creating an idyllic picture. However, the beauty of the village was threatened by the Chinese, who began chopping down the palm trees to get the fruit, until Dad insisted Colonel Lo put a stop to it. Dad also noted lingering evidence of the British presence there in the number of beautiful biracial girls.

The division stayed in Shwegu several days, resting and bartering with the local people. Dad and his radio team stayed in a teakwood house, marveling that the walls, the doors, the furniture, everything was made of teak except the thatched roof.

Another parachute drop provided them not only necessary supplies but material for barter. The silk parachutes were in great demand by the locals. Anyone with a parachute could trade it to the natives for fresh food, vegetables or meat, to relieve the boredom of canned food and rice. To Dad's surprise, the locals prized the white silk more than the colored 'chutes.

In one supply drop came a soldier's best gift: mail. Dad read and re-read the letter from his folks and the one from Flo. Seated at a real table in the teak house, Bo wrote them each a reply.

Nov. 11th [1944]

Dearest Mama and Daddy

This is the only time since I've been over seas that I've waited this long (2 ½ weeks) to write. I'm on some kind of mission that just doesn't have arrangements made for such. I stay busy all the time and it's the most fun I've had since I've been overseas. This is really something to tell about when I get back.

My count calls for 18 more days over here but that's all wet. I expect to be here for a <u>few</u> months yet. The time is going by very fast now because I stay on the go.

I got mail dropped in the other day and I heard from you and Flo. I'll get one off to each of you tomorrow morning and then I'll be off again for a very long time, so don't worry. I'll be perfectly O.K. I will say that I've been over some mighty rough country this past month and I've seen sights that are hard to describe.

When I come back, I'm bringing all the family enough Kashmir wool for a suit - that goes for Pat, Hope, Bruce, you, Doc, Flo and me. It's supposed to be the most famous and also the best in the world. It is very beautiful.

My horse I've had for over a year just couldn't make it over some of the trails. There were only a few places I could ride. He finally fell out and I [told] one of my boys to shoot him. I get a new horse tomorrow but I still walk most of the time.

Some of these girls way down here are very beautiful. Maybe that's one reason the time passes faster.

What is the latest news on Joe? I certainly hope he gets home soon. I'd hate to beat him home 'cause I left [after] he did.

Give my love to all when you write.

Love to you and "Doc."

"Bo"

Japan, lacking resources of its own, had long coveted Burma because the British colony was rich with oil, rubber, teak, tin and precious stones. With the capture of Shwegu, the 66th Regiment entered the resource-rich center of Burma. The land beyond the Irrawaddy was populated with towns and villages supported by

the logging industry and the jade and tin mines. The sight of villages and native agriculture and towering gold-roofed pagodas made the region seem less hostile than the sparcely-populated jungle of the Hukawng Valley, and Dad had to remind himself to keep his guard up. But more and more, as the Japanese receded before them and he could appreciate the exotic culture, the adventurous aspect of the situation piqued his interest.

He could speak basic Chinese by now, and he and Colonel Lo worked well together. Colonel Smith had been rotated home. Foreman was gone—he had foolishly pulled a leech out of his groin and nearly bled to death—but Sam Calapino and the rest of the radio team had been with him from the beginning. The war was almost routine.

While some towns, like Shwegu, had been virtually untouched by the war, other settlements had been ravaged. Wandering through a pagoda blasted by artillery, gilded shards scattered in the brush, Dad found the broken pieces of a carved alabaster Buddha. Fitting the head on the broken neck, he thought, *A little Elmer's glue and this'll be good as new.*

Moving south towards Bhamo, they ran across eerie relics of earlier years of the Burma campaign, skeletons of the retreating Chinese troops and then, astonishingly, a 1940 Buick convertible touring car, far from any road or trace, mired in the wild undergrowth, abandoned by some well-to-do family fleeing the Japanese in 1942.

Dad and Metcalf looked underneath. The axles were intact. The pan appeared undamaged. Aside from the rotted rag top and seat covers, the car was in good condition, the pale yellow paint job forming an odd pool of light on the jungle floor.

Dad, of course, wanted to take it home.

Later they passed by a long clearing designated "Broadway", where British guerillas— - the Chindits - had landed behind Japanese lines seven months earlier with the assignment to blow bridges, mine roads and cut telegraph lines.

The Chindits were the brainchild of British General Orde Wingate, a wild-eyed religious fundamentalist driven not only by his brand of Christianity but by an unshakable certitude that he was destined for military greatness. His tactical gifts were somewhat compromised by his mental instability—he tried to cut his own throat following a career setback and was saved when he hit the floor with a thud that alerted a colleague nearby.

Rehabilitated, he was sent to the one theater where eccentricity flourished: the CBI. In 1944, Wingate developed an ambitious plan to insert his commandos deep into Burma by means of gliders.

Incredibly, the lightweight gliders were loaded with 12,000 men, 3,000 mules, a couple of bulldozers and some artillery pieces. But the night landing at Broadway was a debacle. Local teak wood loggers had left logs in the high grass and the leading gliders slammed into the logs instead of gliding to the end of the clearing. In the dark, the trailing aircraft rear-ended them, creating a pile of balsa-wood and bodies.

Amazingly, there were only a few casualties against many miraculous escapes. Hauling a bulldozer in a sling, one glider shot through the trees, shearing the wings off and slamming the 'dozer into a tree. In a few minutes, though, men had the 'dozer running, clearing a path for the following gliders.

Although the jungle had moved quickly to reclaim the area, Dad said he could still see some wreckage.

The teak industry had been disrupted by the war, and the logging elephants and their handlers were at the mercy of whichever side controlled the district. When the 66th came into possession

of some elephants, the transportation battalion immediately commandeered them to carry their heaviest item, ammunition.

As usual, Dad was intrigued. He had in his possession a block of *kahni* [heroin] the 22nd Division headquarters had given him to use as barter with the natives. Having had little use for it, Dad now figured he'd trade a plug for an elephant ride.

Dad was interested to see how the handlers managed the animals. The *mahout* made the elephant kneel and Dad climbed into the *howda*. Dad said when the elephant lunged to his feet, it nearly threw him out of the basket. As a horseman, Dad decided there was nothing in common with riding an elephant. "Staying in the basket was an art itself. And that damn walk'll make you seasick," he told the peanut gallery.

Nevertheless, the experience was intriguing enough that he tried it several times, determined to get a handle on elephant-riding.

In addition to recapturing teak forests and elephants, the Chinese recovered the jade mines from the Japanese. One evening Colonel Lo presented Dad with a leather pouch containing dozens of pieces of jade, including a diamond-shaped piece with beveled edges that Dad immediately imagined as a pendant hanging around Mom's neck.

But no amount of elephant rides and pouches of jewels could outweigh the stunning news he got one November day down in the jungle.

The campaign in north Burma was wrapping up, and although Colonel Smith had left, Dad had never bothered to go meet his replacement. One day he received word that his presence at headquarters was requested. Sauntering in, he met the 22nd Division's new liaison officer, a lieutenant colonel, and they exchanged news about the campaign.

The colonel finally inhaled and said, "There's a telegram for you." He nodded towards the Red Cross tent.

A thousand horrible thoughts raced through Dad's mind as he stepped into the tent and announced himself. A chaplain looked up suddenly and said, "Traywick. Yes." He adopted the countenance of sympathy as he handed over the yellow envelope with a telegram. "I'm sorry."

With a dry mouth and tightness in his gut, Dad ripped open the envelope.

"We regret to inform you that your brother, Captain Joseph Barre Traywick, has been killed in the fighting at Hurtgen Forest."

CHAPTER 42

JOSEPH BARRE TRAYWICK

While Dad had been swatting mosquitoes and slogging through the jungle in southeast Asia, his brother Joe had been leap-frogging across French fields and through Belgian woods in the deepening chill of fall.

Captain Joseph Barre Traywick's medical skills were put to thorough use as he tended, day after day, the hideous wounds of the men he served with. War means wounds and wounds mean doctors, so, for Joe, there was no break, no surcease from the danger. He made the invasion of North Africa with Patton in November of 1942, just as Dad was preparing to sail from San Francisco; then he went into Sicily with Patton in July 1943, while Dad was training troops in Ramgarh; and then, because the casualties from D-Day were expected to be high, he was sent to make the invasion of Normandy in June of '44, coming ashore at Omaha Beach on the afternoon of the first day as Dad recuperated at the 20th General Hospital. Joe had been overseas nearly two years.

In almost every letter to his parents, Dad asks for news of Joe. Dad apparently tried writing to Joe directly, because in May 1944, he writes his parents, *I never hear from Joe…How's he doing?*

Joe's introduction to war came in North Africa. He landed at Casablanca in November of 1942, and over the next few months, he would move with his unit, the 20th Engineer Combat Regiment, across North Africa until they reached Tunisia, where his unit spent weeks removing 200,000 German land mines.

With details garnered from witnesses and the medal citation, Dad told this amazing story in his usual gripping fashion, as though he were watching it unfold in front of his eyes.

One night in camp, some soldiers asked "Doctor Joe" to check a cow they had killed to see if it was all right to eat. While they were cooking the meat, a soldier came into the area and said "Medic?"

Joe got up immediately. "I'm a doctor. What do you want?"

"My buddy over here is hurt bad. Can you come help him?"

"Let me get my bag. Where is he?"

The soldier pointed in the dusk. "Back over yonder, over that ridge."

The soldiers who were cooking warned Joe, "There's mines over that way." Their regimental commander, Colonel Richard Arnold, had recently been killed by a mine.

Joe asked the soldier, "Can you find your way through?"

The soldier looked Joe in the eye and said, "Well, I got through coming here."

Joe picked up his bag. "If you lead the way, I'll follow."

Careful to step exactly in the man's footsteps, Joe followed the soldier back to his injured comrade and cared for him.

Some time later, Joe received a letter from his commanding officer certifying him for a Bronze Star with a "V" for valor. He went to his CO to inquire about the honor. "What about the fellow who led me through the mine field? Is he receiving the same thing?"

"Well, no," the officer said. "We don't know who it was."

Joe handed him the letter. "Decorate him, otherwise, you can keep it."

Here Dad would shake his head in awe. "What a man."

Next, Joe made the invasion of Sicily in 1943, following which he spent the winter in England stationed near his childhood friend, "Bub" Fogle. Although Bub was not an officer, Joe disregarded the prohibition against fraternization with enlisted personnel, and the two spent many happy evenings reminiscing about Cameron. Joe told Bub about the campaigns in North Africa and Sicily, stories that Bub later relayed to Doc and Miss Janie.

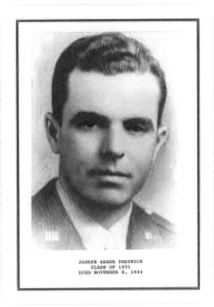

Joseph Barre Traywick (c. 1930s)

In both campaigns, Joe's unit was under General Patton, a flamboyant but brilliant wartime commander. Patton had routed German General Erwin Rommel in North Africa, and then he turned his attention across the Mediterranean to Sicily. The fighting there was rough, and Patton drove his troops hard. Like all good combat leaders, Patton loved and admired his troops and he often visited the wounded men.

On one such occasion in Sicily, Joe told Bub, when he himself was in attendance as part of the medical corps, General Patton moved through the tent, speaking to one wounded man after another. He came at last to a soldier who was suffering shell-shock, or battle fatigue, and who was crying. Patton, incensed on behalf of the other wounded men, slapped him. It became a sensational event and resulted in Patton's being reprimanded by the Supreme Allied Commander, General Dwight Eisenhower. Patton was forced to apologize to his entire army.

Five months after D-Day, the Allies had liberated France and Belgium and had begun to invade Germany proper. On the first

of November, Joe's unit found itself supporting the 28th Infantry Division in its drive to take the villages of Hurtgen and Kommerscheidt. The villages snuggle in the deep woods of the Hurtgen Forest, which covers the steep gorges and high ridges of the Krall River and its tributaries like a thick mat. Beautiful in peacetime, the area had become a muddy bloody nightmare for the combat engineers desperately widening the road for tanks and artillery needed to support the American troops. Rain, mist and fog turned the picturesque region into boggy woods and slick slopes. After brief initial success, the Americans became trapped by a German counterattack. With the tanks bogged down in the mud, the combat engineers were pressed into service as infantry to relieve their comrades on the front line. It was the siege of Myitkyina all over again, only bloody cold instead of bloody hot.

The battle was fought in bitter weather. The temperature fell and rain turned to snow. The heavy clouds dropping endless snow kept Allied bombers from supporting the ground troops. Day after day the Allies struggled through deep snow and dense forest, praying in vain for air support to knock out German artillery and cover their advance.

On the morning of November 8, 1944, the 20th Combat Engineers found themselves in the front line, so desperate was headquarters for replacements. Captain Joe stayed close by, ready to treat his colleagues, several of whom had already been wounded in the preceding days. He himself wore a bandage on his face.

There was a boy in the unit who was from Orangeburg, just ten miles from Cameron. After the war, he called on Doc and Miss Janie to tell them about Joe's courage. He told them Joe had received an injury to his face the day before. Later, Joe's commanding officer, Colonel Edwin Setliffe, confirmed to the Traywicks their son's wound and his heroism.

But the unit chaplain's diary says that Captain Joe lost an eye, which is certainly possible. Just as my father refrained from sharing some hard details of Captain Robert Kadgihn's death with Mr. Kadgihn, when the witnesses of Joe's final hours sat face to face with his parents, they may have softened the details.

230

On the morning of his last day, as Joe crouched beside a wounded soldier rewrapping a bandage, an 88-mm shell blasted a hole nearby, showering them with dirt, snow and shrapnel and killing all but one corpsman on Joe's medical team. He immediately returned to caring for the wounded, directing the one remaining medic to help him. But suddenly the corpsman leaped up and ran screaming towards the German line. Joe and the others could only watch in horror as German fire cut the boy to pieces.

Throughout the day, the battalion desperately clung to their position, frozen hands warmed by the barrels of their guns. Snow drifted over the muddy, bloody holes around them, covering the dead and wounded with an innocent white sheet.

Colonel Setliffe radioed Captain Joe and ordered him back behind the lines. "You've already been wounded. We can't afford to lose you."

Joe refused. "Colonel, we've got wounded up here. Send me an ambulance."

Twice the colonel sent an ambulance team forward, and twice they were hit by artillery.

As night fell and the barrage continued, the colonel tried once more to get the doctor to withdraw.

"I've got eighteen wounded men up here and I can't leave them," Joe answered. They were on the side of a hill and it was snowing heavily. They broke off tree branches and rigged tarps, trying to keep the snow off the wounded. The radio clicked off and then came alive again as Joe repeated, "I can't leave these men."

Among the wounded was the boy from Orangeburg. Shrapnel had laid open his thigh from hip to knee. As Captain Joe taped him up, the boy reported, it quit snowing. Soon the moon popped out and the moonlight on the snow shone bright as day.

In a nearby foxhole, a sergeant smoked a cigarette. Joe joined him, sitting on the side and resting. Suddenly, two stretcher-bearers struggled over the nose of the rise and hollered "Medic!"

Captain Joe and the sergeant got up and ran to help. The stretcher-bearers set their load down and Joe bent to examine the fellow. Then he straightened up and reached back for his scissors to cut away the uniform.

As the boy from Orangeburg watched, an 88-mm shell came whistling in, blasting snow, mud and men, killing all five of them: the two stretchers-bearers, the boy on the stretcher, the sergeant and Captain Joe.

He was thirty-four years old and left a young widow with a two-year-old son who, in the course of time, would grow up to be a doctor.

Although he had been raised on the hallowed status of the firstborn son, Dad hardly knew his brother. Eight years his senior, Joe had left home when Dad was only thirteen and their paths had crossed in Cameron rarely since then. Once Dad himself was grown and they might have had the opportunity to get to know each other as adults, they were separated by the war.

They may have seen each other only one or two times after Joe's marriage to Pat in the summer of 1941. Joe and Pat had been the center of happy family conversation, first for their wedding and then for the news of their impending baby, born July 9, 1942.

The baby's name was Paul, after his grandfather, Dr. Paul Traywick.

Dad and Uncle Joe probably said their farewells in the summer after Mom sent the ring back and Joe's baby had been born, when both men knew they were headed to war. Dad loomed over his older brother, taller by a good four inches and heavier by twenty pounds, but he would have accorded him the respect that little brothers always have for their older siblings. They would have addressed the cuteness of the baby and made a few observations about their parents. As the older brother, Joe would have taken the lead in advising caution.

"You be careful, wherever they send you."

"You too, Joe."

Joe shrugs. "I'll be okay. They'll have me in a hospital somewhere. But you: you've been in a duel, for God's sake, they'll have you leading the charge."

Bo laughs. "I'll tell 'em I can't go without my shotgun."

"I mean it. Don't be a hero. Keep your head down and come home. Mama and Daddy couldn't stand it." They shake hands for a long moment, wordlessly memorizing each other's face.

Holding the telegram in divisional headquarters somewhere below the Irrawaddy, picturing his brother's face, his place at the family dinner table, Dad probably took the news quietly, mourning that he'd never get to know his brother. He would have worried more about his parents. His daddy was the emotional one. His mama would gasp and quietly weep, but his daddy would go outside and rage around, hit something, holler at the help. And Pat. What about Pat and the baby? Pat was a young widow, the husband she hardly knew dead and gone. That little boy would never know his daddy.

As siblings sometimes do, Dad felt an irrational wish that he had been taken and Joe had been spared. The sense that he had navigated the war unscathed while his brother—a doctor, not even a soldier!—had been killed bothered him the rest of his life.

Undoubtedly he underestimated his own suffering, his own contribution, his own exposure to risk. It was apples to oranges. But then it's hard to be rational about losing your brother in war.

CHAPTER 43

PRESSURE TO CHOOSE
FALL 1944

When Mom made the decision not to re-enroll in college in September, it was a crossing of the Rubicon for her. She was committed to waiting for Dad. That did not yet mean a commitment to marriage, but it did mean she was letting go, letting herself anticipate his return and, after years of wartime restraint, opening her heart to dreams of a lifetime with Bo Traywick.

But the war continued to add frustrating uncertainty to possible wedding plans. Mom still didn't wear Dad's ring and she wasn't shopping for a wedding gown; they certainly couldn't set a date or print invitations. There was still too much geography between them, still too many snipers and battles for Dad to survive—and the unexpressed thought, *Would they feel the same after two years of separation?*

So Mom hung around, waiting for Dad with the velvet box holding an engagement ring in one hand and in the other, a fistful of letters and cables from men who were increasingly insistent on pinning her down, even as she abandoned her heart to Dad.

At a time when couples often married with little courtship, it was not surprising that several men mistook Mom's cheery attention and regular correspondence for a serious commitment. Men were eager to have someone at home waiting for them, some connection they could focus on as they suffered through shelling barrages and crouched in muddy foxholes. Many of them seized on letters from a pretty girl as evidence of a deeper relationship than really existed.

Through correspondence, Mom developed closer relationships with several men who, like Dad, had seen her in person only a few times. Mac McCool, veteran of Doolittle's raid on Tokyo, was one of those. This letter was apparently written from England and reveals a lot about an officer's life during the unending war.

Major H. C. McCool, O-419329
344th Bomb. Group (M)
A.P.O. 1240, New York, N.Y.
Sunday, September 24, P.M. [1944]

Dear Little Flo:

...I've been busy working, playing and flying the past 10 days or I would have written sooner... Yesterday I returned from a 3-day vacation in London... Stayed in a very nice hotel and had dinner in the American Senior Officers Mess and Club two nights...

About your bracelet: it has a pair of Navigator wings curved to match your wrist (I hope) with silver links going to the lock. On each side of the clasp is a gold oak leaf connected to the chain and the lock in between them. The oak leaves are from my uniform as I now have only gold embroidered ornaments on my uniforms. It should have reached you sometime ago, as I sent it in the regular mail...

I sometimes wonder when I shall ever see you again, also what you will be like when I do. It is easy to picture you from your photographs and letters along with the fleeting little visit the afternoon I met you. Also what do you have me pictured as? You know I'm 26 years old, in the Army, graduated from college. Love airplanes and aviation and army life. Been on active duty since Pearl Harbor. That I went to China and India. Was shot down. Wounded came home and am back on my second lap about the world at War. Did you ever try to visualize me in a double-breasted gray suit, Homburg hat and two tone tan shoes? I smoke pipes all the time... I also love to smoke cigars in flight and

office. I can't dance very well and I do like all sports except things connected with horses. Riding, Racing and Polo. I love to read and I collect stamps. Now do you think I could show you a good time when next I see you, probably in Wash. D.C.?

Tis time to hear the midnight news... I have to prepare to retire as I am going to France tomorrow to visit a field over there that we bombed about 5 months ago.

Bye for now and love as ever.

Maj. Mac

Gently deflecting serious developments in a relationship was easier to do when the man was 3,000 miles away. It was a little harder when she saw a lot of a man or he was related to a friend, both of which described "Big" George Levi, Cile Moise's first cousin. After seeing each other regularly when Mom visited Cile in South Carolina that summer, Mom and Big continued the relationship into the fall. Big was easy to talk to and always had fun ideas for something to do, and Lord knows Mom wanted something to do besides sit home and worry about Dad. So when Lt. Levi invited her to meet him in New York September 8 for a long weekend, she agreed.

The cable said: "Meet you information booth Pennsylvania station one thirty Friday love Big."

She stayed at the New Yorker Hotel while he stayed elsewhere, as decorum dictated. Big proceeded to pull out all the stops for a glamorous weekend, beginning with sending a dozen and a half red roses to her hotel room. Accompanied by Big's friend, Major Jim Welsh, as a pseudo-chaperone, Big and Mom went to the theater, the zoo and the Metropolitan Museum and ended the weekend dancing at the Copacabana.

Three weeks later Mom went to South Carolina to visit Cile and see Big. One night as they prepared for bed, Cile made a conspiratorial comment about Mom's and Big's "plans".

Mom was startled. "We don't have any plans," she said. "I think he's darling, but we haven't talked about anything serious." She paused. "Does *he* think we have plans or are you just match-making?"

It was Cile's turn to pause. At last she said, coolly, "I think you'd better talk to Big."

I have often wondered how Mom could have mis-read Big's intentions, but apparently she was so used to men lavishing dinners and flowers and bracelets on her that she took Big's attention as more of the same. And, as she told Cile, they had never discussed marriage. In any event, when he invited her to Florida in October, she declined. Undaunted, Big continued sending her red roses at regular intervals.

Another man who misinterpreted their relationship was Jim Browning. Soon after he went overseas in September, a package arrived from England containing a gold bracelet set with amethysts. The card said, "My love, Jim". Only a month later, word of Jim's death reached her.

Mom wrote a sympathy note to his family in Pascagoula, Mississippi, and sent them all his letters to her. She was a bit taken aback then, when Jim's brother made a personal visit to Lynchburg to see her and Jim's aunt wrote a gentle letter of condolence, praising her courage and assuring her that one day she would get over the heartbreak and find another man to love and marry. Touched, Mom played along, declining to disabuse them of the notion that she and Jim had planned to marry.

Meanwhile, the man she truly planned to marry continued to maintain his claim, despite the distance and the competition. When Mom and Betty hosted a wedding breakfast for their friend, Arlene Tweedy, Mom wore an enormous orchid corsage and enjoyed answering everyone's gasps of admiration by saying, "Bo sent it to me. Isn't he wonderful?"

Increasingly, men coming home wanted to press their suits. Robbie Robertson and Bob Angstadt were among those calling to

get a spot on her calendar. Bob, a pilot, wanted to fly a military plane from St. Louis but couldn't get permission for the "cross-country training flight."

Captain Phil Strader, a bomber pilot hero and an old beau from her year at Hollins returned to Lynchburg about this time. Strader had been flying with Major "Pappy" Boyington and his "Bombing Banshee" squadron in the Pacific since early in the war and had survived several close calls during his 146 missions. "Phil finally came home. You know how I felt. Hadn't seen him since May 9, 1942" [her 18th birthday] she wrote next to a newspaper write-up of Strader's exploits.

Toni Castagna sent her a cable in October: "Dearest arrived today. Will proceed home soon. Will wire my arrival. Love Toni." Next to the cable, Mom wrote, "Toni back from the South Pacific! I'm afraid he's wounded."

Don Wycoff sent her a cable in November: "Just a stateside sailor now headed for Ottumwa, Iowa. Will write. Love Don."

But no such cable arrived from Dad. He sent her a cartoon that showed a girl greeting a sailor on the dock. The girl is young and the cane-carrying sailor is stooped and bearded. The sailor says, "There was a slight delay in my rotation." Dad crossed out the sailor's name on his duffle bag and wrote "Traywick." Mom wrote, "Too true to be funny."

Talk of love and marriage now filled their letters. Mom sent Dad a love letter in the form of lyrics to a new song by Dinah Shore, "I'll Walk Alone."

I'll always be near you wherever you are each night,
In every prayer.
If you call I'll hear you, no matter how far.
Just close your eyes and I'll be there.

Dad read and re-read the sentiments, reveling in the commitment the words expressed but hardly daring to hope that Mom

meant the title to be taken literally. *"I'll Walk Alone"—Huh! She's up there at Oakwood Club, dancing with somebody.*

The cartoon with the aged soldier aside, Dad expected to be rotated home before long. Like most soldiers, Dad kept close count of his points, and he estimated that he would be eligible for rotation by the end of the year.

About this time, the box of battle spoils from Maingkwan arrived. Mom was taken aback to open the long box and find a Samurai sword wrapped in bloody, greasy Japanese flags. Folded among the artifacts was a formal declaration of the contents and a note to her.

Japanese flag, thousand-stitch sash, fan inscribed
"To Flo from Bo, Burma '44"

I certify that this is a bona fide gift from a member of the U. S. Armed Forces overseas and as such is intitled [sic] to free entry under public law #790.

1 – samauri [sic] sword
5 – Japanese battle flags

2 – thousand-stitch bands
1 – folding fan
4 – silver bracelets
1 – package of religious charms
1 – package of Japanese invasion currency
1 – package of Japanese picture postcards

I further certify that this is the only package I have mailed this month.

H. V. Traywick
Maj. Inf.

Unpacking the souvenirs of war sobered Mom. Dad had sent her Indian and Japanese money before, and he had sent a copy of the Army's newspaper for the CBI, the *CBI Roundup*, but these items had come from the battlefield or from Japanese positions Dad's unit had overrun. They showed the personal side of the enemy.

The folding paper fan contained columns of Japanese characters, a prayer on each pleat, similar to the prayers associated with the thousand-stitch bands. The blood-stained battle flags, she wrote in her scrapbook, "scared me to death". The white silk squares, each with a red rising sun in the middle, bore black grease spots where Chinese soldiers had, in pointed insult, rammed the cloth down the barrels of their guns to clean out gunpowder grime.

Mom slid the silver bracelets on her wrist, glancing at them admiringly as she read Dad's instructions:

5 flags – 1 small (marked) & one small silk flag, sabre & 1000 stitch jacket & some money – W. R. Crute [Uncle Willie, Miss Janie's half-brother in Texas]

Fan, money, 1000 stitch band, religious charms, large silk flag & one other flag – that's all for Miss Priss. [Dad's nickname for Mom]

Please send Doc the other flag. Sorry to have to bother you 'bout all that mailing – 'Bo'

No sooner had the swords and flags been mailed when Mom received a terse letter from Dad's sister, Bruce.

Dear Flo,

We have received a message saying that Joe was killed in action in Germany on Nov. 8. We wanted you to know. Pat, Mary Hope and I and all the children are with Mama and Daddy –

Love

Bruce
Friday

The news saddened her as she imagined how devastated Dr. Traywick and Miss Janie must be. She wrote them a heartfelt letter of condolence. Having visited in Dad's home with Dad's parents, having spent time with Dad's sisters, having met Joe's wife and baby, she felt a close connection to the family. Joe's death hit close to home, creating in her own heart an irrational worry for Dad's safety and making it difficult to write him about Joe. Joe's death seemed somehow to make Dad more vulnerable, and she redoubled her prayers for his safe return.

And then Steve Thornton called.

If it had been fate that Dad called her the one night she was home from Washington, in September of 1942, it was also fate that Dad's one serious rival came home just before Dad did. It was as though Mom had to tie up this one loose end.

Steve had been gone for a year. Mom saw him off in Washington in September of 1943. Dropped behind enemy lines in France, he had worked with his contact in the French Resistance to gain valuable intelligence for the Allies. With France recently liberated, Steve had come home on leave. He landed at Ft. Dix,

N.J. on November 17 and called Mom immediately. After debriefing in Washington, he told her, he was headed to Georgia to see his family. But first he wanted to see her.

And she wanted to see him.

Mom has often spoken about the raw emotions that people lived with every day during the war years. Against the global backdrop of bombing and battles, there were the personal stories of people you knew. Each day you felt the pain of someone's husband's death or the joy of someone's brother's safe return. Shipping out. Coming home. Every event plumbed the depths of human emotion. You got through today, never knowing what tomorrow held. "You just lived day to day," she often said.

For Mom, that meant filling up her time dancing and flirting with military officers. "I wasn't going to sit home and wait for him, because you couldn't afford to do that, but I never met anyone who could take his place." Steve, however, had been the one serious competitor to the man whose ring sat in her bureau drawer.

Despite her eagerness to see Steve, Mom had to put him off for a week due to "other plans." Steve was enamored enough to wait and on November 25, 1944, she received a cablegram from him: *Leaving one oclock train. Steve.*

Newspaper notice: "Capt. Stephen Thornton, USA, paratroop infantry, whose home is in Milledgeville, Ga., and who recently returned after [12 months] service overseas in the ETO [European Theatre of Operations], is visiting Mr. and Mrs. C. R. Neher on Belmont Street."

They spent the weekend mostly talking and getting reacquainted. Reminiscing about her visit to his family's horse farm bridged the year of his absence and recreated the intimacy of their relationship. Dinner and dancing at Oakwood capped off their romantic reunion.

But when Steve's train pulled away, Mom found herself feeling flat. They had shared a glorious weekend together and

Steve seemed clearly enamored, but there was something missing. Unlike her other beaux, he held back from asking her for a commitment. Steve was thirty-two at the time, and Mom always put his reticence down to concern about the twelve-year age difference. At the time, Steve's ambiguity was puzzling, especially to a girl who collected hearts so easily. Still, it seems doubtful that she would have followed him if he had asked. I think she looked on him as Plan B in the event that Major Traywick didn't make it home. The Best of the Rest, as it were. But she was always curious about the mixed signals he sent.

CHAPTER 44

AIRLIFT TO CHINA
DECEMBER 1944

And then, suddenly, it was over.

Dad's unit was jerked out of the front line and ordered back to China immediately. Nationalist Chinese leader Generalissimo Chiang K'ai-shek, facing an imminent internal threat from Mao Tse Tung's Communist army, needed his trained troops *now*.

The order came on November 30, as the divisional commanders were arraying the units for battle in the Moh-laing-Tonk-wa area. After some back and forth, an American unit arrived to support the Chinese and the combined forces attacked on December 9, retaking ground that had been lost.

Then the Chinese packed their bags and began flying home.

Far from the Ledo Road, deep in the jungle, Major Traywick went to work shipping his regiment out, ordering scouts to find a place for airplanes to land. What they found was a big clearing in the jungle covered with old rice paddies.

In a scene reminiscent of "McGyver" or "Swiss Family Robinson", the engineer corps went to work to build a makeshift airport for DC-3 transport planes. In a few days, using only hand tools, the laborers knocked down the rice paddy dams and leveled off a four thousand-foot dirt strip. Meanwhile, they cut the tops off two trees about twenty or thirty feet up, nailed a ladder to one of them, built a bamboo platform for the tower—and bingo, they had an airport.

The peanut gallery always shook their heads at the notion that an airplane could land or take off under such conditions. They weren't fast, they weren't fancy, and they certainly weren't computerized, but those old WWII planes were tough. They could handle bouncing on a rough dirt runway probably because they *weren't* loaded with delicate temperature—and concussion—sensitive equipment. Just a pilot who knew the plane's capabilities and didn't mind pushing the envelope.

The transport planes arrived with fighter planes as escort. One by one the transports landed, turned and idled their engines while the Chinese clambered aboard. Driving up and down the side of the clearing in a jeep, Dad kept a planeload ready for each transport. Each transport was going to one of three different towns in China, and Dad organized the troops accordingly. Plane after plane would bounce onto the rough runway, load up and zoom off again. The doors of the DC-3s had already been removed to facilitate dropping supplies by parachute, so the sides were open for loading up troops.

The tough DC-3s made the Burma victory possible. *(National Archives)*

The Japanese, though weak and retreating, still had airfields of their own in Burma and they sent bombers out to catch the congregation of troops camped around the jungle clearing. But every morning, a fog cloaked the region, hiding the clearing from the Japanese bombers. Under the jungle canopy next to the clearing, Dad could hear the enemy planes circling, looking for them. Though he didn't envy the Chinese their reassignment to another war, he didn't like his own situation, either.

The fog dissipated each morning at eight o'clock, allowing the Allied fighter planes to take off and chase the enemy bombers away. One morning Dad watched, mouth open, as a fighter plane lifted off far down the clearing and flew towards the still-cloudy

wall of trees. Dad watched him climb, thinking, *God, he's not going to make it. He's not going to make it.* To his relief, the pilot scraped over the wall, clipping a few small branches off one of the trees with the undercarriage.

As the men of the 66th Regiment flew home to China, many of them undoubtedly reflected that a lot had changed since their perilous flight over the Hump to Ramgarh in 1942. The peasants who had arrived in Ramgarh with rags and lice two years earlier went home with "jimmy sticks" bent with bundles of clothes, weapons, ammunition and such other treasures as they had gathered in the interim. They also went home as skilled, confident fighters.

When the airlift began, Dad asked Colonel Lo to allow his orderly, Sam Wu, to remain with him. Concerned that Sam might at some point be considered a deserter, Dad made sure the regimental commander put the authority in writing.

All week long, Sam looked after Dad as he loaded the Chinese and shipped them out. All the other Americans were gone. The radio crews, Metcalf and a few others went back to Myitkyina the first day. At last, as Dad and Sam sat in the jeep and watched, the final load of Chinese was bundled on board an idling DC-3. The plane rumbled down the dirt strip, well-flattened now from so many wheels, and slowly lifted off, climbing over the trees with little to spare.

Dad must have felt a refreshing sense of *mission accomplished.* The goal of recapturing north Burma and opening a road to China was close to achievement. In less than two months, the first transport truck would roll down the Ledo Road and reach the junction to China. Developments in the war elsewhere had, in the interim, reduced the imperative of opening the road, but Dad didn't know that. He had done his part and success was at hand.

He could look at the last receding transport plane with a sense of finality and, perhaps, nostalgia. Behind him were a mélange of images and emotions: That Chinese recruit's horrified face

when the grenade launcher fell into the rushing stream. Bloody body parts after Maingkwan. And Jambu Bum. And Warazup. The bottle of Canadian Club Stilwell's aide gave him somewhere in the Hukawng Valley. Sam leading the little Australian pony away. Cutting a hunk of dope for the elephant driver. The colonel with typhus. Claude and his family waving goodbye in Ramgarh.

Whatever Dad's thoughts were at that moment, they were broken by the drone of an approaching DC-3. He looked up to see another transport drop in over the trees and roll down the empty strip.

"We fly this plane?" Sam asked.

Suddenly Dad realized everyone was gone. The radio teams were gone, the Chinese were all gone, the people in the tower had left, and Dad was sitting in a jeep with Sam Wu all alone. The pilot, seeing no more troops to load, turned the plane and revved the engine. Popping the clutch on the jeep, Dad roared out onto the strip and raced directly towards the moving plane.

"Wave at him, Sam!" Both men took off their hats, waved and hollered at the pilot.

Mercifully, the plane slowed and stopped again. As they pulled alongside, the pilot opened the side window and shouted, "You boys want a ride?"

Dad said he left the jeep running in the old rice paddy as he and Sam grabbed their gear and climbed into the empty belly of the plane. They sat on the floor, giddy with relief. Once airborne, Dad made his way forward to the cockpit, where the pilot greeted him, "Cutting it a little close there, weren't you, major?"

"Oh God, I thought you were going to leave us there in the jungle by ourselves!"

"Nah, we wouldn't do that, would we?" he said, laughing with the co-pilot. "But you're going to owe Uncle Sam a boatload for that jeep."

"Hell with the jeep, just get me outta here. I don't know where you're supposed to go but *not* to China."

"This bus stops at Mitch. That good enough for you?"

Dad allowed himself a smile. "Yep. That's good enough."

The flight was a short hop to headquarters where he would get orders to his next station, but Dad couldn't think about that. He was just glad to be on the last plane out of the jungle. He had all his gear, such as it was. He also had an aluminum canteen with the dates of all the north Burma battles recorded on it, a summary of his life for the preceding year. The canteen, which he had won in a poker game, had been engraved by hand: *Maingkwan, Walabum, Jamba Bum, Moguang, Myitkyina.*

But Dad, still distracted by his close call getting out of the jungle, left the canteen behind, leaping out of the plane in Myitkyina without it.

Once an actual city, Myitkyina had suffered tremendously from the bombing and the seventy-six-day siege. But after six months in the jungle speaking pidgin Chinese and eating rice, Dad thought Myitkyina looked like the promised land. It felt like it, too, as he luxuriated in a hot shower and a shave and dinner in the mess with a table and chairs and a knife and fork.

The following morning, refreshed and ready for whatever came next, he checked in with the office.

The dispatcher handed him his orders with a smile. "Congratulations, sir."

He read the paper quickly. *Home!* He was going home! "Hot damn! I'm going home!"

It is hard to imagine the depth of excitement and relief he must have felt, the bittersweet anticipation of seeing his parents, deep in mourning for Joe, the unadulterated eagerness to see and hold and kiss his girl, the promise of smoking a cigarette or sleep-

ing in a bed with no snipers about. For a soldier at war, there is nothing like the prospect of going home.

But Dad's joy was tempered by his orderly's reaction.

"Major take Sam?"

Dad stopped cold. He could always put himself in another person's shoes, and immediately the vision of Claude and his family in Ramgarh waving goodbye with tears on their faces leaped to his mind. Like the Indian boy, Sam knew he had the chance for a much better life in America than in his own benighted country. At last Dad sighed. "Sam, I'd love to take you with me, but I can't."

"Please, major. Please take Sam. I work hard for major."

Dad looked at the earnest face before him. They had spent a year together in the worst possible conditions, and Sam had never failed to do his work cheerfully. He had looked after the major's comfort - to the extent the word "comfort" could be applied to life in the jungle under war conditions—with a smile on his face. He himself had tried to look out for Sam the best he could, most recently by keeping him from being shipped back to China with the rest of the troops. But there was simply no way he could ship him to the United States, no matter how much he wanted to.

Over the next few days, Dad said Sam quietly "collected his things," appropriating useful items from around the camp and stowing them in his bags. One afternoon, he drove Sam and his bulging bundles to the airstrip. He found a plane that was going to a town near where Sam wanted to be and gave him the papers confirming that he wasn't a deserter. Then he said goodbye.

In later years, he often wondered what happened to Sam, as well as his Ramgarh orderly, Claude. He'd count up and guesstimate how old they would be and look east, towards India and China, imagining the crowded village where each man lived, wondering how many children Claude and his child bride had, wondering what happened to Sam when the Communists took over, always regretful that he couldn't bring either man back to America

with him. With his knowledge of American customs and his ability to speak English, Claude had a leg up in the world when the war ended. Sam had some advantages, too, from his service with an American officer, but he went back to a country at civil war. How did that play out? Dad always wondered.

Dad had a few things of his own to collect, but he learned that the footlocker he had left with Moselle May in Ledo a year earlier had been destroyed in a fire. The footlocker held his dress uniforms, a record player he had bought in India, letters from home and a few other personal items not thought to be useful in the jungle. Everything had burned up.

But the loss seemed minor, all things considered. He prepared to celebrate his third Christmas overseas with orders for home and a deep feeling of gratitude for having survived malaria, dysentery, unbroken ponies, drunken lieutenants, errant hand grenades, sniper bullets, knee mortars, pitched battles, river crossings, mind-numbing boredom, nerve-gnawing stress, wrathful visiting generals, a rice diet and the possibility of missing the last plane out of the jungle.

He cabled his parents and Mom. Once he reached the United States, he would have twenty-one days' leave that he intended to spend with Mom. Then, given all his jungle experience, they'd no doubt send him to the Pacific, one of those damn islands where the Japanese were dug in, making G.I.s fight and die for every inch of dirt. On the bright side, maybe he'd get to command American troops in the field, instead of following the Chinese around and begging their commander to fight.

After a week, he got a few dribbles of mail. Mom said she had gotten his letter saying he might be home soon and not to write anymore, but she had to write one more time and tell him how excited she was, that she couldn't wait to see him. *Me too, baby,* he thought.

On Christmas, the nurses from the hospital in Myitkyina had a party. Dad didn't have his whiskey ration, so he had nothing

to contribute, but the nurses welcomed him with excited squeals and festive revelry. He quickly joined in the spirit, drinking somebody else's whiskey ration and—joy of joys!—dancing to new records. As each nurse or officer added his records to the communal stack, Dad scanned the titles.

"What are you looking for?" asked one of the girls.

" 'I'll Walk Alone,' by Dinah Shore."

"Anybody have 'I'll Walk Alone'?" she called over the chattering room.

"A friend of mine sent me the lyrics, so I wanted to hear the tune," Dad explained.

The girl looked back at him with a bemused grin. "A 'friend,' huh? A *girl* friend, I bet."

Dad grinned in return. "Now that you mention it, I think she is a girl."

The nurse shrieked with laughter and took his hand to dance. "You know how to do this?" she asked and launched into a new dance step.

He was still humming and dancing two days later when he got on a plane and flew out of Burma. As the plane gained altitude, he looked down on the green canopy that covered the mountains and valleys, the leeches and snipers, the elephants and Kachin scouts, the bones and bodies and bloody, muddy ground. The canopy covered it all, presenting a clean green rolling surface, rising to the white-capped Himalayan peaks in the background. Here and there he could see the winding silver rivers and there, at last, the wrinkles and twists of the Ledo Road.

(National Archives)

CHAPTER 45

A TRIP IN A TIME MACHINE
DECEMBER 1944 - JANUARY 1945

It took Dad forty days to get to war and a month to get home. The trip home was a long climb out of the absolute depths of the savage, unmapped jungle in Burma and up through increasingly refined layers of civilization to *home*. It must have felt like swimming to the surface of the ocean after being trapped in a submerged vessel.

Of course, it wasn't easy to get home from Burma without going through somewhere else, and Dad changed planes eleven times on the trip from Myitkyina to Ft. Dix, New Jersey. In those days, "aeroplanes" didn't go far. There were no jets. Propeller-driven planes droned across the Atlantic for thirteen hours to get from the Azores to Gander Air Force Base in Newfoundland.

Had there been another way to travel, I'm sure Dad would have taken it. The flights home were nerve-wracking and occasionally life-threatening. As Dad said later, he wasn't entirely convinced air travel was here to stay.

Having traveled to Burma across the Pacific, Dad now made his way home across the Atlantic, completing a circumnavigation of the globe in a time that was no threat to Phileas Fogg's record of eighty days.

In Ledo, he caught the meat plane to Calcutta, changed planes and flew on to Karachi, India, which is now Pakistan. Debarking in Karachi, he ran into his roommate from Ramgarh, Gunther Shirley.

They exchanged stories and lamented the death of Kadgihn. Then Shirley reached up and removed his hat, a German-style cap with a short bill, approved as officers' uniform. "This is your cap. You want it back?"

Dad grinned. "I bought that thing at Ft. Benning. Yeah, I'd like to have it."

The two men swapped hats, Dad surrendering his overseas cap and donning the memento from Benning, even though it didn't have the "scrambled eggs" on the brim that, as a major, he was entitled to wear.

"See you back in the States."

They saluted each other cheerfully.

While Dad was in Karachi, he also ran into Ken Lainey, a fellow Clemson graduate and Colonel Smith's aide with the 22nd Division. When Dad received his orders, he didn't have time to get any money. He had directed that all his pay be sent to the bank in Cameron, since there were few shopping malls in the jungle. Lainey came to his rescue, loaning him some money for the trip home.

He had three or four days to kill in Karachi and went shopping for a gift for Mom in the bazaar. After browsing through a few stalls, he stopped to admire a large star sapphire. He haggled with the shopkeeper, who closed the deal by saying that Dad could bring it back and he would return his money. Studying the gem for the next day or two, Dad realized he couldn't tell a fake from the real thing and reluctantly decided to return it. After the shopkeeper returned his money, Dad left wondering whether his mistake was in buying the gem or returning it. He consoled himself that he had a pouch full of jewels from the jade mines.

A few days later, as Dad waited in the airport, he recognized an incoming soldier as Sam Summers, a childhood friend from Cameron. They had a happy reunion, reminiscing about home until Dad had to leave.

For the flight to Cairo, Dad boarded a twin-engine C-46 with about eighteen other soldiers. Some time in the night, one of the engines started acting up. Every once in awhile it would back-fire, startling Dad as he saw the engine spit fire out the back. Dad, who had little confidence in airplanes to begin with, went forward to speak to the pilot, who was struggling to keep the old, war-weary plane limping along.

"We can't maintain altitude with this load," the pilot shouted over the engine noise. "We might have to jettison the baggage."

As the senior officer on board, Major Traywick was nominally in command of the plane, and he said, "You just let me know and we'll shove everything we've got out the window." Dad was ready to lean out the window and flap his arms if he had to. He hadn't come all the way through the Burma campaign to die in an airplane going home.

He returned to the cabin to report to the worried passengers. "The pilot can't seem to make that engine work right and he is having trouble maintaining altitude with all this weight. We may have to jettison the baggage." He paused, then added, "We'll go by rank, starting with the privates."

The men laughed uneasily.

"And all of you smokers put those cigarettes out. Keep 'em in your pocket till we get there."

A chain-smoker, he wanted to smoke in the worst way, but he wanted to survive the flight even more.

Even in the darkness, Dad could tell the plane was continuing its inexorable slide to earth. Disconcertingly, sparks and flames blasted from the engine. Finally, the pilot killed the engine, coasting on the other one. When the engine cooled, he cranked it up again and it ran a little better.

Dad didn't want to bother the pilot, but he checked with him from time to time. "We're still losing altitude, but by the time

we hit the ground, we might be in Sharja," he told Dad, who was not exactly comforted. At daylight, they made a forced landing on a sandbar in the Persian Gulf. To everyone's surprise, the pilot had nursed the plane all the way to Sharja, Arabia.

Now a city in the United Arab Emirates across the Persian Gulf from Iran, Sharja then was nothing but a fuel dump: no buildings, just pyramidal tents and a field full of fifty-five-gallon drums of fuel as far as the eye could see. Dad and the other soldiers gratefully got off the plane while a maintenance crew worked on the engine for most of the day.

It was nearly dark when they took off again and as they approached Cairo, Dad could see the lights outlining the Suez Canal. Up and down the canal sparkled a double row of lights with odd lights from ships moving along its length. In a thoughtful mood, he marveled at the ingenuity of man, connecting the Mediterranean and the Red Sea with the canal, and at his opportunity to view the engineering feat from the air. Remembering the pagodas in Burma, the Taj Mahal, the Ledo Road itself, the sands of Sharja and now the Suez Canal, he thought, *If I get home, I'll really have some stories to tell my grandchildren.*

Dad had three days to tour Cairo before his next flight. Determined to add to his store of stories to tell, he went to the famed Shepherds Hotel (which has since burned) and had a drink in the bar. Then he took a cab to see the pyramids and the Sphinx. At that time, the monuments stood sentinel miles out in the desert, but just as downtown San Antonio has engulfed the Alamo, the city of Cairo has spread like lava all around the stone tombs. After riding a camel to one of the pyramids and paying a freelance guide a few coins, Dad found the interior empty except for broken cups, paper wrappers and other trash. Taj Mahal redux.

The next day, he crow-hopped across north Africa, stopping in Ben Ghazi and Tripoli and arriving in Casablanca about eleven o'clock that night. "Humphrey Bogart and Ingrid Bergman were not there to meet me," he reported.

But all across north Africa there were thoughts of Joe, who had made the invasion there in '42, a hundred years ago, it seemed.

After two or three days in Casablanca, Dad boarded his next flight at midnight, headed home at last—only to be delayed in the Azores by other homeward-bound planes. Eighteen "stretcher" planes transporting wounded soldiers from the Battle of the Bulge were stacked up ahead of them, waiting to land and refuel for the flight to Newfoundland.

The delay lasted the better part of the day as the pilot flew to the north island of the Azores and waited for the congestion to clear. Once back on the south island, they refueled and left on the longest leg, across the Atlantic.

After flying from Ledo to Casablanca in a series of two-engine planes, Dad was comforted to look out the window on each side and see a total of four engines, but he was dismayed by the gas fumes and the loose parts rattling around in the fuselage. The extreme sense of self-preservation that got Dad through a year of jungle warfare did not dissolve just because he was out of the jungle. So he was shocked when the pilot came on the intercom and said, "When we get up to our cruising altitude, you can fire up those coffin nails."

As soon as the intercom clicked off, Dad stood up, clutching a stanchion overhead to steady himself in the turbulence. Looking around at the men in the back of the plane, he said, "Now I want to tell you all something. I'm a chain smoker." He looked from face to face before continuing. "I smoke three packs a day." More glaring. "…and I'm *not* going to smoke with all these gas fumes." Another pause. "Now, if anybody fires up a cigarette on this aeroplane, *if* we get to New York, I'm going to court martial you."

As the flight droned on hour after hour through the long tense night towards Gander Air Force Base, nobody smoked. Dad didn't smoke and nobody else smoked.

As January of 1945 progressed, Mom and her parents waited eagerly by the phone. Mom knew that Dad was en route home and she expected a call from him any day. Meanwhile, Dick's wife, Pat, was due to deliver their first child at any time. The two happy events coincided on January 23, when Patricia "Poppy" Neher was born and Dad landed at Ft. Dix, New Jersey.

Mom had stopped making entries in her scrapbook in December, shortly after Steve Thornton's visit. Apparently all the loose ends had been tied up and there was no dinner, no dance, no corsage worth mentioning as she waited for Dad to arrive. There was no more mental conflict about Bo versus Steve. She had relegated Steve to the ranks of "just a pastime," like all the other men she'd danced with over the previous two years. An attractive pastime, but that's all. Just like Robbie and Big and Bill Bay and Captain Miller and Toni and Don and…

They all paled beside the man who was bearing down on her from the other side of the world.

Dad had once been ambiguous. But his letters over the past year had been distinctly unambiguous, especially the last one: *I'm coming home soon. I'll have twenty-one days' leave, so I hope we can get married before they send me to my next assignment. I love you.*

Mom slid the engagement ring—platinum, size five—onto her finger.

After flying all night and seeing the sun catch up with them, Dad figured they were getting pretty close. But once again the flight encountered a delay. As they hit some turbulence, the pilot came on the intercom. "Gentlemen, you may have noticed the cloud cover below us. Underneath that mess is a snow storm." The men groaned. "The tower has diverted us to Goose Bay. Sorry to extend your tour, but I don't make the weather."

Dad must have thought he couldn't get a break. They flew on for another hour, landing at last to cheers. Goose Bay had little

to offer, though, except solid ground. Happily, later in the day, they got word to try Gander again and made the short hop.

Although more developed than the field at Goose Bay, Gander Air Base was still only a bare, spare airfield on an island with a small village of Canadians. It was an outpost no one had ever heard of until September 1, 2001, when Gander residents famously took in the passengers on seventy planes that were ordered out of the sky to land at the nearest airport after the attacks on the World Trade Center and the Pentagon.

In 1945, Dad said the officers' club at Gander was comparable to a nice hotel, but given his recent accommodations and travel experiences, it's possible his judgment was impaired. At any rate, after a drink—with ice!—he enjoyed a leisurely dinner, followed by a good night's sleep in a real bed.

The next morning, January 23, the sun shown as bright as a new penny. They got on the airplane and flew to Ft. Dix, New Jersey.

American soil.

CHAPTER 46

RIGHT CLOCK, WRONG CITY
JANUARY 23-25, 1945

The freezing January air gave Dad a brisk welcome when he stepped off the plane in New Jersey. It had been three years since he'd seen winter. With his eyes watering, he blew out a frosty cloud and headed indoors, shivering in his fatigues and jungle boots.

He was glad to be through with flying for awhile, but Ft. Dix was just another military installation, still part of the Army, still part of the war. Being in the United States scarcely registered; he wasn't *home* yet.

He had had plenty of hours to decide what he wanted to do when he landed. True to form, he immediately began arranging things to suit himself. In his haste, though, he forgot that rubber-and-canvas jungle boots were not all-weather gear. As he stepped onto an icy walkway, he fell and hit his head. The fall didn't knock him unconscious but it rang his bells. Whether it was the fall or his eagerness to get settled and find a telephone, he forgot his cap. Once again he was separated from the cap with the short bill that Gunther Shirley returned to him in Karachi.

He wasn't thinking about his hat when he tossed his bag on a bunk in the Transient Officers' Quarters and went looking for a telephone.

"Hey, Baby," he said softly when Mom answered.

He told her he had to report to Ft. Bragg, North Carolina, and go see his parents, but he wanted to see her first.

"Where are you staying?" she asked.

"The Taft," he said, giving her the name of the first nice hotel that came to mind. He had a few things to attend to in New York to make himself presentable for a stateside date, so they planned to meet the next afternoon. They both suggested meeting places—"under the clock"—"at the Waldorf"—"Union Station"— talking over each other, laughing at the simple pleasure of hearing the other's voice. Neither one could wait for Dad to get to Lynchburg. They had to meet sooner.

After they hung up, he called Cameron. His mother answered. "Oh, Heber," she gasped, calling him by his given name. He could hear the tears in her voice and it choked him up. "It's all right, Mama. I'm home."

"Your father's gone to Orangeburg. He'll be sick that he missed your call."

"I'll be home in a few days, Mama."

"Oh dear, I can hardly believe it."

"Mama, I need you to do something for me." During his two years overseas, the Army had, at his direction, deposited his pay in the bank back home, and he asked her to alert the bank that he was going to write a check.

Mom and Dad had been separated since that night at the train station in Lynchburg, two and a half years earlier, and he wanted to look sharp when he returned. He had executed his campaign of overseas courtship diligently and effectively; no way was he going to blow it by showing up with bad teeth, yellow skin and jungle fatigues. He had twenty-four hours to do a make-over. First of all, when he left Myitkyina almost a month earlier, he had quit taking Atabrine and the yellow tinge it imparted to his skin had mostly faded. Check. In the morning he would get a new uniform from Roger Peete or one of the other men's stores. Check.

But years of eating a rice diet, not to mention smoking heavily, had left him with bad teeth and gums, which demanded immediate attention. It was late in the day by the time he found the dental office on base. The dentist was closing up and told him he'd have to come back tomorrow.

That did not suit Dad. "I can't come back tomorrow," he said. "You have to do it now. I'm going home to see my intended and I don't want to go like this."

The dentist took umbrage at Dad's insistent tone. "Now see here, major, you can't order me around. It's after five. I've been here since eight-thirty and I'm quitting for the day."

Infuriated by the man's unsympathetic response, Dad took a step closer, raised his voice and said, "I've been over yonder in the damn jungle for two and a half years and we didn't go by any damn clock. I want you to fix my teeth now."

The dentist was moved to reconsider, perhaps by Dad's impassioned speech. Or, Dad admitted, "I may have had my pistol in my hand."

The peanut gallery nodded. After what Dad had been through, a little ol' dentist wasn't much of an obstacle.

The next item on the agenda was to get out into the civilian world. When he returned to the Transient Officers' Quarters, he found that someone had rescued his hat and put it on his bunk. Everything was working out just fine.

Dad caught a ride into New York City and went to the Taft Hotel.

"I'm sorry sir, but we are full." The desk clerk suggested another hotel nearby.

But once again, there was no room at the inn. The city was full of servicemen coming or going and every hotel seemed

to be booked. Walking along the street with his bag, Dad ran into a fellow who had been on the plane coming over. His colleague had scored a room and Dad begged to share it for one night, even though it had only one bed. In those days, girls were used to doubling up and so were boys. Dad felt he was somewhat beyond that stage—except today he was desperate.

Once he got settled in a hotel, Dad could afford to take a deep breath. He was ready to enjoy being in a big American city with good scotch, ice in your drink, Big Band music and a ballroom full of well-dressed people. He himself was still relegated to wearing fatigues. Clean fatigues, of course.

Despite his sartorial limitations, Major Traywick walked into the hotel dining room that night with the aplomb of a civilian in white tie and tails. He sat down to order a drink and enjoy the twenty-piece orchestra. Oh this was heaven: live music and no damn leeches.

During a break, the bandleader passed by and Dad stopped him. "How about having a drink with me? I just got back and I'm enjoying your music."

The bandleader accepted his invitation and they talked over a cocktail. "I just got off the plane this morning."

"Welcome home," the bandleader said with feeling.

"It's wonderful to hear music and be in civilization. You can't imagine," Dad said, and the bandleader smiled at his pleasure. Suddenly Dad had an idea. "There's a song that my girl sent me the words to, but I don't know what it sounds like: *I'll Walk Alone,* by Dinah Shore. Will you play it for me?"

The bandleader nodded. "I'll play it for you in a few minutes." He stood up to leave. "I have to tell you, though, my singer's husband just left yesterday to go overseas. She's pretty upset, but I'll ask her sing it."

After a few minutes, the bandleader looked over at Dad and nodded, so he walked to the edge of the dance floor to listen.

The singer stood by the mike during the intro then stepped up and launched into the lyrics with a beautiful voice.

I'll walk alone because, to tell you the truth, I'll be lonely.
I don't mind being lonely
When my heart tells me you are lonely, too.

I'll walk alone, they'll ask me why and I'll tell them I'd rather
There are dreams I must gather
Dreams we fashioned the night you held me tight

I'll always be near you wherever you are each night
In every prayer
If you call I'll hear you, no matter how far
Just close your eyes and I'll be there.

Dad was riveted by the singer's performance, touched by the tears streaming down her face as he remembered what the bandleader had told him. No wonder Mom had sent him the lyrics to this song. He felt himself swaying to the music, imagining holding her again and dancing with her.

Please walk alone and send your love and your kisses to guide me.
Till you're walking beside me, I'll walk alone.
I'll walk alone.

Dad left the ballroom feeling that these last twenty-four hours apart from Mom were the hardest of the entire war. After a sleepless night lying rigidly next to his roommate, he leaped up to take care of his final preparations for meeting Mom that afternoon. His trunk had burned up in Ledo, so he had no clothes, no uniforms, no shoes, nothing but fatigues and jungle boots. At Roger Peete's he bought a pair of Army regulation dress slacks, as well as shoes, socks, a shirt and tie, all off the rack.

Although none of the Army blouses fit him, Dad did not have to stick a pistol in Peete's face to get a blouse tailored pronto. After a few measurements and a few pins, Peete said, "Give me a couple hours, and we'll have it ready for you."

By noon, Major Traywick, resplendent in his new uniform, was on the train to Washington, the last leg of a two-and-a-half year, 25,000-mile journey back to his girl. Well, almost the last leg. Theirs was not to be the movie-climax reunion with the two lovers rushing across the platform to embrace. It almost didn't happen at all.

The train was crowded with other soldiers, coming home, going away, transferring to another post, but Dad was oblivious to them. He could hardly sit still for imagining the sight of Mom waiting under the clock in Union Station. When the train pulled in, he was the first one off. He walked quickly to the steps and climbed them two at a time. Across the central hall, he saw the clock and, under it, crowds of strangers streaming in every direction. He scanned every female face. He went and stood under the clock. He looked all around for a tall brunette. A new group of passengers entered the hall, and he looked at them eagerly. Finally, convinced she wasn't there yet, he checked the arrivals board to see when the next train from Lynchburg was due. He bought a cup of coffee to kill time, threw half of it away when the train came in. Once again he scanned the faces of passengers hurrying through the station, but he didn't see the one he wanted.

Finally, he called Lynchburg. Mrs. Neher answered the phone and told him, "Flo's gone to meet you in New York."

"New York?" he said. "She's supposed to meet me in *Washington*, under the clock at Union Station."

Mrs. Neher seemed remarkably unsympathetic, he noticed.

Instead, Mom was under the clock at the Waldorf in New York.

Mom had caught an early train and gone to New York, hoping to surprise Dad at his hotel. But when she got to the Taft, she found he wasn't there and never had been. With hours to fill, she amused herself wandering around Manhattan. She ran into a fellow from Lynchburg, which led to a circle of new contacts who took her to lunch while she waited. When she didn't find Dad at the Waldorf, she called home, and her mother said, "Come on back to Lynchburg."

Disappointed to tears, Mom got on the train back to Lynchburg.

Meanwhile, Dad began checking trains from New York, hoping Mom would call home and find out that he was waiting for her in Washington. After a couple hours, he called Lynchburg again. When Mrs. Neher answered, he could tell she was mad, but he couldn't figure out why. She said, "Flo's on her way back from New York," and hung up.

Dad sat on a bench facing the clock and smoked a cigarette until another train from New York came in. He studied the situation, and every time he went over it, he came around to the fact that Mrs. Neher was the one who made Mom send the ring back to start with. He began to doubt the future of the relationship. If her mother wanted to keep them apart, she could do it, especially if obedience to Mrs. Neher was more important to Mom than her love for him. Maybe the thing for him to do was get on the train and go on down to South Carolina.

Neither Mom nor Dad was sure, that evening, whether things would get un-mixed, or when. She had a seven-hour train ride home from New York to wonder where he was and what he thought. And he had a long moment in the midst of tramping feet, squealing wheels and hollow public announcements when the romance hung in the balance.

But just as when he sat in front of the stack on the *Ile de France* two years earlier and made up his mind that he wanted Flo, he made up his mind to go after her. If she didn't want him badly

enough to stand up to her mother, she'd have to tell him that to his face. He hadn't come this far to give up without a fight.

He got on the next train that left for Lynchburg, arriving about two o'clock in the morning and spending the rest of the night at the Virginian Hotel.

Mom, too, had gotten in late, possibly on the same train. Her father met her at the station and took her home, where she fell into bed.

The next morning, Dad walked down Church Street to a tailor's shop for some final touches to his uniform. He had picked up his unit patch and battle ribbons from Jambu Bum and Maingkwan in New York and wanted the tailor to sew them on his new blouse.

Smoking nervously, he caught a cab to 859 Belmont Street.

As Dad paid the taxi driver, Nana looked out the window and saw him. She hurried upstairs to awaken Mom.

"You've got a visitor."

Rushing to the window in her nightgown, Mom saw her lover, stunningly handsome in his uniform, walking towards her house.

"Oh, doesn't he look cute?" she gushed. Throwing on some clothes, she ran downstairs and threw herself into his arms.

Nana and Pop left the young couple in the parlor and went to the kitchen. Dad and Mom, entwined on the couch, giggled and kissed and talked. Dad put his cigarette down with the burning tip extended over the edge of a mahogany piecrust table and forgot about it as he and Mom caught up on the past two years.

The table sported a long burn mark ever after as a memento of the day.

As Major Traywick visited with his girl in Lynchburg, he was, technically, AWOL, Absent Without Leave. He was

supposed to be in Fort Bragg, N. C., for processing before taking a few weeks' leave. After that, he expected to go back overseas. The campaign in north Burma was over—As Mom and Dad greeted each other, a cheering crowd of Chinese was greeting the first convoy of supplies to travel the entire Ledo Road—but Dad knew his jungle experience would be put to use somewhere in the Pacific, perhaps the invasion of Japan.

He had no intention of leaving again without a wife. As he had three years earlier, on their first date, Dad went after what he wanted. "Why don't we go ahead and get married now?"

Mom was more than ready. They settled on Saturday of the following week, February 3, 1945.

2-3-45

As happy as Dad was to have his engagement to Mom nailed down at last, he could not relax. There were deeper emotions ahead as he kissed Mom goodbye and left for home to see his parents and mourn again the loss of his brother.

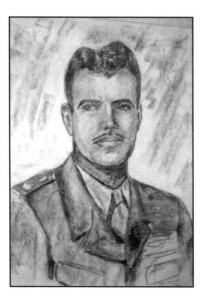 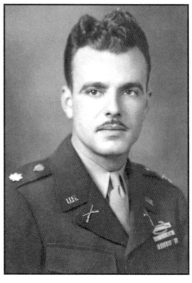

Artistic talent runs in the Neher family,
and Mom produced this charcoal portrait
of Dad while waiting for his return.

Chapter 47

Wedding Plans

It takes awhile to organize a big wedding. You have to announce the engagement, book the reception venue, find a dress, arrange the catering, order flowers, make up the guest list, issue invitations, engage the band, invite the bridesmaids, pick out dresses for the bridesmaids—all of which can take a year or more.

Nana had nine days. By wartime standards, that was more than adequate.

When Betty got married in Boston in 1940, the groom and his fellow officers (and their wives) arranged a lovely day of traditional nuptial festivities, including a wedding breakfast aboard Ed's ship, the formal ceremony and a champagne reception, all with about two weeks' notice.

Ironically, in an era when the default venue for weddings was a church, the site of their wedding became an issue. An Irish Catholic, Ed called on the priest at his church to arrange the marriage to his Presbyterian fiancée. Father Cushing - later to become well known as a Cardinal and a close friend of the Kennedy family's - told Ed he could not perform a wedding service involving a non-Catholic. Then he asked the young ensign why he didn't find a nice Catholic girl to marry. Offended, Ensign Luby let the priest know he would marry whom he (expletive deleted) chose. Ed then went to the priest at St. Cecilia in Back Bay, where the understanding father was willing to compromise and hold the ceremony in his study.

On the morning of the wedding, following a champagne toast at the home of friends, Betty and Ed drove to the shipyard for breakfast on the *USS Trippe*. There they found the *Trippe* decked out in wind-whipped streams of flags. As Ed helped Betty out of the car, sailors hanging over the sides of all the nearby ships whistled and cheered as loudspeakers suddenly blared "Here Comes the Bride" all through the Boston Naval Shipyard.

Following the brief ceremony at St. Cecilia, Ed's shipmates formed an arch of swords for the newlyweds to pass through leaving the chapel. The celebration continued with a reception at a private home nearby.

When Dick got married in Washington, D.C. in 1943, Pat's family had a little more time to organize the day, but once again, the venue was an issue. Pat, who was also Catholic, found that her priest had similar reservations about the Presbyterian groom. Her dreams of a church wedding dashed, Pat tearfully relayed the news to her fiancé. Whereupon Dick arranged for the Catholic chaplain at Ft. Myer, Father Mallifske, to perform the service in the chapel on base.

Fortunately, the minister at Rivermont Presbyterian Church in Lynchburg did not hold Dad's Methodist faith against him.

During the war, the attendants in a wedding often turned out to be whoever was handy. Mom had on several occasions held a bouquet for a bride she didn't know, couples rushing to the altar just as the groom was shipping out. Rounding up groomsmen was an even bigger challenge. Unsurprisingly, Bill Mount, who was 4-F and never left Lynchburg, was in high demand as a groomsman, a role he filled for Mom and Dad, among many others.

The peanut gallery always thought it was funny that Garrison Wood served as a groomsman in Mom and Dad's wedding. Garrison was an old beau Mom had met at one of the first college dances she attended. Three or four days before the wedding, Garrison called to ask her for a date. Mom blithely replied, "Garrison, it's so nice to hear from you! I'm sorry I can't

go to dinner Saturday, I'm getting married. But we'd love for you to be in the wedding." Garrison gallantly accepted the alternative.

It was funny enough that the guy didn't know she was engaged, but asking him to be in the wedding said a lot about Mom's social life and the dating customs of the day. Was it the need to fill out the wedding party or was it automatic execution of Nana's Rule #8? *Offer an alternative when you turn him down.* We can only guess.

The peanut gallery was amused but Dad was floored. He was still distracted by the excitement of being back in America, back with his girl, so he didn't make an issue of it, but in the early years of their marriage, Mom frequently had to contend with Dad's grousing about any male attention she received, no matter how innocently polite or perfunctory.

"He's just an old friend I've known for years," Mom told her jealous fiancé, a comment she would have occasion to repeat many times.

During the war, textile manufacturers made uniforms, not wedding dresses. Over the previous three years, the Lynchburg stores had been picked clean, so Betty and Mom took the bus 120 miles to Richmond. Thalhimer's and Miller & Rhoads had nothing left of any interest, but a boutique called Montaldo's displayed a candlelight satin gown with a sweetheart neckline and a train. Mom slipped the voluminous fabric over her head and worked her hands through the long sleeves. The clerk fastened the seed pearl buttons along her wrists as Mom admired the beaded bodice in a mirror.

Betty nodded. "Look no further."

The dress had the eye-popping price-tag of $125 [about $1,800 in 2020], necessitating a collect call to Lynchburg. In a moment Betty hung up and said, "It's all yours. She and Popsy didn't get to have a wedding for me so they want to do everything for yours."

The dress has become a family institution, with several brides choosing the elegant garment for their special days. I wore it twice: once at my first wedding and again when my brothers and I performed a humorous reenactment of our parents' vows for their fiftieth anniversary.

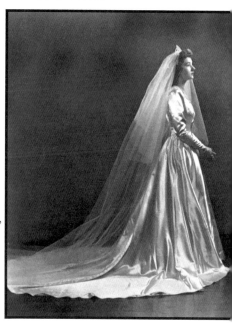

The proprietor of La Vogue, a Lynchburg boutique, called New York and found four matching bridesmaid dresses in dotted swiss, which determined the size of the wedding party. With Betty as matron of honor, Mom asked Fanny Watts to be her maid of honor and Ceevah Rosenthal and Tug Trent to be bridesmaids. Betty's three-year-old daughter Michele made an adorable flower girl.

Wedding attire wasn't the only thing hard to come by during the war. By the time 1945 rolled around, the fine china and gift department at Milner's department store had been pretty well picked over. Bowen's Jewelry store had little to offer, either. What Mom received instead were the prototype gift cards: heavy stock printed cards with blank lines filled in. "<u>Miss Ceevah Rosenthal</u> has bought <u>one Repousse teaspoon</u> which will be delivered from the manufacturer when available." Everyone knew that meant when the war was over and factories returned to producing luxury items.

With her wedding portrait made, her dress in the closet and her attendants lined up, the bride had nothing to do but hang out with the groom.

So while Betty and Nana burned up the phone lines calling guests, ordering flowers and planning refreshments, Mom got on the train and met Dad in Cameron.

CHAPTER 48

HOME AND FAMILY

For a soldier, coming home from war must be one of the most deeply-felt emotional experiences of a lifetime. Simply surviving, not getting killed. Seeing your loved ones again. Being on American soil. Being *home*. Coming home touches us at our core. Home is synonymous with family, and Dad had the strongest allegiance to family of anyone you can imagine. He loved his relatives, he was proud of them and he wanted to spend time with them.

Separation from his family during the war was hard. He asked about everybody in his letters home, especially Joe. And he welcomed letters from each family member, his brother, his sisters and both parents. He was overseas for that quintessential family holiday, Christmas, three years in a row. Like any soldier, he longed to see again the beloved faces of his family, faces he thought when under fire he might never see again.

For Dad, coming home from the war, knowing his brother had been killed while he had survived to rejoin the woman he loved, created a conflicting stew of emotions. Going to see Mom was uncomplicated, joyful. But going to see his parents would, he knew, be both painful and restorative.

Dad left Lynchburg and went home by way of Ft. Bragg, North Carolina, where he dealt with the bureaucracy and stayed overnight in the Transient Officers' Quarters. He had an unsettling experience in the night, waking up from a nightmare about the war to find himself facing the bedroom door with a loaded pistol in his hand. Thereafter, instead of leaving his pistol by the bed, he buried it in the bottom of his duffel bag.

The next day, he took a short bus ride across the state line to Florence. South Carolina! At last! Eager to cover the last few miles to see his family, he was frustrated to find that the connecting bus to Hartsville, where his sisters lived, had already left. He called Bruce, and her husband, Riley Gettys, drove the twenty miles to Florence to pick him up. Riley welcomed him home with what was clearly deep, if understated, emotion. The joy of one soldier's safe return was entwined with the pain of another's loss. As Dad asked Riley about the family's reaction to Joe's death, Riley revealed that his own brother, Hugh, had been killed, too.

Bruce and Mary Hope hugged their younger brother and clung to him almost as much as Mom had. Bittersweet tears punctuated their welcoming cries. As the family sat in a circle around Dad that night, babies on the floor, first one and then the other sister reached out to touch him in disbelief. They smiled distractedly at his happiness about marrying Flo and promised to make the trip to Lynchburg the next weekend. But overshadowing Dad's presence in their living room was the specter of Joe.

The reunion with his parents went much the same, tears and hugs of relief mingled with tears of irreparable pain.

They had aged so that when Dad saw them, he was shocked. They looked as though two decades had passed since he left, not two years. The landscape of their hearts was as ruined as the bombed out remains of Desden or Hamburg. There would always be a reserve about them, a little hollow place that would admit of no light or gaiety; it was like a pocket in Miss Janie's apron or a pouch like the one Dr. Traywick carried for his pipe tobacco, a small container for the pieces of their hearts broken when their son was killed.

Their anguish pained him. As pained as he was himself, he knew their suffering was worse. For the rest of their lives, Dad tried to be and do everything he could to make up for the loss.

But for the moment, he was caught with one foot in his childhood home and the other poised on the threshold of a home

with Mom. As he shared his parents' grief, he also exchanged telegrams daily with his beloved, until Mom caught the train south to meet him.

Mom rode the train to Cameron with a song in her heart, joyful music that was immediately quelled when she walked into Doc and Miss Janie's house. The furnace could not take the chill off and the electric lights could not dispel the deep gloom.

Miss Janie's hospitality was strained and Dr. Traywick's conversation was distracted. Mom's heart went out to them, but she was puzzled that they didn't seem cheered by seeing Bo. They were so mired in mourning Joe they could scarcely appreciate that their other son had come home safely or that he was embarking happily on marriage to the girl he had loved for almost three years.

On Thursday, after an emotional and affectionate farewell, the couple took the train north. The train ride flew as they made silly lovers' talk.

"Just a week ago today, you came up the walk and you looked so handsome I thought I'd die."

"If you had listened to me, we'd have met sooner."

"Maybe you should have listened to me."

Mom's spunk always made Dad laugh.

The sanctuary at Rivermont Presbyterian Church was packed at four o'clock on February 3, 1945, as one of Lynchburg's belles walked down the aisle on her father's arm to meet the dashing Army officer from South Carolina.

His parents could not bring themselves to face the happiness and excitement of a wedding, so Miss Janie's older half-brother, William Crute—Uncle Willie—came from Texas to serve as Dad's best man. Additionally the family was well represented by cousin Tom Traywick and his wife, Lib, and Dad's sisters and brothers-in-law.

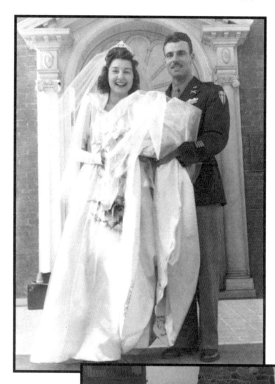

L-R, Ceevah Rosenthal, Tom Traywick, Frances Watts, Garrison Wood, Flo & Bo, Betty Luby, Willie Crute, Tug Trent, Bill Mount, Massie Yuille.

Betty's daughter Michele joins the wedding party.

During the reception at Oakwood Club, as the bride and groom received the good wishes of their guests, Garrison Wood fulfilled his unofficial duty by slipping Dad a glass of scotch in the receiving line. After they cut the cake, Dad led Mom to the dance floor. She slid comfortably into his arms, and they danced around the floor as though they had practiced every day. A perfect fit.

Dad was certainly in a state of disbelief. He had survived leeches, snipers, runaway horses, burning airplanes, drunken lieutenants, a year of tedium and cold-sweat fear in the jungle and two years of wondering whether he'd ever get home to claim "that Flo gal". He'd set his sights on her almost three years earlier and now she was his.

And Mom, at long last, after years of watching other brides, after fielding proposals from other officers and wondering if she should marry someone else, years of dancing and flirting with men who went to war, men who came home and begged her to marry them, and men who didn't come home, after years of worrying where Bo was and whether he would ever come home, and after working in Washington and taking a second year of college, had reached this glorious day: she was marrying the man of her dreams.

It is sort of unbelievable to think she was only twenty years old.

It says a lot about my father that Mom, in the end, waited for him to come home when she had her pick of many attractive, successful men. In fact, looking over her scrapbooks and her diary, it seems that she examined every other possible candidate, rejecting them all in favor of Bo Traywick.

And it says a lot about my mother that Dad, who clearly had women swarming around at all times, focused a long-distance courtship campaign for two years on the one woman who stood out from the crowd.

They both had strong personalities and, given that they hardly knew each other when they said "I do," it was perhaps

inevitable they would have some disagreements while working out the terms of their partnership.

"Oh we had lots of divorces in the beginning," Dad often said with a grin.

Mom would roll her eyes. "Your father…"

But they worked things out and had sixty-one years of the kind of marriage that people write books about.

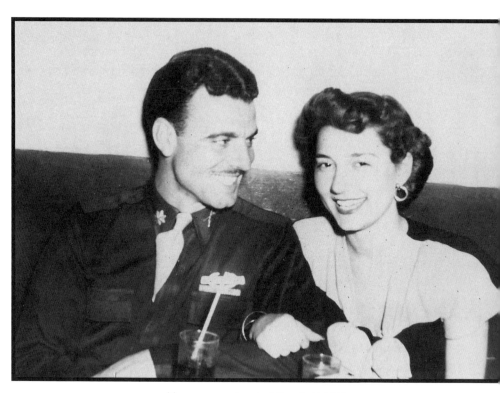

Honeymooning in Miami. (1945)

EPILOGUE

DRINKING ELIZABETH TAYLOR'S CHAMPAGNE

As Mom and Dad left their wedding reception, the first convoy of supplies pulled into China after traversing the 500-mile long Ledo-Burma Road. North Burma was secure and the rest of the country would be under Allied control in a few months. In six months the war would be over, and the men and women of the Greatest Generation would emerge from the conflict to find everything had changed. They would hug each other and embrace the new, post-war social order. The wartime industrial economy would quickly shift into producing consumer goods, and the children of the Depression would buy TVs and wringer-washers and new cars and they would build houses in the suburbs and produce a bumper crop of babies. My parents leaped into the thick of it.

In time, they became an early sort of power couple. Dad enjoyed success in business, built a columned mansion on a hill and flew his own airplane. Mom made her own career in politics that included an historic campaign for Congress, frequent invitations to the White House and a ride on Air Force Two.

But first they had to get to know each other.

When the happy couple left on their honeymoon, they had seen each other fewer than a dozen times in three years. Parties to an arranged marriage know more about each other than Flo and Bo did. Inevitably there were surprises and disagreements as they took each other's measure.

To make matters more challenging, Dad, despite having been raised a gentleman, suffered from the extended time away

from civilization and now gave vent to the jealousy he had banked for two years. While he himself had danced with plenty of nurses and enjoyed female companionship wherever he could find it, he was beside himself at the thought that Mom might have danced with another man or—horror of horrors—permitted a chaste peck on the cheek. When an officer at their table one night invited Mom to dance, she arose with a smile, only to have Dad jerk her back to her seat with a vociferous "No!" (Mom roasted him for his rudeness when they got back to their room.)

For her part, despite having had a million dates, Mom had had little experience with men beyond the realm of formal social manners. She found herself calling her mother regularly for advice on dealing with this jealous and earthy man she had married. The spunk that stood her in good stead over the years came in especially handy now.

One night in their Miami hotel room, Dad groused, "Do you have to call your mother *every* night?"

Incensed, Mom snapped back, "Do you have to have a drink *every* night?"

Struck by the fairness of this charge as well as the spirit of his beautiful new wife, he laughed and said, "Call her as much as you want."

After a couple of weeks honeymooning in Miami, Dad was relieved to receive orders for Ft. Benning—not the South Pacific. The Sullivan Rule probably spared him. In November 1942, five Sullivan brothers perished together when the *USS Juneau* went down in the naval battle at Guadalcanal, and the Defense Department established an informal policy that any surviving brothers of a man killed overseas would remain stateside.

Mom and Dad set up housekeeping in a seven-room apartment on base, and Nana shipped Mom's clothes and a few household items to her there. A cable from Lynchburg in March read: "Don't buy pans. Shipping a set tomorrow." They had the most

basic of furnishings, supplemented by any number of Army cots they wanted. They criss-crossed several layers of single mattresses to make a double bed and set up couches and guest bedrooms the same way.

Mom set about reintroducing Dad to civilization and working out the terms of their marital relationship, a process that frequently involved conversation at above-normal decibels. After one such exchange, Dad stalked out of the apartment with Mom flinging additional comments out the window at his retreating back.

Dad's temper flashed quickly but receded just as quickly, so he was dismayed when he returned a few minutes later to find the apartment empty. After half an hour, when Mom had not returned, he called Dick and Pat, who lived off base, and began searching the neighborhood. He had worked himself into an anxious fit when, some two hours later, Mom strolled back into the apartment.

"Where have you been?" he demanded, angry and relieved.

She smiled. "At the movies."

Dad always recalled that moment vividly and he would close his eyes and shake his head, mimicking the despair he felt. "Gollee, I thought, what hope is there for this marriage? She doesn't even care enough to stay mad."

Like many young brides of the era, Mom found herself "in the family way" just a few months after the wedding. Although she planned to go home to Lynchburg to have the baby, she had to struggle through the hot Georgia summer with no air conditioning first. Finally, in November, she packed her things and went to her parents' house in Lynchburg to wait out the last six weeks of her pregnancy. It was her first visit home since the wedding.

Mom was expecting Dad to take some leave and join her in mid-December when the baby was due, but to her surprise, he showed up the first week of December.

After greeting him effusively, she said, "You're here so early. Did you get extra leave?"

He shook his head. "Nope. I got out."

"You got out?" Mom was puzzled.

"I resigned from active duty."

Mom was flabbergasted. A million thoughts went through her head. She was having a baby, and her husband had quit his job! What was he going to do to support them? Where would they live?

She hadn't been married but ten months, but she was of the opinion that husbands and wives should consult one another before making life-changing decisions.

They argued, but Dad convinced her that the Army was not the career he wanted. He had several months' pay coming, which gave him the leisure to get his family settled and find a job. He had saved $16,000 while overseas, a sum large enough to buy a house or start his own business, so he felt confident about the future. As war production shifted to domestic production, the economy boomed, creating many opportunities for a young man with Dad's drive and salesmanship to prosper.

On December 17, 1945, Mom presented Dad with Heber Venable Traywick, Jr., one of the first babies of the generation that became known as Boomers and the first of their three children. She did not study Lamaze or have a "natural birth." She gratefully accepted every drug the doctors were willing to pump into her. "Twilight sleep" was the euphemism for knocking a woman out so that she wouldn't have to suffer any pain or embarrassment from the immodesty of giving birth. She might have to deal with a few contractions before her husband got her to the hospital, but then she could count on being blissfully unaware of parturition until the resulting baby was bathed, swaddled, displayed to the father, fed some formula and had a good nap.

They were living with Mom's parents at the time, but after Bo Junior's birth, it was time to move out. With Dad in his uniform and Mom carrying the baby, they walked down Rivermont Avenue knocking on doors and looking for a place to live. Eventually the

Pearsons offered them their third floor attic apartment, which had a separate entrance on the back of the house. Mom and Dad scraped together odds and ends of furniture, and they were able to celebrate their first anniversary in a place of their own.

Dad felt the best road to success involved being your own boss and he drove headlong down that road. Over the years he sold various products, his career culminating with a waste-to-energy marketing firm he founded called Air Pollution Control Products—now APC, Inc. He and Mom raised three children together, enduing them with strong conservative values and showering them with love and many lively adventures.

The 1950s were a boom time, and Mom and Dad built an imposing brick house surrounded by horse pasture and overlooking a small valley. Acutely aware of his father's lingering fears about his ability to support a family, Dad eagerly prepared to lay those fears to rest by showing Dr. Traywick the place he had built. Sadly for

The house on the hill. (2019)

all, Doc died in July of 1958 without ever seeing "the house on the hill." But Miss Janie made several visits and was duly impressed. As a native Virginian herself, she particularly appreciated the front porch view of the Blue Ridge Mountains.

With Dad on the road Monday through Friday selling whatever, Mom was called upon to manage a large household by herself a good bit of the time. Juggling three children and a well-stocked farmette required impressive organizational skills, not to mention the ability to forge Dad's signature whenever necessary. Long before Women's Liberation, Mom and Dad approached their marriage as a partnership. He turned over his paycheck to her and

Flo and Bo with the peanut gallery and pets.
Not pictured: many cats. (photo by
Lynchburg News & Advance, 1963**)**

she ran the household and paid the bills, squeezing eleven cents out of every dime, as befit the daughter of an accountant. He marveled at her efficiency and economy. She appreciated his respect for her abilities but occasionally despaired when he bought an off-budget item, such as a horse or an airplane. Flo managed the budget, and Bo busted it.

My dad was good at making money, but he excelled at spending it. Mom's Depression-era thrift was often at odds with his extravagance. They both grew up in a time when money was tight and yet they reacted differently as adults. Dad, once he made money of his own, was not afraid to spend, confident that he could

285

 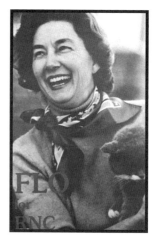

Memorabilia from Flo's political life include this 1980 campaign poster and a photo with Elizabeth Taylor taken during John Warner's 1978 campaign for the U. S. Senate.

always make more. Mom to this day will not throw anything out until it is completely used up, forcing her children to go behind her back and clean out the refrigerator to keep her from drinking sour milk. She does her bookkeeping each month, as she always has, on the back of an envelope or a sheet of stationery left over from some political campaign in the 1980s.

Although she always put her family first, Mom has had a job from time to time and enjoyed it. In another era, she would have had a brilliant career at something. As it was, balancing home and work, she managed to do quite well in both arenas. And somehow, in the midst of managing a home, raising a family and running for public office, Mom found time to return to college, graduating from Randolph-Macon Women's College at age 53.

Mom and Dad's experiences with boats, horses, dogs, cats, a beach house, three children, politics and international travel would fill another book. For my parents, life was always an adventure, met with gusto and humor. Dad approached every occasion as an opportunity to do something new, experience something different. Mom was always ready to party and meet new people. They made an adventuresome pair.

For Dad, though, the greatest adventure of his life was being married to Mom. An entertaining storyteller, he loved most of all to tell the romantic story of their courtship. They celebrated their fiftieth anniversary in 1995 with, appropriately, a dance at Oakwood Country Club. We three children put on a skit re-enacting their vows. I wore Mom's wedding dress, Bo Jr. wore his father's uniform and Cris wore a choir robe and performed the ceremony. Mom and Dad had always been able to laugh at themselves, and the script humorously touched on all the disasters, missteps and family jokes of their marriage.

Eleven years later, they celebrated their sixty-first anniversary quietly at home with their children around the table. For a toast, I pawed through the liquor cabinet and found an old bottle of champagne.

"We bought that for Elizabeth Taylor, when she came here to campaign for John Warner," Dad said.

"We were going to put it in the room for her to have when she freshened up before the event," Mom said.

They both laughed.

"When she got here, the first thing she said was, 'I'll have a double bourbon on the rocks.'"

"So we put the champagne away."

As the peanut gallery smiled, Dad leaned back and began to reminisce. "You know, I met Flo on April Fool's Day. This friend of Dick Neher's asked me to take her out because they had to go out on night maneuvers. I wasn't much on blind dates, but I went over to the Officers' Club to check her out, and whooo-ee! Here comes this good-looking gal wearing a little fur jacket and high heels that made her twitch just right...and that was all she wrote."

And they lived happily ever after ~

ACKNOWLEDGEMENTS
AND THANK YOU TO…

Megan Daum, who told me the 150,000-word FFD ("Full Family Documentary") version had to be completely rethought and recast and retold, simply, in my personal storyteller's voice. "You can't write about your own parents in third person from arm's length." I was so overwhelmed at the prospect of completely rewriting a book I had already spent ten years on that I wept. But she was right, so I sucked it up and did it.

Lynn Bayliss, whose editorial advice was so good and so charmingly rendered that I didn't mind killing a lot of darlings. Thanks for helping pull the book out of a mire of personal self-indulgence and transform it into a readable account of a wartime love story.

Nancy Parrish, who gave me the first and most valuable reading, plowing tirelessly through the first draft with detailed editing and comments, a wonderful gift.

Virginia Quarterly Review, for the amazing writers' seminars that I attended in 2014-2016, meeting, learning from and working with such great writers as Bret Anthony Johnston, Wells Tower, Megan Daum, Richard Bausch.

WriterHouse, for the classes and community of writers this terrific organization fosters in Charlottesville, Virginia, such as the one with…

Michael Cordell, whose entertaining and instructive class on screenwriting helped me hone the central story of the book.

James River Writers, for the always-valuable annual conference in Richmond where I met writers and learned from writers as I worked through this project. Among the most valuable introductions were…

Dean King and Jim Campbell, for telling me, "You have to go there." Even though I didn't get to Burma or North Africa, I did follow Dad's footsteps through New Zealand, Sharja, Arabia and India. And of course, Ft. Benning.

Readers Bill Wiley, Gabrielle Thomas, Martha Steger, Dean King, Michele Luby Eldredge, Mary Buford Hitz, who gave me valuable feedback and encouragement.

Barclay Rives, with whom I have enjoyed many conversations on writing and on foxhunting and on writing about foxhunting, who gave me wonderful quotes and helpful edits.

Henry Hurt, editor, writer, night hunter, whose review of the book and whose friendship I treasure.

Norman Fine, foxhunter, writer, editor and engineer—an all-around Renaissance Man—who has now helped me with two books.

Gabrielle Thomas, whose excitement about the book kept me going through many discouraging days.

Wayne and Dianne Dementi, who have put so much love, enthusiasm and talent into this book.

Jayne Hushen, who has designed yet another gorgeous book cover for me. What an artist!

Professor Hitendranath Sarma, the keeper of the flame of the Stilwell Road, who deepened my feel for life in India during the war and who made sure Bo Junior and I got in and out of Assam safely.

My brother Bo, for suffering through the FFD version and also for giving me all of Daddy's books about Burma, many of which have notes penciled in his own hand.

My brother Cris, who also suffered through the FFD version and who made some great catches of errors in this version.

And mostly, thanks and deep appreciation go to my amazing and supportive husband, Cricket.

A NOTE ON SOURCES

This book has been carefully researched.

Although this is the personal story of my parents, the war was an inseparable part of that story. Their courtship would not have unfolded as it did had they not met at the precise moment of America's entrance into the war. Telling the stories of their courtship and their wartime experiences required an immense amount of study. In fact, the second draft of this book was almost twice as long as the final draft and included what I refer to as the "full family documentary version".

What you have read was drawn from my parents' scrapbooks, diaries, letters and personal reminiscences, including more than thirty hours of recorded interviews. For background on the war and the culture of the Thirties and Forties, I used contemporaneous sources as much as possible. I certainly read every memoir of the Burma Campaign written in English that I could lay my hands on, as well as Stilwell's diary and several notable histories of the China-Burma-India theater of war.

Listed below is a selected bibliography.

Increasingly, the Internet provides access to original papers and source material that would be difficult to find otherwise. Even in cases where the actual papers had not been scanned into a database, I could at least find out where they were and pursue them through other avenues.

For instance, I spent time at the National Archives in Maryland seeking to corroborate details of troop movements and to learn more about some of Dad's colleagues. Unfortunately, I could find little or nothing about what I estimated to be a dozen or so of Dad's fellow liaison officers with other Chinese units. I found only

a few tidbits about Dad's rival, Steve Thornton, but he was a spy, after all, and early records of OSS activity are apparently scarce or filed somewhere else. Since he did not end up with Mom, I decided not to worry too much about gaps in his story.

This is a memoir and many anecdotes are based simply on my parents' memory of how they happened. To the extent possible, I fact-checked their accounts. I found only two occasions where my research disagreed with their memories:

Mom enjoys telling about working for Lend-Lease in Washington and saying that she made "$150 a month—ten dollars more than the graduates of the Naval Academy." I was unable to nail this down definitively amidst conflicting tidbits of data. But it is clear that by the next year after Mom left Washington, the Naval Academy graduates were making $150 a month, Congress having apparently decided ensigns were worth as much as a clerk with Lend-Lease.

Dad's war stories were anecdotal, not chronological, and it took me two years of studying the Burma Campaign of 1944 to understand the role of the 66th Chinese Regiment so I could fit Dad's stories into the proper chronology. He read the first draft of the book and said that I had accurately chronicled his experiences overseas, with one exception. He felt the incident when General Stilwell walked up to the front and relieved Colonel Ch'en of command occurred much later, as they were approaching the Irrawaddy River in October. Dad was correct that Colonel Ch'en had been replaced by Colonel Lo by then, but the sensational incident when Stilwell temporarily relieved Ch'en is documented by Tuchman and others as occurring in February, when the 66th Regiment got lost on its assignment to take Yawngbang GA. In any event, by October, Stilwell himself had been relieved and was back in the States.

The dialogue in the book is based on my parents' recollections of various conversations. Dad seemed to relive each incident as he told the story, and his style involved quoting the relevant dialogue: *He said this and then I said that*, etc. Mom, too, remem-

bered what she talked about with various people. For instance, her retort to Paul Schultz—"I fell out of my highchair yesterday"—came from her diary, while her fishing for information about Steve Thornton's military posting came directly from her repeated account of that event.

Despite my scrupulous care, there may well be errors of historical fact, for which I take sole responsibility. The other members of the peanut gallery may also have different memories or interpretations of some events, but they'll have to write their own books.

A PARTIAL LIST OF SOURCES

Allen, Louis, *Burma: The Longest War 1941-1945*, Phoenix Press, 3d impression, 2001

Ambrose, Stephen E., *Band of Brothers: E Company, 506th Regiment, 101st Airborne from Normandy to Hitler's Eagle's Nest*, Simon & Schuster Paperbacks 2004

Ambrose, Stephen E., *Pegasus Bridge*, Simon & Schuster Touchstone 1988

Anders, Leslie, *The Ledo Road: General Joseph W. Stilwell's Highway to China*, University of Oklahoma Press 1965

Brokaw, Tom, *The Greatest Generation*, Random House Trade Paperbacks 2005

Budiansky, Stephen, *Battle of Wits: The Complete Story of Codebreaking in World War II*, Simon & Schuster Free Press 2000

Campbell, James, *The Ghost Mountain Boys: Their Epic March and the Terrifying Battle for New Guinea—The Forgotten War of the South Pacific*, Crown Publishers, 1st ed., 2007

Carpenter, Alton E. and Eiland, A. Anne, *Chappie: World War II Diary of a Combat Chaplain*, Mean Publishing, 2007

Chan, Won Loy, *Burma: The Untold Story*, Presidio Press 1986

Costello, John, *The Pacific War 1941-1945*, William Morrow & Co. 1981

Diebold, Lt. William, *Hell Is So Green: Search and Rescue over The Hump in World War II*, Lyons Press 2012

Dunlop, Richard, *Behind Japanese Lines: With the OSS in Burma*, Rand McNally & Company 1979

Editorial staff, LIFE magazine: *LIFE'S Picture History of World War II*, TIME Inc. 1950

Editorial staff, LIFE magazine: *LIFE: The First 50 Years, 1936-1986*, TIME Inc. 1st edition 1986

Editorial staff, Time Magazine: *Absolute Victory: America's Greatest Generation and Their World War II Triumph*, TIME Books 2005

Eldridge, Fred, *Wrath in Burma: The Uncensored Story of General Stilwell and International Maneuvers in the Far East*, Doubleday & Company, 1st ed., 1946

Erenberg, Lewis A., *Swingin' the Dream: Big Band Jazz and the Rebirth of American Culture*, The University of Chicago Press, 1998

Fraser, George MacDonald, *Quartered Safe Out Here: A Recollection of the War in Burma*, Harper Collins trade paperback edition 1995

Gawne, Jonathan, *Finding Your Father's War: A Practical Guide to Researching and Understanding Service in the World War II US Army*, Casemate, 2006

Greene, Bob, *Once Upon a Town: The Miracle of the North Platte Canteen*, William Morrow, 1st ed., 2002

Grun, Bernard, *The Timetables of History: A Horizontal Linkage of People and Events*, Simon & Schuster Touchstone 1982

Hanson, Victor Davis, *The Second World Wars: How the First Global Conflict Was Fought and Won*, Basic Books, 1st ed., October 2017

Ludeke, Alexander, *Weapons of World War II*, Parragon Publishing 2007

Moser, Don, and the editors of TIME-LIFE Books, *China-Burma-India*, TIME-LIFE Books 1978

Ogburn, Charlton, *The Marauders*, William Morrow Quill 1982

Prefer, Nathan N., *Vinegar Joe's War: Stilwell's Campaigns for Burma*, Presidio Press 2000

Prehmus, Drew, *General Sam: A Biography of Lieutenant General Samuel Vaughan Wilson*, Hampden Sydney College 2011

Romanus, Charles F., and Sunderland, Riley, *China-Burma-India Theater: Stilwell's Mission to China*, Department of the Army, U. S. Government Printing Office 1952

Rooney, David, *Military Mavericks: Extraordinary Men of Battle*, Castle Books 2004

Scutts, Jerry, *War in the Pacific: From the Fall of Singapore to Japanese Surrender*, Thunder Bay Press 2000

Seagrave, Gordon S., *Burma Surgeon*, W. W. Norton & Company Book Club Edition 1943

Slim, Field Marshall Viscount, *Defeat into Victory*, Pan McMillan 2009

Stilwell, Joseph W., *The Stilwell Papers*, arranged and edited by Theodore H. White, McFadden Books 1962

Stokesbury, James L., *A Short History of World War II*, Harper Perennial 2001

Tuchman, Barbara W., *Stilwell and the American Experience in China, 1911-1945*, Grove Press, 1ˢᵗ ed., 1985

Toland, John, *But Not in Shame: The Six Months After Pearl Harbor,* Random House, Second Printing, 1961

Tumpak, John R., *When Swing Was the Thing: Personality Profiles of the Big Band Era*, Marquette University Press 2009

Unknown author, *Ramgarh-Now It Can Be Told*: A pictorial story of the Chinese American Training Centre in India where the soldiers of two great nations have combined their efforts to mould the means of defeating the common enemy, Catholic Press, (Ranchi, India) 1945

Walker, Leo, *The Wonderful Era of the Great Dance Bands*, Da Capo Press 1964

Webster, Donovan, *The Burma Road: The Epic Story of the China-Burma-India Theater in World War II*, Harper Collins Perennial 2004

White, Theodore H., and Jacoby, Annalee, *Thunder Out of China*, William Sloane Associates 1946

Yellin, Emily, *Our Mothers' War: American Women at Home and at the Front During World War II*, Simon & Schuster Free Press, 2005

About the Author

Robin Williams is an award-winning journalist and author. A graduate of the Hollins University creative writing program, Robin worked as a features writer for the *Richmond Times-Dispatch*. She served ten years on the Virginia (Horse) Racing Commission during the early years of racing in Virginia, six years as chairman. She was also instrumental in founding a successful chapter of the Thoroughbred Retirement Foundation and later served as president of the national organization. Well-known for her humorous essays and her entertaining talks, Robin lives on a farm-ette in Virginia. She and her husband have one daughter and a menagerie of horses, dogs and cats. She is a recovering craftaholic.

The author with her parents and brothers at Flo and Bo's 50th wedding anniversary. (Oakwood Club, 2005)

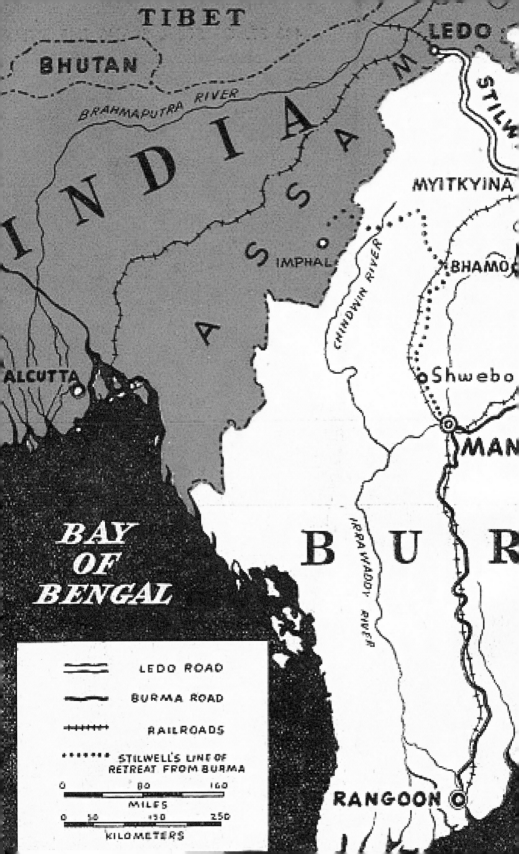